THE DALAI LAMA

*May all sentient beings,
oneself and others, find constant happiness through
love and compassion associated with wisdom.*
—Dalai Lama, Tenzin Gyatso
December 27, 1989

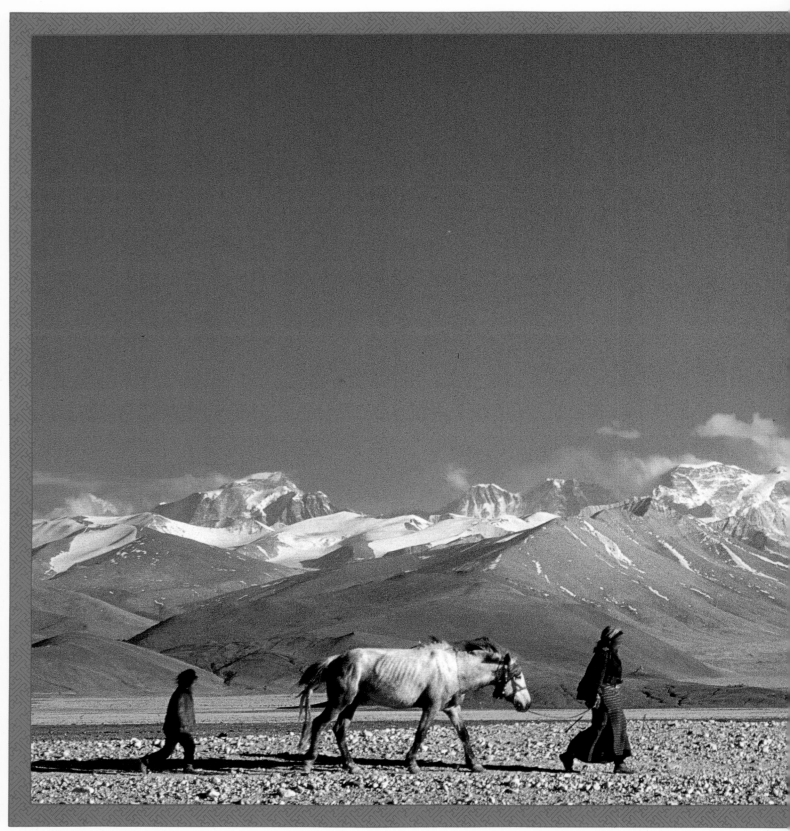

EVENING ON THE TINGRI PLAIN BELOW CHO OYU (26,750 FEET); 1988

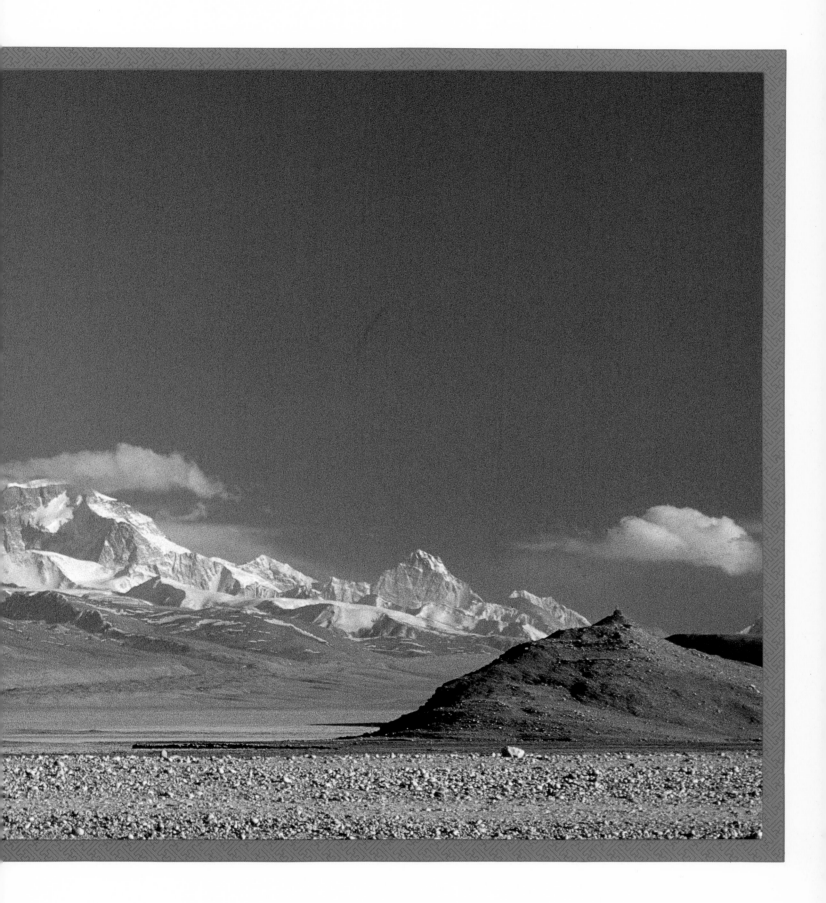

MY TIBET

TEXT BY HIS HOLINESS THE FOURTEENTH DALAI LAMA OF TIBET
PHOTOGRAPHS AND INTRODUCTION BY GALEN ROWELL

A Mountain Light Press Book published by
UNIVERSITY OF CALIFORNIA PRESS
Berkeley and Los Angeles

University of California Press
Berkeley and Los Angeles

Portions of the text reprinted by permission of the Information Office
of His Holiness The Dalai Lama, Dharamsala, India; Buddhist
Perception of Nature, Hong Kong; Snow Lion Publications, Ithaca,
New York. Additional photographs, pages 5, 41, 46, and 51, by
Barbara Cushman Rowell.

First Paperback Printing 1995

Library of Congress Cataloging-in Publication Data
Bstan-'dzin-rgya-mtsho, Dalai Lama XIV, 1935–
My Tibet / text by His Holiness the fourteenth Dalai Lama of Tibet;
photographs and introduction by Galen Rowell.

"A Mountain Light Press book."
ISBN 0-520-08948-0
1. Rowell, Galen A. II. Title.
 BQ7935.B774M9 1990 90-10868

951'.505—dc20

Printed in Hong Kong 3 4 5 6 7 8 9

Table of Contents

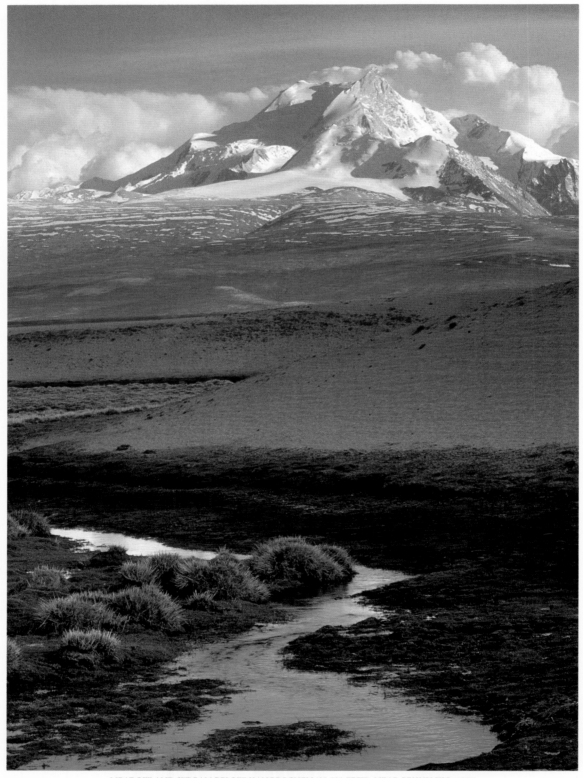

MEADOW AND STREAM BELOW KANGBOCHEN (23,933 FEET), NEAR PEKHU TSO; 1988

*"When I think of Tibet, this is the kind of scene I see
in my mind. Here the snow, mountain, plain, water, and grass come together
in a way that gives me the true feeling of being there."*

*The Norwegian Nobel Committee has
decided to award the 1989 Nobel Peace Prize to the Fourteenth
Dalai Lama, Tenzin Gyatso, the religious and political
leader of the Tibetan people. The Committee wants to emphasize the
fact that the Dalai Lama in his struggle for the liberation
of Tibet consistently has opposed the use of violence. He has instead
advocated peaceful solutions based upon tolerance
and mutual respect in order to preserve the historical and
cultural heritage of his people.*

*The Dalai Lama has developed his philosophy of
peace from a great reverence for all things living and upon the concept
of universal responsibility embracing all mankind as
well as nature. In the opinion of the Committee the Dalai Lama has
come forward with constructive and forward-looking
proposals for the solution of international conflicts, human rights
issues, and global environmental problems.*

Oslo, Norway October 5, 1989

BHALU (RHODODENDRONS) IN THE KAMA VALLEY, EAST OF CHOMOLUNGMA (MOUNT EVEREST) (29,108 FEET); 1988

"Many people are surprised to learn that
large areas of Tibet have greenery and heavy vegetation. I camped in valleys
like this one with thick forests, rhododendrons, and wildflowers
of every color on my way to Beijing in 1954 and to Sikkim for the 2,500th
anniversary of Buddha's birth."

INTRODUCTION
By Galen Rowell

I remember my nervousness, long ago, when I gave a slide show for a roomful of people for the first time. I agonized over how they would respond. As my home slide shows evolved into professional lectures, that early nervousness disappeared. I had nearly forgotten the giddy feeling when it returned on a spring day in 1989. Once again, I was to give a simple home slide show. This one, however, was in the old British hill station of Dharamsala in the foothills of the Indian Himalaya, where the word audience had a different meaning. I was about to have an *audience* with His Holiness the Fourteenth Dalai Lama of Tibet. The fate of an idea for a book upon which I was ready to commit my heart and soul depended on his singular response.

I had come halfway around the world to pursue a book project that so far had no publisher. I was lucky to have strong support and encouragement from my wife, Barbara, and two American friends, Rex Fuqua and Suzie Eastman, who had come to India with me to help with the project. Before we had left America, Barbara and I had formed Mountain Light Press as an addition to our photo-stock business, enabling us to edit and design our own picture books. Though we were gearing up to deliver camera-ready copy to a publisher, we knew in our hearts that the success of this unusual project rested far less on all our efforts than on how His Holiness responded to photographs of a homeland he had not seen with his own eyes for three decades. Our pilgrimage to Dharamsala had been made possible by Tenzin N. Tethong, the Dalai Lama's personal representative in Washington, D.C. He had arranged our audience with the calm assurance that His Holiness would be receptive.

Dharamsala became the seat of the Tibetan government in exile when His Holiness resettled here in 1960, but it has become much more than that. His Holiness says: "If it were not for our community in exile, so generously sheltered and supported by the government and people of India and helped by organizations and individuals from many parts of the world, our nation today would be little more than a shattered remnant of a people. Our culture, religion, and national identity would have been effectively eliminated. As it is, we have built schools and monasteries in exile and have created democratic institutions to serve our people and preserve the seeds of our civilization. With this experience, we intend to implement full democracy in a future free Tibet."

During our five-minute walk from the Tibet Hotel to the Dalai Lama's residence, one scene dissolved into another in fast-cut Hollywood fashion: a bazaar of shops with honking taxis; a construction site for a new tourist hotel, where Hindu women in garish saris passed pots of wet concrete to gray workers, whose skin and clothing were permeated by the color of the foundation; a courtyard filled with Buddhist monks in maroon robes; a gate where Indian military police in starched uniforms confirmed our appointment, gave us a body search, and closely examined the box of chocolates we had brought for His Holiness.

From the gatehouse we were ushered into a quiet meeting room with a mixture of Tibetan and Western decor. It could have been a guesthouse lobby, except for the presence of a throne and an altar. To our surprise, an aide helped us set up an old projector and screen in such a way that His Holiness could see the slides from an ordinary chair next to two sofas where the rest of us would sit. With no warning he simply walked in, dressed in the robes of a Buddhist monk. We stood up and nervously prepared ourselves for the solemn pomp and circumstance of meeting a great religious and political leader. The aide passed each of us a *kata*, a prayer scarf of white silk that we were to present with both hands, according to tradition. As His Holiness neared, he bowed slightly toward us, clasping his hands together in front of his face. Instinctively I began to return the greeting, conditioned by countless meetings with Buddhists during my journeys to Tibet. I realized too late that the two actions didn't go together. As I raised my hands, the *kata* came up over my face. I dropped them, hoping no one would notice, but His Holiness had already begun to laugh. Within seconds his low chuckle swelled into an all-consuming bass rumble that communicated joy and openness without any hint of derision. To this day I don't know if he saw my fumbling, but his laughter completely defused my nervousness. He greeted each one of us as one human being to another, and I felt ready to begin the show. Before he reached me,

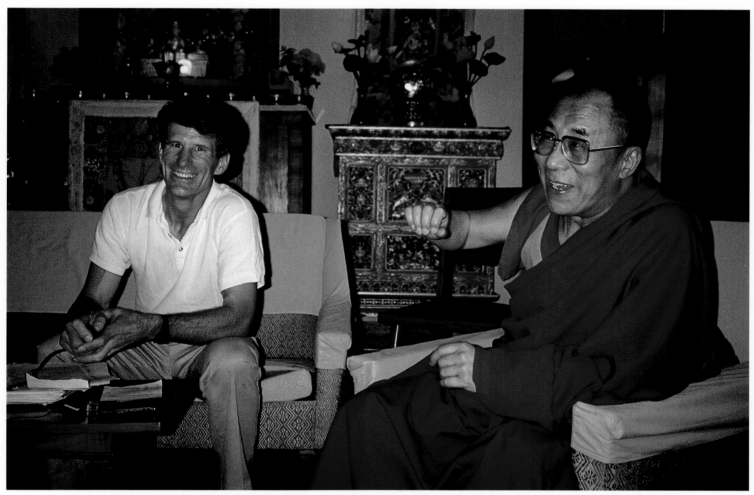

HIS HOLINESS THE DALAI LAMA WATCHING SLIDES OF TIBETAN WILDLIFE, DHARAMSALA, INDIA; 1989 (PHOTO: BARBARA CUSHMAN ROWELL)

*"Our planet is our house, and we must keep it
in order and take care of it if we are genuinely concerned
about happiness for ourselves, our children, our friends, and other
sentient beings who share this great house with us."*

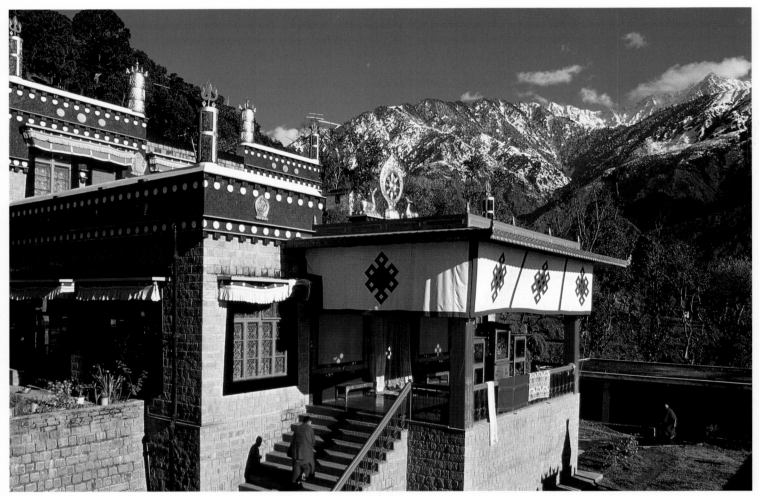

NEW NECHUNG MONASTERY OF DHARAMSALA, INDIA; 1989

*"We have built schools and monasteries in exile
and have created democratic institutions to serve our people and
preserve the seeds of our civilization. With this experience we intend
to implement full democracy in a future free Tibet."*

he stopped beside Barbara, took both her hands in his, and broke into a broad grin as he saw her lapel pin: a miniature flag of Tibet.

Until 1950 the Tibetan flag flew over an independent country that had its own government, religion, postal system, and currency. Like the mythical kingdom of Shangri-La, Tibet sought isolation from the rest of the world. Diplomatic relations were shunned, as was membership in the United Nations. Thus when Chinese communist armies occupied Tibet by force in late 1950, no international framework existed to support the Tibetan cause. His Holiness the Dalai Lama, Tenzin Gyatso, a fifteen-year-old boy, fled across the Himalaya in winter to seek political assistance for his country. He was dismayed to find his cause rejected by both the United Nations and the world's great powers. Especially disappointing was the lack of support from Britain and the United States, a lack of support that continues to this day. Britain had just washed its hands of its massive Asian empire, creating the newly independent nations of India and Pakistan. These two countries were too involved with conflicts between them to divert their attention across the Himalayan barrier to support a nonaligned kingdom that had few economic or political fruits to offer. Nor did they wish to irritate their great northern neighbor, China, which made it clear that any support for Tibet would be taken as intervention in internal Chinese affairs. The United States had watched the black cloud of Mao's communism quickly spread over Asia and had just gone to war with Korea. Thus the United States, too, was committed elsewhere at that critical moment.

Both Britain and the United States severed all ties with China and blocked its membership in the United Nations after Mao came to power. With the world's most populous nation kept out of the game, the United Nations played its hand without a full deck for the first twenty-three years of Mao's reign. Thus negotiations on behalf of Tibet were closed off from both the East and the West.

When Richard Nixon "normalized" Sino-American relations after 1972 with the help of Henry Kissinger and Special Envoy George Bush, friendship with China came at the high price of purposeful obliviousness toward an ongoing reign of terror unparalleled in world history. According to a report by the U.S. Warren Committee, by 1972 somewhere between thirty-two million and sixty-three million people had been killed by Mao's regime, more than the combined total of all the Holocaust and battle deaths of World War II. An estimated 1.2 million of those killed were Tibetans, a death rate at least five times greater per capita than for China as a whole. In 1960 the Geneva Report of the International Commission of Jurists concluded that "acts of genocide had been committed in Tibet as an attempt to destroy the Tibetans as a religious group." Twenty-seven categories of human rights violations were listed, including large-scale "torture and cruel, inhuman, and degrading treatment" combined with "murder, rape, and arbitrary imprisonment."

Today world leaders continue to avert their eyes. As of April 1990, the Dalai Lama has not once been received by the U. S. State Department, and no president has ever been willing to shake his hand. Wherever His Holiness travels, Chinese diplomats lobby foreign governments to cancel meetings with him.

Some world leaders have resorted to covert meetings with His Holiness, risking discovery by the press as they sneak in back doors of hotels or private residences. George Bush, however, has gone a step beyond merely avoiding the Dalai Lama. In 1977, after visiting Lhasa flanked by a Chinese entourage, he wrote an article for *Newsweek* in which he erroneously reported how the Dalai Lama, a lifelong advocate of nonviolence, "led an unsuccessful revolt against Peking." He described His Holiness only by parroting Chinese phrases about "the lavish splendor of his former lifestyle and his callous attitude toward the people." *Newsweek* printed a covey of critical letters to the editor. One, from Helen Steffen of Ventura, California, summed up the feelings of those who understand Tibet's true heritage: "It is deeply saddening that such malicious and biased propaganda should be passed on as objective reporting to an already poorly informed American public."

Whatever the merit of China's claims of treaties and agreements between Tibet and old Chinese dynasties, the very concept of holding a nation in bondage is untenable in today's world. By the same line of reasoning, not only could the Soviets hold onto Eastern Europe by force, but also the British could reclaim their old empire, including India, Ireland, and the United States. Significantly, China's tenuous presence in Tibet ended before World War I. From that time until the communist invasion, Tibet was unquestionably independent in both domestic and foreign affairs.

Although China had sporadic influence in Tibet in the eighteenth and nineteenth centuries, its claim of sovereignty clashes with one area of meticulously documented British history. If China was really in control of Tibet, or even only its foreign policy, why did the British send the Younghusband military expedition to Lhasa in 1904 to negotiate directly with the Tibetan government when they heard rumors of Russian influence there? For political reasons, the British remained ambivalent about Tibet's autonomy. Practically, however, the Tibetan campaign of the legendary "Great Game" of nineteenth-century British exploration and intrigue in Central Asia came about because Tibet was neither part of China nor controlled by China.

My personal experiences confirm the ongoing Chinese political deception. On my first visit to Lhasa in 1981 a Chinese tour guide pointed out an inscription in front of the ancient Jokhang Temple as evidence of a treaty made in the year 822 in which Tibet first acknowledged Chinese sovereignty. I later learned the

true translation of the Tibetan inscription: "Tibetans will live happily in the great land of Tibet. Chinese will live happily in the great land of China."

Barbara and I had not come to Dharamsala to discuss politics with His Holiness. Our goal was to let others report on the ongoing conflict with the Chinese, covered in depth elsewhere, in favor of producing a book that would focus on the more enduring meaning of Tibet. We believe that ancient Buddhist philosophy and the modern environmental ethic merge where the future of Tibet's vast natural landscape and ancient culture is concerned. Both ways of thought underscore the idea that no person or nation has the right to destroy the birthright of other citizens of the world.

The Tibetan Plateau is one of those remaining legendary wild places, such as the Serengeti Plain, the Galapagos Islands, and Yosemite Valley, that must be preserved for their own sake for everyone instead of being altered for the short-term benefit of a few. So, too, should Tibetan culture be allowed to endure in its natural environment.

His Holiness is far more interested in talking about common ground than about conflict. He bears no ill will, even toward the Chinese. To dwell on the agony the Chinese have imposed upon his land is to lose most of the essence of his being and his message to the world. To Tibetans the Dalai Lama is the incarnation of Chenrezi, the Buddha of compassion. His Holiness personifies the Buddhist belief that all sentient beings achieve their greatest happiness in feeling compassion toward one another and that if we cannot escape hatred, it should at least be directed toward the deed rather than the doer. He advocates "the kind of love you can have even for those who have done you harm." Thus his strong statements about Chinese atrocities in Tibet are tempered with seemingly incongruous expressions of love for the Chinese people.

In every situation His Holiness searches for a way to express compassion. He once wrote, "My enemy is my best friend and my best teacher because he gives me the opportunity to learn from adversity. You do not learn much from your friends when you are comfortable; you learn much more from your enemies!" Hidden in this simple statement about adversity is the philosophy that led me to Dharamsala. The Buddhist attitude of compassion also extends to the natural environment, which has been the central focus of my life and work. While most of the civilized world has spent the last few centuries in conflict with the environment by treating nature as an enemy to overcome, Tibetans have maintained a reverence for the interdependence of humans and nature. Instead of seeking physical comfort in altered surroundings as a pathway to happiness, Tibetans gain spiritual awareness through encounters with adversity in their natural environment. Their traditional pilgrimages through the rugged highlands of their country bear an uncanny resemblance to the wilderness travels we in the West find so liberating. The primary motivation of confronting adversity for its own sake, without promise of external reward, is much the same.

A major difference is that Tibetans have traditionally lived their entire lives with a spiritual regard for all land and beings, whereas most of us in the West practice one set of values within a national park on our vacation and quite another in our everyday lives. At a basic level, our nature preserves are set up in opposition to our prevailing culture.

One reason Tibetans have never been active proponents of nature preserves as we know them is that it is hard for Tibetans to conceive of what would be different on the other side of the boundary. Until the coming of the Chinese, their culture lacked the environmentally abusive habits that led us to create the parks and nature reserves we like to think of as the foundation of our environmental ethic.

I knew from conversations with his aides that His Holiness not only felt strongly about protecting Tibet's natural environment, but also had a special place in his heart for wild animals and natural history. They had suggested putting my images of wildlife early in the show to spark his interest. In the book I was planning to use a mixture of quotations selected from His Holiness's published work and his direct responses from the slide show, so I began with a couple of examples to show him what I wanted from him. He calmly nodded his approval. The first image for which I had no quotation was a herd of *kiang*, the Tibetan wild ass. The instant the animals appeared on the screen, His Holiness leapt off his chair with boyish delight.

Once a common sight, *kiang* have been almost exterminated since the Chinese invasion. The Dalai Lama's sister Pema Gyalpo traveled through Tibet for three months in 1980 on a fact-finding delegation from Dharamsala. Afterward she reported to her brother, "I did not see any wild animals," even though she visited places where in her youth "herds of deer or wild asses would mix with your caravan and travel with you for hours." She remembered how she used to see "more gazelles, deer, and antelope than people." His Holiness had similar memories from his own five major journeys across Tibet between 1939 and 1959.

I saw very few wild mammals on my first visits to Tibet in 1981 and 1983, but my later travels eventually led me into more remote regions where the evolutionary flow of old Tibet still exists. In the high steppes of western Tibet I found valleys where herds of wild asses, gazelles, and antelope flow across the open ground like the wind rippling through a field of grain.

The *kiang* in my photograph were running at full speed on the plains. With an expression of sheer joy, His Holiness began pouring out his feelings: "We have always considered our wild animals a symbol of freedom. Nothing holds them back. They run free. So, you see, without them, something is missing from even the most

SACRED PATH AROUND THE DALAI LAMA'S RESIDENCE, DHARAMSALA, INDIA; 1989

*"Nehru personally chose Dharamsala for us, based on
what he called its 'peace and tranquility.'"*

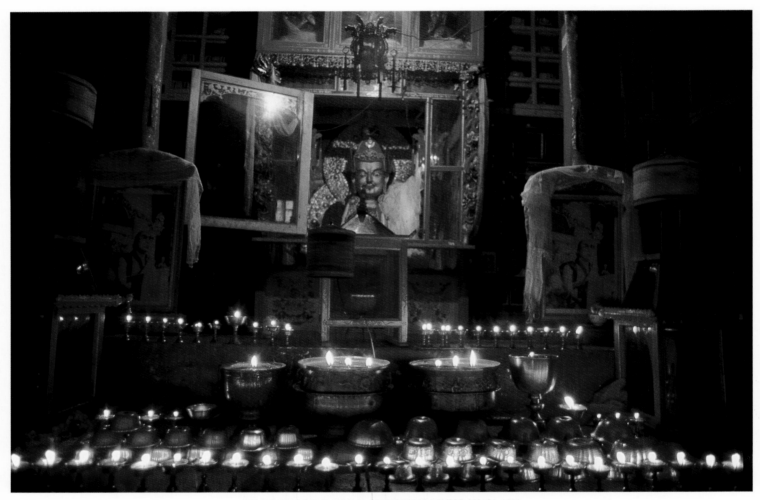

IMAGES OF THE DALAI LAMA IN NECHUNG TEMPLE, LHASA; 1988

*"My overseas trips have, in fact, nothing
to do with politics. Essentially I am interested in meeting different
people and seeing different countries, cultures, and
religions. I act the way any human being would toward other human
beings, with moral responsibility and concern for each
and every one. In this sense, I'm trying to encourage greater solidarity
among people. This is my main interest."*

beautiful landscape. The land becomes empty, and only with the presence of wild living things can it gain full beauty. Nature and wild animals are complementary. People who live among wildlife without harming it are in harmony with the environment. Some of that harmony remains in Tibet, and because we had this in the past, we have some genuine hope for the future. If we make an attempt, we will have all this again."

I knew that these were no idle words. Given control of Tibet, His Holiness would quickly reverse the downward spiral of environmental problems. Over the course of my visits I have witnessed a phenomenal resurgence of Tibetan culture and religion since the Chinese loosened some of their economic and religious restrictions. In 1981 the old culture within Tibet appeared virtually gone, victim of the systematic destruction of ancient ways. The axiom that a culture can never return to a former state doesn't apply to a people who have kept the flame of their faith burning in their minds and hearts as their physical world is forcibly altered. Tibetan Buddhism seems especially well equipped both for this task and for allowing the remaining vestige of wild Tibet to recover.

As His Holiness spoke, I thought about his 1987 proposal to "transform Tibet into our planet's largest natural preserve." I had overheard several American environmental activists quickly dismiss the idea as too impractical and idealistic. They thought he should think smaller and begin with a national park or two and hope that more might be established someday, as we have done in America. As I sat in the presence of His Holiness, listening to him speak about the old Tibet he had ruled, I found myself coming to some radical conclusions. Not only does Tibet's history of environmental thought and protection far predate our own, but also Tibet once had the world's most successful form of environmental protection. His Holiness was simply calling for official designation for what Tibetans had taken for granted until the Chinese invasion. All of Tibet was environmentally protected for thirteen hundred continuous years of Buddhist rule because respect for the natural world had been instilled in every individual at a very young age. Before the Chinese invasion and the resulting destruction of wildlife and property, "national park" would have been redundant.

When each new image of Tibetan wildlife appeared on the screen, His Holiness squirmed with joy, and as he related his personal experiences with wild creatures, he also revealed his extensive knowledge of Tibetan natural history. After I had plenty of quotations to accompany my photographs, I encouraged him to talk about an aspect of his personal philosophy that especially intrigued me. His Holiness perceives a connection between the Tibetan landscape and his people's way of thinking. Buddhism alone does not account for their unique way of viewing life. Buddhists in other parts of the world have a somewhat different way of looking at

things. Although all Buddhists seek to elevate their minds above temporal concerns, His Holiness believes every sentient being is influenced to some degree by its surroundings. Just as a Tibetan yak's temperament is quite different from that of an Indian cow, the people who live on the Roof of the World think and behave differently from those in other parts of the world.

His Holiness recognizes that Tibet is no longer a world apart, but a culture that is becoming ever more integrated into the human community. He knows that his people have much to learn from the world, but he also thinks that perhaps the world has something to learn from his people. For example, I have always considered myself a very practical person. I used to feel smugly certain that rocks endured, but people did not. I am not a Buddhist, but Tibetan Buddhism made me rethink my judgments about both impermanence and immortality. I was surprised to learn that unqualified immortality is not a Buddhist concept, and that even inanimate objects are considered impermanent. His Holiness says, "Most of our troubles are due to our passionate desire for and attachment to things that we misapprehend as enduring entities. The pursuit of the objects of our desire and attachment involves the use of aggression and competitiveness as supposedly efficacious instruments. These mental processes easily translate into actions, breeding belligerence as an obvious effect. Such processes have been going on in the human mind since time immemorial, but their execution has become more effective under modern conditions."

That human beings have had past lives as any number of creatures is a basic tenet of the Tibetan Buddhist belief in reincarnation. Occasionally deities are incarnated in human form, although deity, or God, in the Christian sense is not an accurate translation, since Buddhists do not believe in a supreme creator. Any act of creation occurs entirely within one's consciousness. At the most basic level, Buddhist deities are awareness-beings that represent aspects of personal consciousness. Of course they have deeper significance too, but personifying a deity as a living being aids meditation on otherwise abstract concepts.

Compassion by itself is an example of a difficult subject for meditation, but Chenrezi, the Buddha who is the embodiment of compassion, is fortunately present on this earth in the form of the awareness-being Tenzin Gyatso. His tangible nature provides believers with a tool to better understand the abstract.

Thus with no sense of contradiction Tibetans simultaneously regard His Holiness as a remarkable human and as the incarnation of the Buddha of compassion. He is both, and his body is recognized to be mortal. The many Tibetan deities reflect the different facets of the human personality. Buddhism recognizes that at various times in their lives people benefit in different ways from meditation on different aspects of their characters. Tantric images in wrathful poses

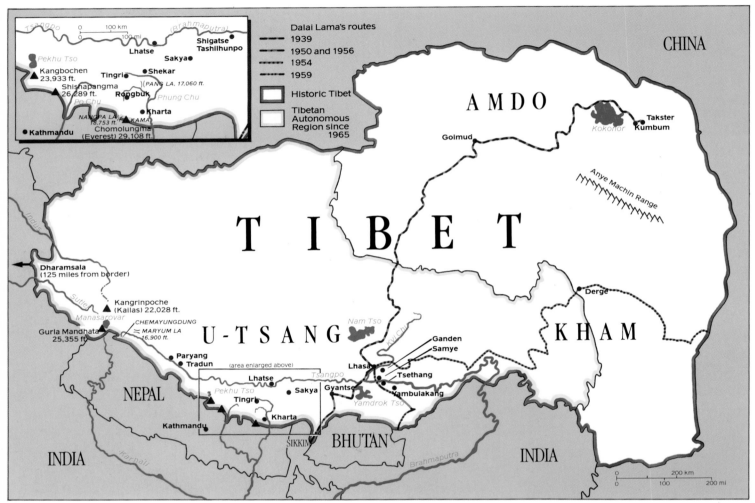

Inset map labels:
Tsangpo / Brahmaputra
0 100 km
0 100 mi
Lhatse
Shigatse ● Tashilhunpo
Sakya ●
Pekhu Tso
Kangbochen ▲ 23,933 ft.
Tingri ● ● Shekar
Shishapangma 26,289 ft. ▲)(PANG LA. 17,060 ft.
Rongbuk ● Phung Chu
Po Chu
Kharta ●
NANGPA LA 18,753 ft. ▲ ▲ KAMA
Chomolungma (Everest) 29,108 ft.
● Kathmandu

Dalai Lama's routes
— — — 1939
— · — 1950 and 1956
— · · — 1954
— ··· — 1959
☐ Historic Tibet
☐ Tibetan Autonomous Region since 1965

CHINA
AMDO
Golmud ●
Kokonor
Takster ● Kumbum
Anye Machin Range
TIBET
Dharamsala (125 miles from border)
Kangrinpoche (Kailas) 22,028 ft. ▲
Manasarovar
Gurla Mandhata 25,355 ft. ▲
Indus
Sutlej
CHEMAYUNGDUNG
≈ MARYUM LA 16,900 ft.
U-TSANG
Nam Tso
Derge ●
KHAM
Paryang ● Tradun ●
(area enlarged above)
Ganden
Samye
Lhatse ● Tsangpo Lhasa ● ● Tsethang
Sakya ● Gyantse ● ● Yambulakang
Tingri ● Yamdrok Tso
NEPAL
Kathmandu ● Kharta ●
Karnali
SIKKIM BHUTAN
Brahmaputra
INDIA
INDIA
0 200 km
0 100 200 mi

MAP OF TIBET SHOWING HISTORICAL AND CONTEMPORARY BOUNDARIES

suddenly become less frightful and more understandable when viewed in this context.

Although the Dalai Lama is the reincarnation of only one of dozens of Tibetan deities, he is the unquestioned spiritual and temporal ruler of his people. Compassion is a singularly important virtue in Tibetan tradition, and Chenrezi has long been considered the primal father of all Tibetans and the guardian deity of Tibetan Buddhism. All this helps explain to a doubting outside world how Tenzin Gyatso can take his role as the Dalai Lama very seriously, yet think of himself as entirely human. It allows him to exhibit a lightness of being unlike any other world religious leader. He says that in his dreams he does not appear as the Dalai Lama, or as a god, but as an ordinary Buddhist monk. Indeed, he was born into a peasant family of Takster village in Amdo on July 6, 1935. Other than being somewhat larger, more alert, and more curious than other youngsters, he seemed

to be a perfectly ordinary little boy. His parents named him Lhamo Dhondrup. When he was two, a group of forty important men arrived at Kumbum Monastery, a day's ride from his home. They were one of three search parties sent out from Lhasa to find the latest incarnation of the Dalai Lama. Four years earlier the Thirteenth Dalai Lama had died in Lhasa. Several auspicious signs suggested his rebirth in Amdo. A few days after his death, his head, by itself, turned toward the northeast. Unusual clouds filled the Lhasa Valley, and a number of rainbows beckoned northeastward over the mountains. An image of a green-tiled monastery appeared on the surface of a holy lake.

The search party that reached Kumbum wasn't in a hurry. The men had already spent two months riding across the rugged Tibetan Plateau. Kumbum was Amdo's most important monastery, built at an auspicious location, where Tsongkhapa, the founder of the Gelukpa sect of

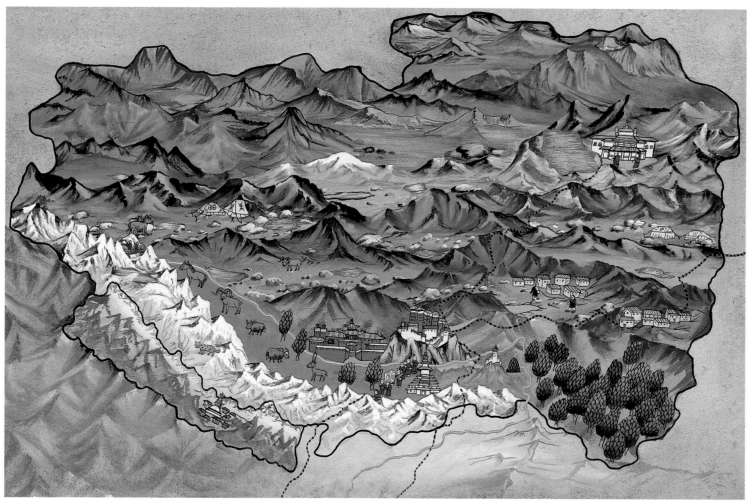

ARTIST'S CONCEPTION OF TIBET (PAINTING BY B.B. THAPA; 1989)

Buddhism, was born in 1357. The monastery had unusual green tiling, and the party lingered there for months, examining local children to no avail. Most of the members had given up hope when they decided to check out a rumor about a very special child in the village of Takster. To their amazement, Lhamo Dhondrup identified a member of the secret party as a lama of Sera Monastery in Lhasa. The child also exhibited all eight of the bodily marks of the reincarnation of Chenrezi. When he was shown a mixture of objects, he chose, from others that appeared similar, a bowl, a drum, eyeglasses, and a cane that had belonged to the previous Dalai Lama.

Thus Lhamo Dhondrup came to be renamed Tenzin Gyatso and recognized as the Fourteenth Dalai Lama of Tibet. While he was still a boy his regents would carry out certain political and spiritual duties, but as he came of age he would take over full leadership of his country. When he arrived in Lhasa at the age of four, he

held court with a natural air of calmness and authority, giving out blessings in the time-honored fashion. No one had shown him how.

The little peasant child stepped into a fairy-tale world as fantastic as that of *The Wizard of Oz*. His winter palace, the Potala, had more than a thousand rooms, chapels, and temples filled with statues of gold, suits of armor, and a strange assortment of worldly possessions owned by his past incarnations. Whenever he came across some mechanical gadget, he had an uncontrollable urge to know how it worked. His aides stood by in consternation as he began to disassemble priceless Swiss watches and music boxes presented by czars of Russia. They breathed more easily when they saw his uncanny ability to reassemble the parts into working order.

During the warmer half of the year, he lived in a smaller summer palace at the Norbulingka, a walled park filled with gardens, ponds, and tame wildlife. At

the age of six, His Holiness began an intensive course of religious education that would continue over the next two decades. Old copies of *National Geographic* and *Life* magazines helped him figure out the geography of the world and the rudiments of the English language. At eleven, he had a fortuitous meeting with an Austrian mountaineer and skier who had fled a prison camp in British India during World War II. Heinrich Harrer made his way overland across Tibet to seek asylum in Lhasa. His Holiness asked Harrer not only to become his English tutor, but also to make movies of everyday Tibetan life, develop them, and show them at the Potala Palace in private sessions. His Holiness took a broken projector that had belonged to the Thirteenth Dalai Lama, disassembled it, and put it into working order. Thus he was able to see the normal life of his country, which ceased at the first word of his approach.

As a teenager, His Holiness turned his mechanical wizardry toward Lhasa's only three automobiles. Two 1927 British Austins and one American Dodge from the same period had been disassembled and carried over the Himalaya by mules and men. In Lhasa they were reassembled as gifts for the Thirteenth Dalai Lama. They had not run for fifteen years when His Holiness decided to see what he could do with them. With another young monk, he put together enough usable parts from the two Austins to make one of them run. He was asked not to drive the vehicle, but like a typical teenager he couldn't resist sneaking out for a joyride. Having had a childhood without wheeled toys, he found steering rather more difficult than he had imagined. He hit a post and smashed a headlamp. Finding no way of gluing it together and seeing no possibility of getting a replacement for months, or even years, he disguised a piece of ordinary glass by brushing on a thick syrup in an artful way that exactly replicated the appearance of the other lamp. Although no one noticed the difference, His Holiness opted for early retirement as a driver.

The fantasy world of the young Dalai Lama began to crumble almost as abruptly as it had begun. In 1950, after Chinese armies invaded Tibet's eastern frontier, His Holiness was invested with full political power well before his time. That snowy December he fled over the Himalaya to a village near the Indian border, poised to continue into exile. A few months later, after the Chinese guaranteed the Tibetan people full religious freedom and internal political control of their homeland, he returned to Lhasa.

Throughout the fifties, His Holiness worked hard to maintain peace and to protect his people's traditional ways. As the Chinese broke promise after promise, many Tibetans began to fight back, especially in the eastern areas of Amdo and Kham. Today there are vast areas where virtually no Tibetan family has male members over the age of thirty-five.

In the aftermath of the great Tibetan uprising of March 10, 1959, as Chinese troops shelled his home in the Norbulingka, His Holiness escaped with a small caravan overland across the Himalaya to India, where Prime Minister Nehru offered him political asylum. He has not returned to Tibet and does not plan to do so until the Chinese government restores his people's basic human rights and personal freedoms.

The Tibetans by themselves are highly unlikely to regain their lost nation through physical confrontation with the Chinese. Tendzin Choegyal, the younger brother of His Holiness, uses this analogy: "A small child running out of a burning building is powerless to put the fire out by himself. All he can do is yell 'Fire!' in hope that some bigger, stronger people will listen and take action. That's exactly what we Tibetans are doing. Our home is disintegrating and our relatives are in there."

Although many Tibetans are committed to regaining complete independence for their homeland, His Holiness has proposed the far more moderate solution of allowing the government of China to control Tibet's foreign policy so long as Tibetans themselves determine their own internal affairs. To date the Chinese have not come to the negotiating table.

"The Chinese government misused the opportunity for a genuine dialogue," His Holiness told the Congressional Human Rights Caucus in Washington, D.C., on September 21, 1987, when he first announced his Five Point Peace Plan. "Instead of addressing the real issues facing the six million Tibetan people, China has attempted to reduce the question of Tibet to a discussion of my own personal status." He was referring to the Chinese government's attempts in the world press to hold the Dalai Lama personally responsible for all civil unrest and demands for independence within Tibet. In reality, there are few, if any, historical examples of a minority's struggle to secure its rights in which such a conciliatory attitude has been expressed by its leader.

The Five Point Peace Plan—and the extreme Chinese reaction to it—inadvertently set me on the course of doing this book. A few months before His Holiness's proposal, I traveled extensively through Tibet, often giving out photos of the Dalai Lama as gifts to devout Tibetan Buddhists. That same year a friend doing a Tibetan survey with a Chinese forestry official was told by him to bring along photos of the Dalai Lama as gifts to ease relations with the local people. I happened to travel with the same official the following year, 1988, when I returned with Barbara on assignment for the *National Geographic* magazine.

Meanwhile, the Chinese attitude toward Tibet hardened in the face of demonstrations for independence. The American organization that was helping coordinate my photography in Tibet suggested that we not give out photos of the Dalai Lama in the presence of the mandatory Chinese hosts who would accompany us in the field. I seriously underestimated their reaction when I decided to make an exception at a chance meeting with a nomad who had joined me the previous year on a pilgrimage

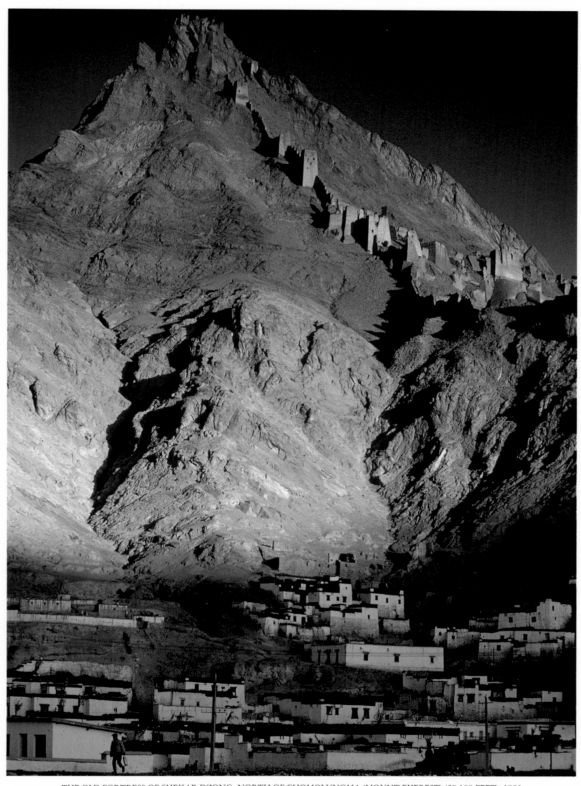

THE OLD FORTRESS OF SHEKAR DZONG, NORTH OF CHOMOLUNGMA (MOUNT EVEREST) (29,108 FEET); 1983

"Recent geological excavations in Tibet have
produced evidence that Tibetan civilization dates as far back as
4,000 B.C. In 127 B.C. Tibet's king unified the nation.
Recently China has begun to take interest in the details of Tibetan history.
This is good. Not a single Tibetan record states that Tibet
has, at any time, been a part of China."

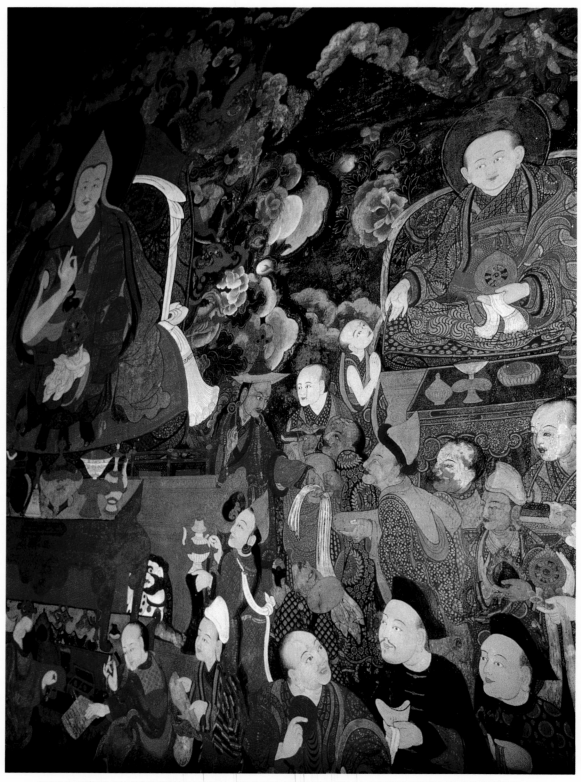

WALL PAINTING OF THE FIFTH DALAI LAMA AND DESI SANGYE GYATSO, SAMYE MONASTERY, NEAR TSETHANG; 1987

"The Fifth Dalai Lama was a very great
man who, as the first leader of both religious and political affairs,
united Tibet. We call him the Great Fifth. At his side is
his regent, Desi Sangye Gyatso, who concealed the Great Fifth's death
for fifteen years to keep Tibet strong until a successor came of age.
He is always depicted beside the Great Fifth and
Tibetans feel so familiar with him that they fondly call him
by the nickname Flathead Desi."

around sacred Mount Kailas. The Chinese, too, were guests in the nomad's humble tent as I gave out a small, commercially reproduced photo of His Holiness that was readily available for pennies in the Lhasa bazaar. Family members closed their eyes and held the image to their foreheads to receive blessings.

After I returned to America, I was notified that I had been tried *in absentia* in Beijing and found guilty of sedition. I wrote a carefully worded letter to the Chinese ambassador in Washington, apologizing for any embarrassment I might have caused my hosts, explaining that I in no way thought of my actions as being political. Afterward something inside me snapped. I felt humiliated and ineffectual. Whatever the consequences, I vowed to free myself from the Chinese censorship of the American press that for years has been nearly as effective as China's censorship of its own press. Until recently, American publications have consistently watered down negative stories about China for fear of having their journalistic access cut off.

On further reflection, I became most intrigued by the implied power of that single photograph of the Dalai Lama. Why were the Chinese so threatened? What would happen if I tuned into the positive power of that photo to make it work, not only for me, but also for the future of Tibet? Like notes of a tune I couldn't get out of my head, the dual power of photography and the Dalai Lama spontaneously ran through my thoughts.

The idea for this book came to me just a week later as I began walking a spur of the John Muir Trail in eastern California. The terrain bears an uncanny resemblance to Tibet. Both regions are in the rain shadows of high mountains where open vistas of arid lands rise up to join the snows. Both places have an evolutionary flow that is far more intact than that of neighboring lands. Despite the fact that Tibet has been severely damaged environmentally, it is still better off than most of China, where wild creatures are shot on sight and the first priority of the few nature preserves is to attract foreign currency.

As the appearance of the Sierra and Tibet began to merge in my mind, so did my thoughts about them. I considered the deathly fear the Chinese feel toward the Dalai Lama's possible return to Tibet and the Western world's general skepticism about the reincarnation of the Dalai Lama. In California I was working on both a magazine story about the John Muir Trail and a book to celebrate the 1990 centennial of Yosemite National Park, which would match my photographs with quotations from John Muir. Tibetan Buddhism had already influenced ideas I expressed in the book's introduction. Although Muir died three-quarters of a century ago, he has achieved a considerable measure of immortality in every sense except the physical. His efforts to preserve Yosemite for all time also preserved the environment of his own writings, allowing his words and thoughts to live on today for those who see the same

scenes, or for those who see modern photographs of his world. His spirit is still saving wild places today.

It came to me then and there that the Dalai Lama's words could serve the same higher purpose when matched to photographs of Tibet. His voice speaks through the centuries of enduring entities that are threatened, but very much alive, in Tibet today. Although my photographs are my personal vision, and I did not set out on my first trip to Tibet in 1981 with a Buddhist perspective, my pursuit of enduring natural values has led me along a converging path. My original goal there, as in other parts of the world, was simply to follow my own passions and do participatory photography. As much as possible I want to be part of the events I photograph, rather than a spectator. I have never wanted to be a classic journalist who keeps a purposeful emotional distance from his subject matter. Thus to photograph a Tibetan pilgrimage, I became a pilgrim, following the same paths, taking notice of the same auspicious places. To photograph a Tibetan wolf, I became a predator myself, stalking, taking aim, clicking my shutter.

Similarly, the Tibetan Buddhist view of the world is participatory, not fixed in dogma. His Holiness says, "If there's good strong evidence from science that such and such is the case, and this is contrary to Buddhism, then we will change." Tibetan Buddhism teaches that only by sharing compassion and universal responsibility can practitioners reach nirvana, the ultimate blissful state beyond the normal cycles of existence and rebirth.

Over the years, the core of my work in Tibet had grown into a visual record of one of the earth's unique wild places, where civilized human beings have lived in harmony with their environment for more than a millennium. As I walked away from His Holiness's mountain home with a palm full of microcassette tapes that held most of the new text and quotations for this book, the path that had led me to Dharamsala seemed strangely logical and inevitable. At each juncture I had made a clear choice that only with hindsight could I call spiritual.

I remembered a meeting many years before with a Tibetan Buddhist who managed a calendar company. He liked my work, and as I began to mention the friends we had in common and the fortuitous events that had led me to his doorstep, he said, "I know what you mean. We have a simple phrase for that: ancient twisted karma."

After Barbara and I left Dharamsala, I took the tapes of His Holiness's remarks during the slide show with me on an expedition to Gasherbrum II, a remote 26,360-foot peak on the border of Pakistan and China. Barbara returned home through Europe carrying a second set of tapes of our interviews to be used for the essays. After I reached the mountain, it snowed on all but two days of the next month. I lay in my tent during the worst storms transcribing and editing.

In base camp we had a powerful radio receiver. On June 5 our Pakistani army liaison officer picked up

a BBC radio broadcast from India about hundreds of Chinese civilians being killed by their own army in Beijing's Tiananmen Square. As he spoke, tears welled up inside me, and I wondered why. I thought of the Tibetans and how many of them had been killed by the same army, but that wasn't quite it. My feeling was more personal, yet at the same time so broad that I couldn't define it specifically. It encompassed not only the Tibetans and myself, but also the Chinese victims and the millions of others before them who had died by their own government's hand. I thought about some words His Holiness had said, and I rushed back to my tent to rewind a tape and listen to him talk about our universal responsibility for the welfare of every sentient being in a world that, as he says, grows "communicably smaller" with each passing day.

At dinner I told my teammates about Tiananmen Square. I was shocked to discover that my reaction to the news broadcast was not universally shared. A fellow climber began shouting me down. "I don't believe it! The Chinese wouldn't do such a horrible thing. I know them; I've been there. You should know better than to pass on unsubstantiated information. We have no idea if it really happened. You weren't there to see it."

But others were.

The horror played live in living rooms around the planet, even though we in the high Himalaya were hearing it third-hand, as the rest of the world has heard and shrugged off reports of unseen massacres in Tibet and China over the past four decades.

Back home our office manager, Terri Brown, was busy transcribing the Dalai Lama's essays. Often she would have to go back and forth as many as ten times to get the words of a single sentence. His Holiness might begin in English and switch to Tibetan. Much of it was being translated by Tenzin Geyche Tethong, his personal secretary. After I returned home, I read the transcript and was especially struck by prescient thoughts in the first essay: "Today we are seeing people all over the planet begin to confront the evil forces within humanity that threaten the basic human spirit. We are watching Marxism-with-power, a system born in this century, lose its youthful exuberance and turn into a very old man with thick glasses, walking unsteadily with a cane. Within this century we may see him go to his grave."

My first reaction was that this wonderful prediction of what came to pass later in 1989 could be lost on readers. As forethought the words were powerful; as afterthought they could appear to repeat the new common wisdom.

Barbara and I were planning to go back to Dharamsala in December for final interviews and manuscript approval. We considered having His Holiness add new words to the essay, but on second thought we saw that the prophetic integrity of a statement made just before Tiananmen Square and the collapse of communism in Eastern Europe is far more powerful as it stands.

One morning in October, Terri told us she was awakened by a familiar voice on her clock radio. She thought she was dreaming about work until she listened closely to the deep, melodious sound: "I accept the Nobel Peace Prize in a spirit of optimism despite the many grave problems which humanity faces today. . . . We must seek change through dialogue and trust. It is my heartfelt prayer that Tibet's plight may be resolved . . . and that once again my country, the Roof of the World, may serve as a sanctuary of peace and a resource of spiritual inspiration at the heart of Asia."

China threatened to cut economic ties with Norway if the government or king attended the Nobel ceremonies, but the Norwegians stood characteristically firm. Nobel Committee Chairman Egil Aarvik responded by publicly assessing China's reaction to the prize as the strongest by any government since Adolf Hitler's fury when an anti-Nazi won the award fifty-three years earlier. As he presented the award, Aarvik said, "The world has shrunk. Increasingly peoples and nations have grown dependent on one another. No one can any longer act entirely in his own interests. It is therefore imperative that we should accept mutual responsibility for all political and ecological problems. In view of this, fewer and fewer people would venture to dismiss the Dalai Lama's philosophy as utopian: on the contrary, one would be increasingly justified in asserting that his gospel of nonviolence is the truly realistic one, with most promise for the future. And this applies not only to Tibet but to each and every conflict."

For the first time in history, the Nobel Peace Prize citation directly mentions efforts on behalf of the environment. Specifically, it cites how His Holiness bases his philosophy for world peace on "great reverence for all things living and the concept of universal responsibility for all mankind as well as nature." In Oslo on the day after the award, His Holiness further explained the peace sanctuary concept at the heart of his 1987 Five Point Peace Plan:

"It is my dream that the entire Tibetan Plateau should become a free refuge where humanity and nature can live in peace and in harmonious balance. It would be a place where people from all over the world could come to seek the true meaning of peace within themselves, away from the tensions and pressures of much of the rest of the world. Tibet could indeed become a creative center for the promotion and development of peace. The Tibetan Plateau would be transformed into the world's largest natural park or biosphere. Strict laws would be enforced to protect wildlife and plant life; the exploitation of natural resources would be carefully regulated so as not to damage relevant ecosystems; and a policy of sustaining development would be adopted in populated areas. Tibet's height and size (the size of the European community) as well as its unique history and spiritual heritage make it ideally suited to fulfill the role of a sanctuary of peace in the strategic heart of Asia."

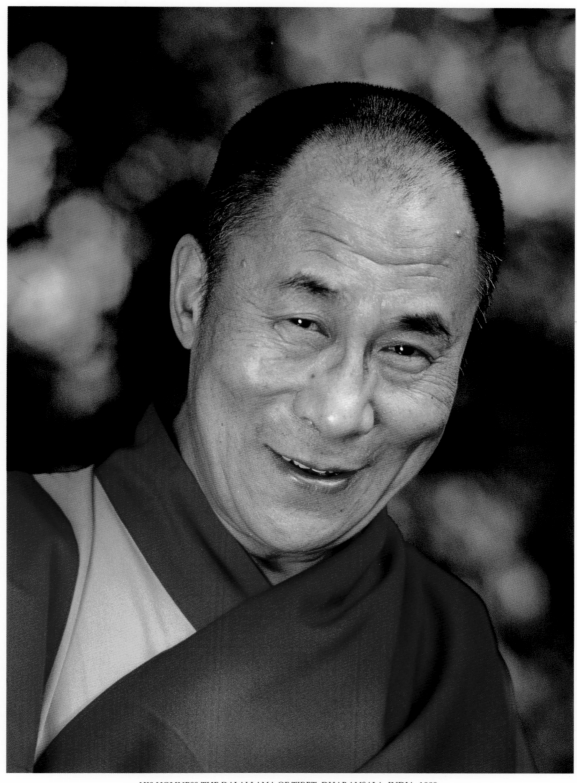

HIS HOLINESS THE DALAI LAMA OF TIBET, DHARAMSALA, INDIA; 1989

"In my dreams I do not see myself as a god, but as a simple Buddhist monk."

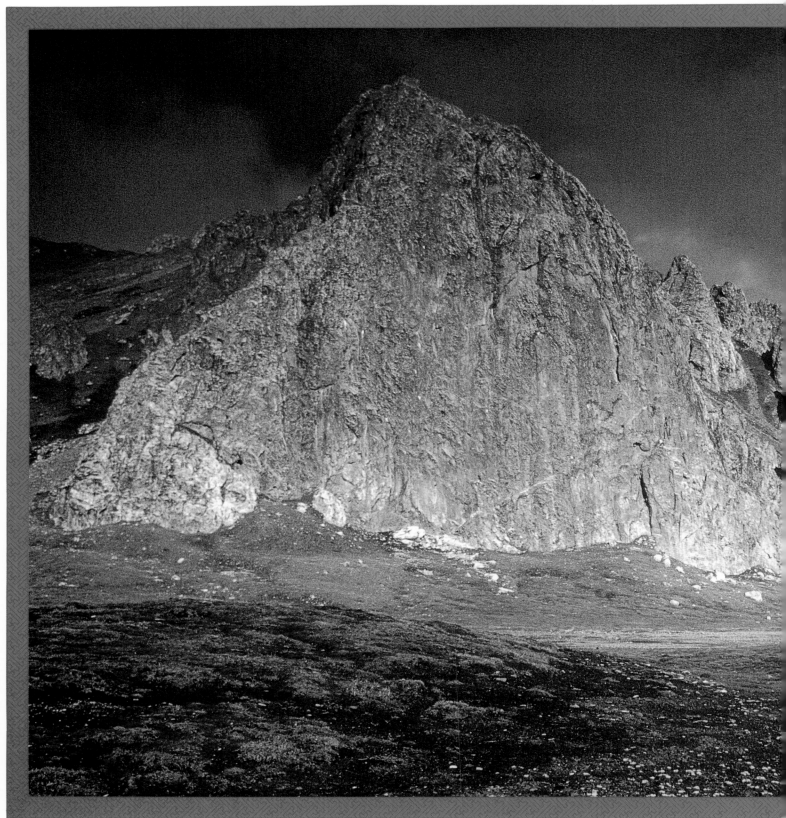

STORMY EVENING IN THE ANYE MACHIN RANGE, AMDO; 1981

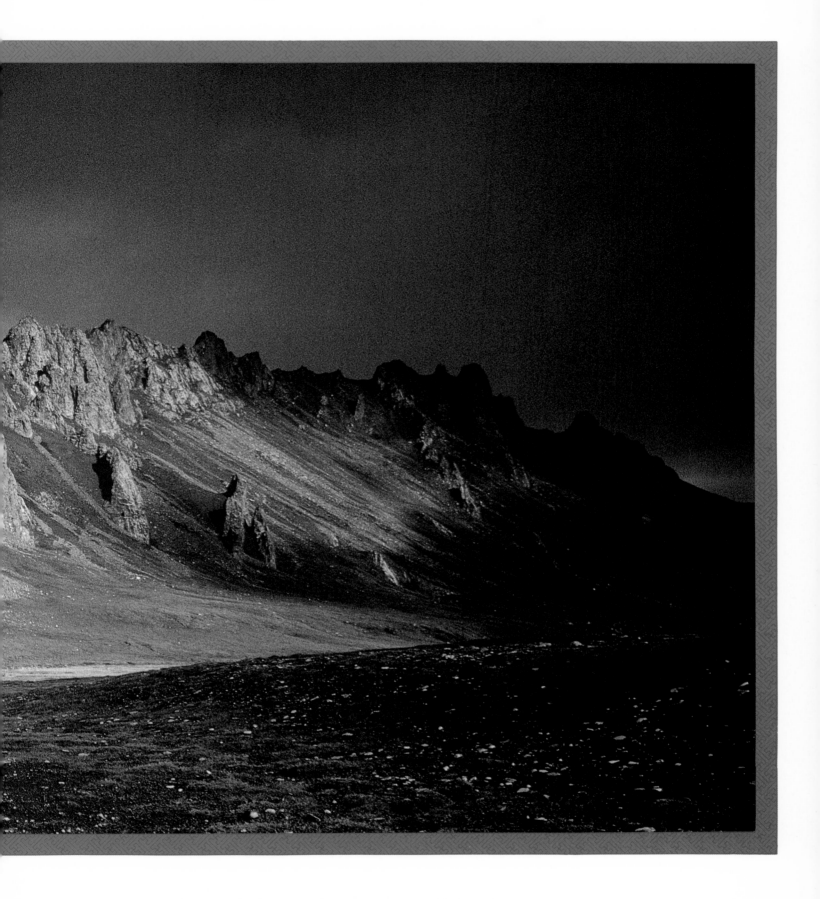

*"It is my hope and dream that the entire Tibetan Plateau
will someday be transformed into a true peace sanctuary: an entirely demilitarized
area and the world's largest natural park or biosphere."*

Amdo—The Northeast Frontier

Amdo, the old northeastern province of Tibet, formed much of what is now called Qinghai Province of the People's Republic of China on modern maps. His Holiness the Fourteenth Dalai Lama was born in the small village of Takster in 1935. Nearby is the great monastery of Kumbum, built four centuries ago on the site where Tsongkhapa, the founder of the Gelukpa sect of Buddhism, was born. The search party looking for the fourteenth reincarnation of the Dalai Lama arrived at Kumbum from Lhasa in 1938, after following auspicious signs.

Despite nominal Chinese overlordship since the eighteenth century, the Tibetans of Amdo had considerable autonomy until the arrival of Mao's armies in the 1950s. Intermittent control of their affairs came more often from local Moslem warlords than from the old Chinese dynasties. After 1950, the more than one hundred thousand members of the nomadic Golok tribe fiercely resisted communization with guerrilla warfare for more than two decades. Only forty-seven hundred survivors were counted in a 1979 census after a series of massacres, executions, imprisonment, starvation, and deportations. The Goloks are descendants of rugged warriors sent to guard the northern edge of the Tibetan empire during the ninth century.

Eastern Tibet is the breeding ground of the two opposite political responses to the forceful Chinese occupation of Tibet. On the one hand, the Goloks and their Khampa neighbors to the south formed the core of the armed resistance movement during the 1950s and 1960s. On the other, the Tibetan people as a whole have been deeply influenced by their Dalai Lama's consistent advocacy of nonviolence and compassion, in line with the Buddha's teachings.

—Galen Rowell

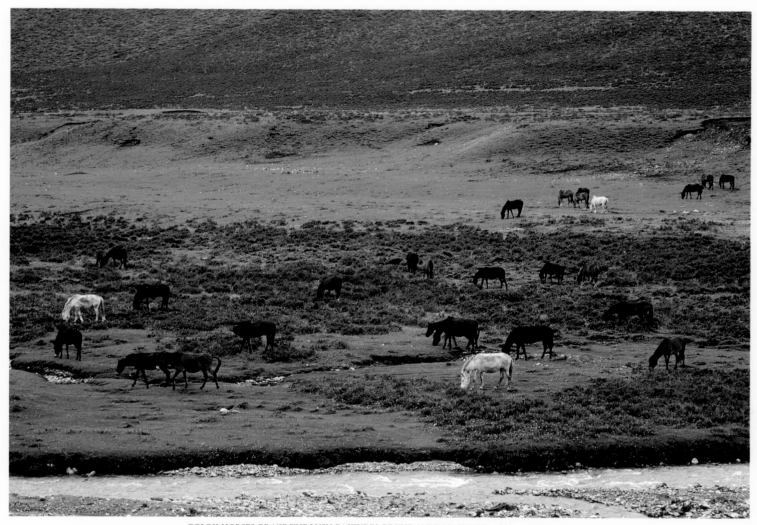

GOLOK HORSES GRAZE THE LUSH PASTURES OF THE ANYE MACHIN RANGE, AMDO; 1981

*"My father was especially fond of horses
and used to ride a great deal; he had a talent for choosing good horses
and for healing them when they were sick. He came to Lhasa
with me and would come visit me almost every day. After seeing me, he went to the stable
where the horses were kept. I have always thought the main
reason for his visits was to be with the horses, and he just stopped
off on the way to see the Dalai Lama!"*

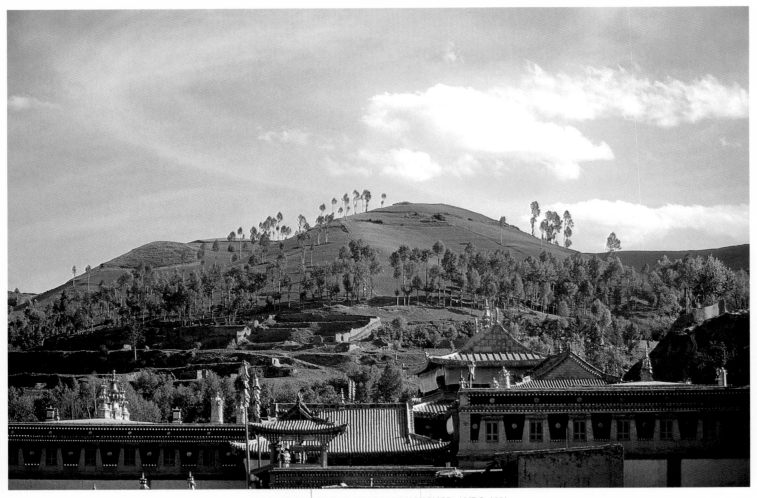

KUMBUM MONASTERY, NEAR LAKE KOKONOR, AMDO; 1981

*"My monastery! My immediate elder
brother's monastery! He entered Kumbum and spent three years
there as a young monk. When I was a small boy, before
the search party came for me, I visited my brother at his place there. He had to remain
with his teacher to recite and learn scriptures and things, but I was a
free boy, and I used to ask him to come and play. He couldn't. I was back home in my
village of Takster when the search party for the Fourteenth Dalai
Lama came. They took me, along with other young candidates, to Kumbum
for several months. While I was there it was more or
less decided that I was the true incarnation. So, you see, I became
the one who couldn't come out and play."*

*Right: "I remember my elder brother doing
prostrations at Kumbum. He was a very young monk then, about
six years old. And I still recall one prayer that the lamas
recited there. It is meant to sharpen the memory, and it takes about ten minutes to
recite once. Knowledge regarding our own minds, our deep nature, is still
limited in the Western world. This is because consciousness is formless and cannot
be touched, and so cannot be measured with instruments. It can be
known only through meditation and other methods."*

24

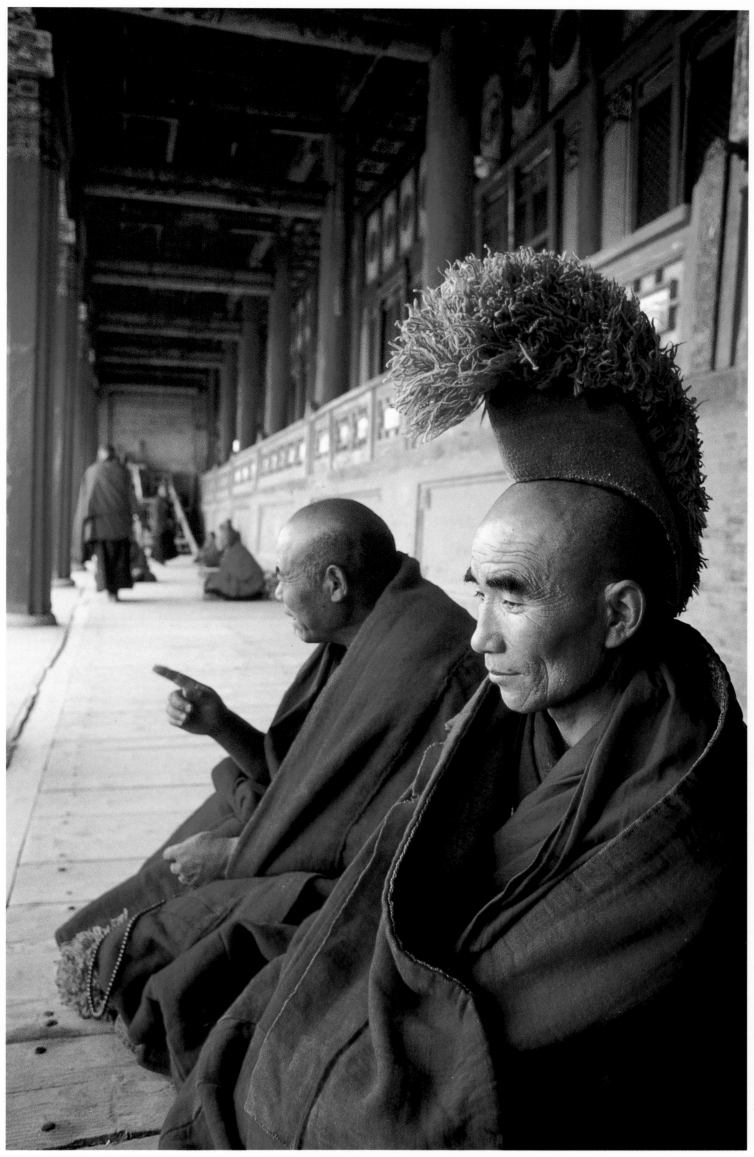

MONKS DEBATING AT KUMBUM MONASTERY, AMDO; 1981

25

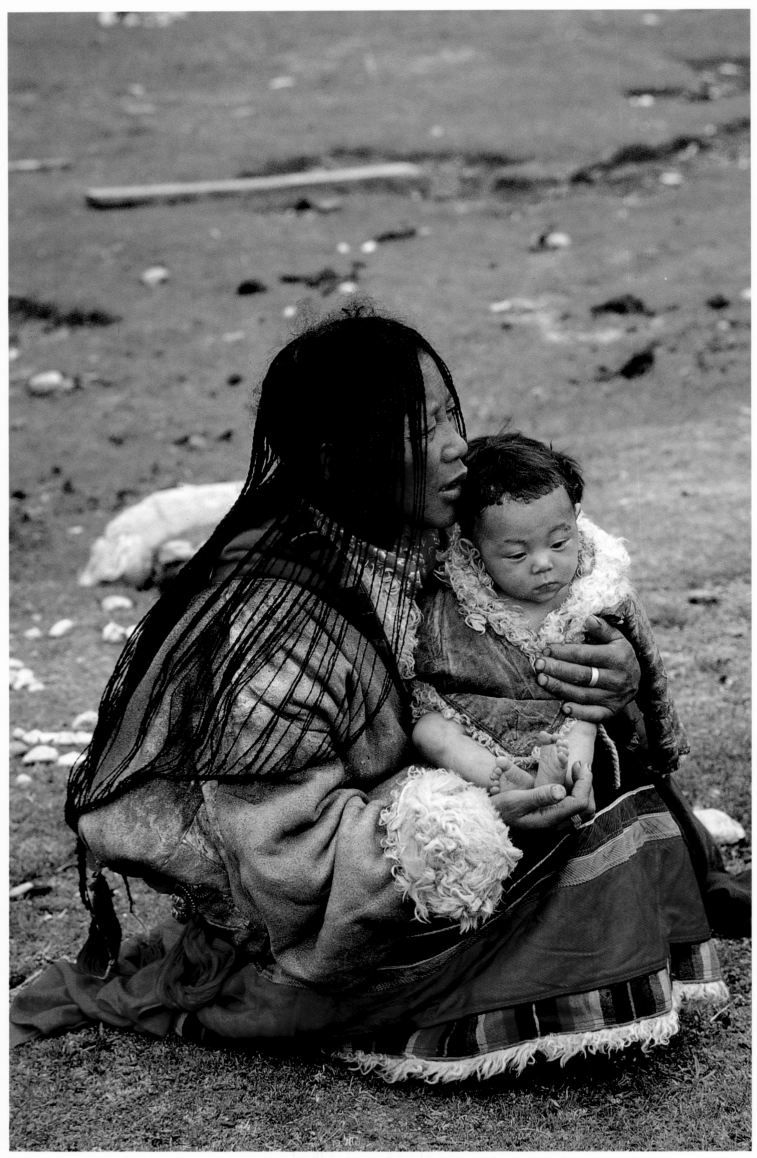

GOLOK WOMAN AND CHILD IN THE ANYE MACHIN RANGE, AMDO; 1981

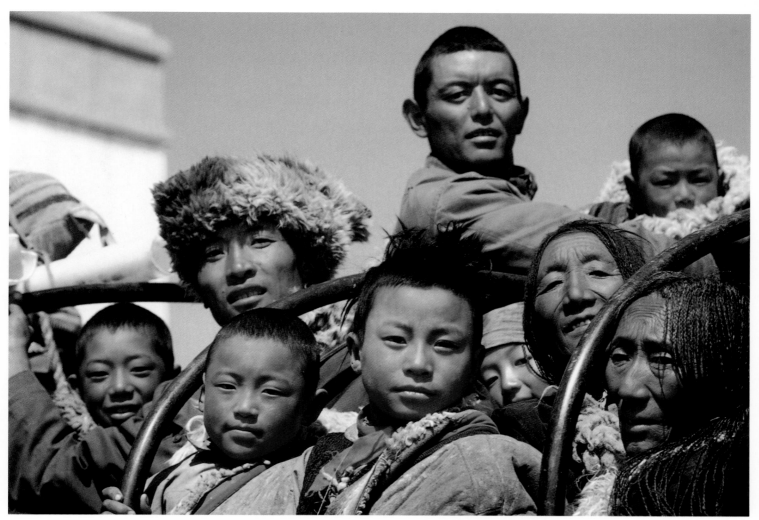

AMDO PILGRIMS CROSSING THE 17,000-FOOT GURING LA EN ROUTE TO LHASA; 1983

*"The world has become communicably
smaller today, and with respect to its limitations, no nation can
survive in isolation. It is in our own interest to create
a world of love, justice, and equality, for without a sense of universal responsibility
based on morality, our existence and survival are at a perilous precipice.
The qualities required to create such a world must be inculcated right from the beginning,
when the child is young. We cannot expect our generation
or the new generation to make the change without this basic foundation.
If there is any hope, it is in the future."*

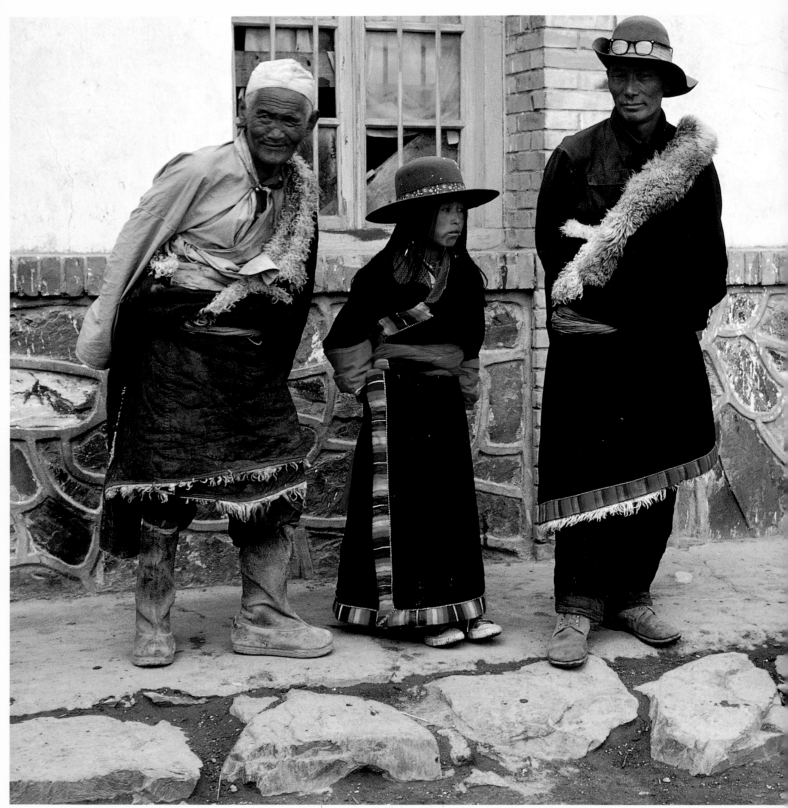

GOLOK PEOPLE OF TA HO PA, AMDO; 1981

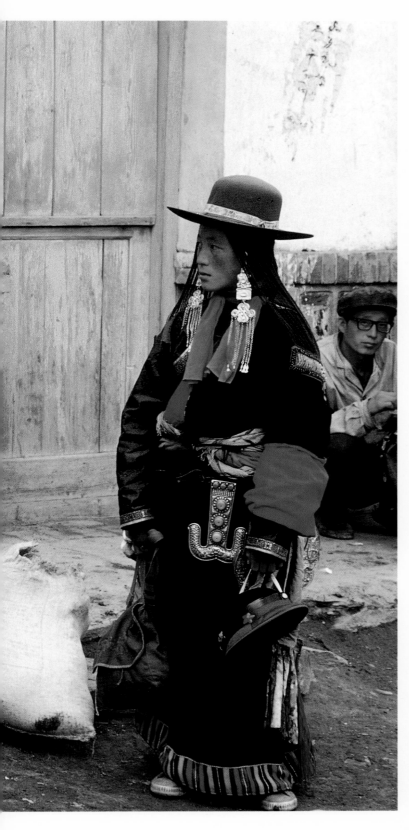

The hook that dangles from an Amdo woman's belt was originally designed to prevent feisty yaks from spilling milk. During milking the pail handle is clipped to the hook. The engraved brass hook at right is functional, but the unusually large silver one above has evolved into a bejeweled heirloom worn only for special occasions.

"In Amdo where I was born, the people's dress was purely Tibetan: the men wore fur caps and high leather boots, and the kind of cloak which was seen in different varieties all over Tibet. The women wore long sleeveless woolen dresses with bright blouses of cotton or silk, and on special occasions long ornate headdresses. I remember women in my village of Takster wearing the fancy headgear, but now you see most people in the bigger towns choosing headgear that is simpler. This woman's traditional dress doesn't go very well with her department-store felt hat. In nomadic areas most people keep on with the old traditions, despite being less comfortable."

29

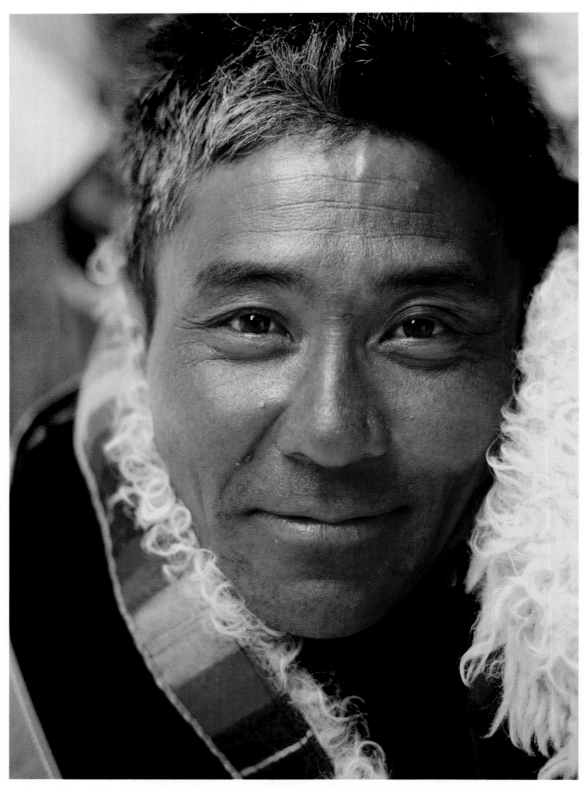

GOLOK MAN ON PILGRIMAGE IN THE ANYE MACHIN RANGE, AMDO; 1981

"His face represents the Tibetan people,
with an expression that shows gentleness and sincerity, plus an attitude
that is not discouraged or depressed. Hers (right) shows mixed
feelings: a little embarrassed to have her picture taken, but,
as you can see, quite happy."

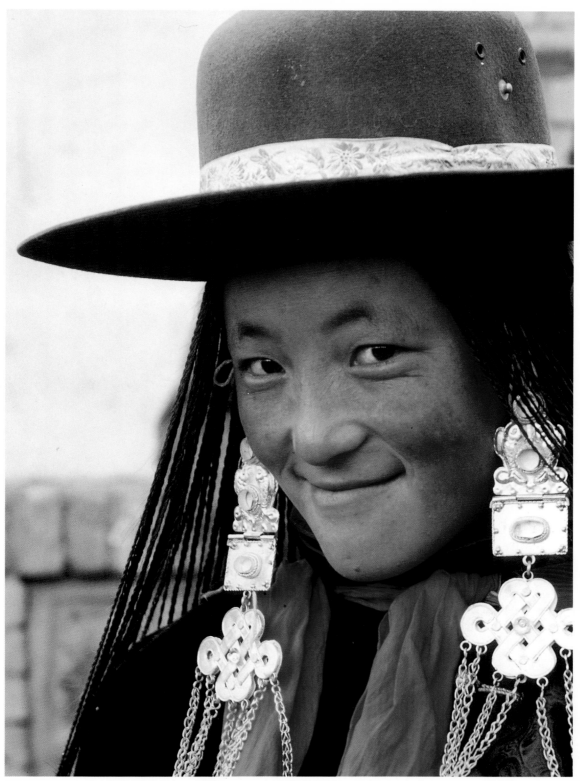

GOLOK WOMAN OF TA HO PA, AMDO; 1981

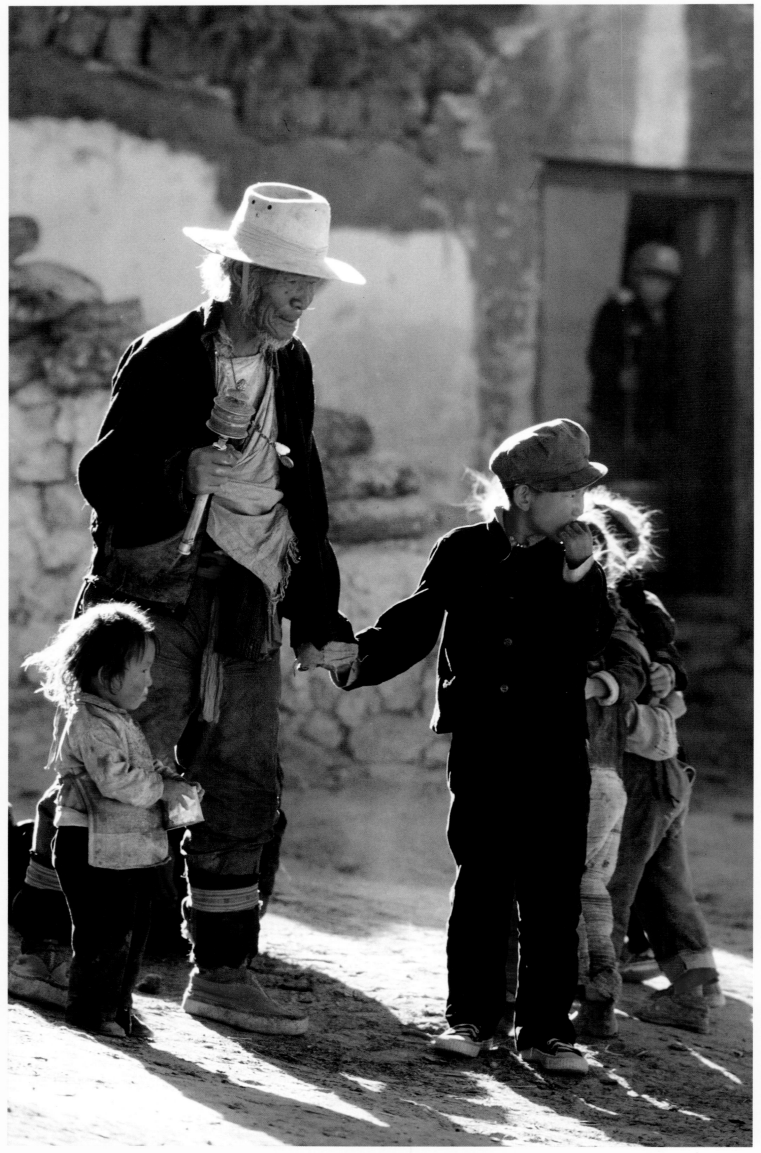

CHILDREN LEADING VILLAGE ELDER IN TINGRI, NEAR THE NEPAL BORDER; 1988

COMPASSION, WORLD PEACE, AND HAPPINESS
By The Dalai Lama

"It's time for elders to listen to the child's voice.
You see, in the child's mind there is no demarcation of different nations—
no demarcation of a different social system or ideology."

When I visit different places on my overseas trips, my number-one motivation is to meet people as another human being. I try not to think of myself as an Easterner or a Tibetan or a Buddhist, but simply as a human being who wants to exchange different ideas and experiences with other human beings.

It's time for elders to listen to the child's voice. You see, in the child's mind, there is no demarcation of different nations—no demarcation of a different social system or ideology. Children know in their minds that all children are the same, all human beings are the same. So, from that viewpoint, their minds are more unbiased. When people get older, though, they start to say "our nation," "our religion," "our system." Once that demarcation occurs, then people don't bother much about what happens to others. It's easier to introduce social responsibility into a child's mind.

I'm interested in all the problems that confront humanity, not just those of Buddhists or Christians. Although I may speak of certain techniques and ideas related to my own experience with Buddhism, I keep in mind that not only Buddhists inhabit this world, and when I travel abroad I try not to refer always to the next life or nirvana, because these are, you see, the business of Buddhists, not of all humanity.

My main idea is to communicate easily with different people, irrespective of their religious faith. So long as they are human beings, they need mental peace, and mental peace comes from a genuine sense of brotherhood or sisterhood on the basis of love and kindness. Even in economics this idea is increasingly important. When we talk about the economy, there are no longer firm national boundaries. In economics now each continent is interconnected. If we try to hold onto only our own boundaries and property, we are no longer able to develop properly. The structure of economics has become global. We have the European Common Market—hardly what anyone would call religious—presenting us with the reality that we need some kind of genuine universal responsibility. The same thing, to a lesser degree, has begun to happen in politics. The narrow view that politicians had early in this century is much changed today.

My people in Tibet tried to live in isolation from the rest of the world. We found out too late that this was no longer feasible. Today we see people all over the planet beginning to confront the evil forces within humanity that threaten the basic human spirit. For example, in the early part of this century many people believed that honorable decisions should be pursued through war. Now that concept is to a great degree gone, because today's war, nuclear war, has become something unthinkable, hasn't it? There's no viable alternative, really, except coexistence—living and working together.

War and peace are in competition. Now the force of peace seems to be gaining momentum, and freedom is ever more important. All through the early part of the century and into the fifties and sixties, many people believed that human society could best develop through the sheer sort of discipline given out by one dictator. Through force, efforts were made to change human society. Political goals were obtained

without concern for human suffering or the human cost of social experiments. In the Soviet Union and even more so in China, millions and millions of people perished in order to create a new human society. Many had complete faith in and allegiance to the communist way.

I make a distinction between original Marxism and the Marxism-with-power that became the political reality. Today we are watching Marxism-with-power, a system born in this century, lose its youthful exuberance and turn into a very old man with thick glasses, walking unsteadily with a cane. Within this century we may see him go to his grave. Communist countries are losing the battle against the basic human spirit, which cries for justice, freedom, and liberty.

According to my own experience, the most effective source of happiness is simply sincere motivation. The ultimate destroyer of peace is anger and hatred. That's clear. The common definition of an enemy is a person who may harm one's self or one's friend or one's belongings. We consider that person to be our enemy because our friends and our belongings are what we judge to be the source of our happiness. Therefore, the enemy is really the forces that might harm the source of one's happiness.

If we look more closely, we see that our friends and our belongings are no doubt one of the sources of our happiness, but certainly not the sole source. Sometimes we suffer very much because of our belongings and our friends. Even our brothers and sisters may create a lot of suffering and pain for us. Sometimes a belonging that doesn't work properly creates suffering for us. I believe that calmness and tranquility are the real source of happiness and peace of mind. Even without a friend, you may, inside yourself, have peace of mind. In fact, even when you are surrounded by your best friends with all the best material things and gadgets inside the finest possible home, you may not feel happy. Happiness comes from mental peace.

If we look for the destroyer of mental peace, we will find that it is usually an internal enemy. The external nuclear weapon will not disturb your mental peace if you use the proper technique or energy to keep your mind at peace. Internal peace of mind can be so steady, clear, and faultless that the external cannot destroy it. The thing that most easily destroys mental peace is hatred. Once hatred and anger come out, peace of mind disappears automatically. Therefore, the real enemy is also anger within ourselves. Strong anger pushes along hatred, but many people feel that anger is a source of energy for them. In some aspects this may be true. When anger comes, it can create unusual energy along with it. But this is the type of energy that can destroy all happiness and destroy world peace. Energy that brings about violent anger is usually very blind. It may give you the power to do something that you cannot normally do, such as lift a car or a tree at the scene of an accident, but more often energy born of anger brings disaster upon you.

The same powerful energy you feel with anger can be used in another way. Analyze the situation. It may indicate that you need some kind of strong counteraction in order to achieve a positive result. To achieve this, you need clear reasoning and understanding of the realities involved. Then you can divert that energy and use it with far less danger of making the wrong decision.

If we must fight or use a harsh word, we should do it without anger in a way that is properly thought out and planned. Maybe you are surprised to hear me talking of using harsh words, but in some situations there is no choice. Although in the short run the wrong reaction may come, in the long run it may be necessary to bring about some positive result. But first you must do everything you can to avoid that anger or harsh word, because if you show an expression that is very unpleasant to a person, you will afterward usually feel shy about meeting that person. You cannot withdraw negative words and actions once they are expressed. The only thing left to do is to apologize. So if a situation really needs a harsh word, use it, but without anger, because anger is really useless.

Tolerance is the force that counters anger, and the source of tolerance is compassion. First you must realize the negativeness of anger. Then through training or study carefully analyze the external matters that trigger your anger. Just as a scientist observes the external world, documents it, and helps us choose things that are useful for humanity, we should observe and choose from the perceptions of the world that reach our brains. Some things may be useful for humanity or for ourselves. Other things are not much use, and to give them much attention is actually wasteful. Buddhism has been called a science of the mind. Our brains have millions of different parts, and it is worthwhile for us to experiment and analyze which of these certain parts

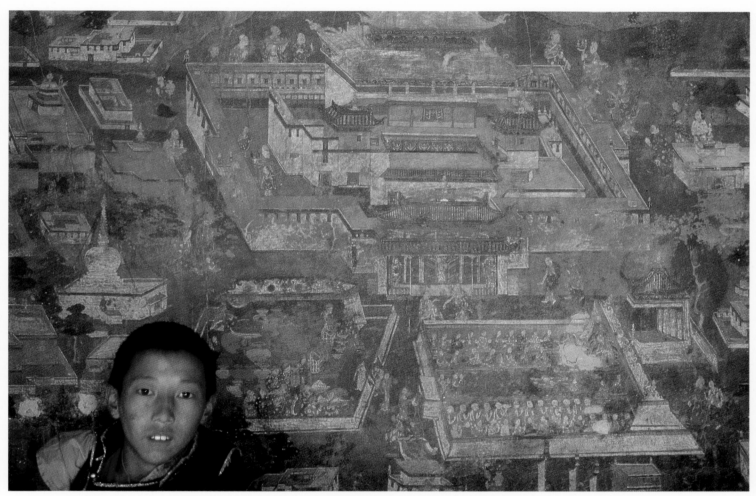

WALL PAINTING AT SAMYE MONASTERY, NEAR TSETHANG; 1987

*"The painting tells the ancient story of Tibet
in pictures. The big monastery is Samye, our very first. It was
destroyed after I left Tibet in 1959. This boy, who lives
there now, sees its old splendor only in a painting. He looks keen and
enthusiastic with the same strong faith as those who are
now rebuilding Samye, restoring our past. Soon he will see
Samye whole again with his own eyes."*

bring us happiness and joy. Then we can take care and nurture these areas, further increasing our happiness by consciously choosing to control and eventually eliminate, or at least minimize, those parts that bring us suffering or unhappiness.

We Buddhists don't worry about God. Whether there is a God or not doesn't matter. The most important thing is in our mind, here, now, and the way we use that mind in daily life. Check, investigate, and create your own positive mind, and it will bring you deep satisfaction. Eliminate those thoughts that bring you the uneasiness and discomfort that come from a negative mind, from negative thoughts. I do not say that certain thoughts and things are holy or unholy. I simply consider whether they are useful or not useful for humanity and the health of our planet.

In the last century and the early part of this century, scientific and spiritual pursuits were considered far apart. People believed there was almost no common ground. But today science and spiritual values are merging. Science is also concerned about the future of humanity and the global environment. Modern scientists have become less sure of whether their work will bring a positive or negative result. So much depends on the human mind.

Over the last few years, I have had the opportunity to talk with some famous scientists in different fields, such as psychology, neurobiology, and nuclear physics, and I see many things in common between their scientific explanations and our Buddhist explanations. There are two sides—scientific and spiritual— to realizing how best to serve humanity. In Buddhism we have no Creator. We consider each one of us as a creator. We burden ourselves with the events we carry on our own shoulders much of the time. Science, too, is telling us this. And even if someone accepts the idea that God created everything, a great responsibility still lies on humanity. We still need constant human effort, without losing courage or hope to be able to lead happy, useful lives. In my lifetime I have seen a tremendous amount of suffering, a tremendous number of people killed by other people. It would be easy to have a pessimistic view of human values and truth, but trust and optimism are equally important. In our case, when we think of our experience of the last forty years, since the Chinese invasion, and particularly of those years immediately after 1959, we remember that some of Tibet's closest friends very sadly and confidently expressed that Tibet was gone. There was no hope. Now we know that Tibet has not died. From ashes and ruins it is slowly rising. Would the Chinese consider the Tibetan question to be so sensitive if old Tibet were dead?

When we look from a distance, the Tibetan situation doesn't seem nearly so hopeless. If we compare the strong force of China and the weak position of Tibet—only six million Tibetans and one thousand million Chinese—it's clear why the outside world wants to be good friends with China: for practical reasons, for reasons of power, but not for true friendship. Because of political sympathy for China, it has been very difficult for governments of major powers to support Tibet. This is reality, but beneath this reality the Tibetan issue lives on. Not only is it alive, but also it gains more and more strength. Time is an important factor. Back in the sixties and seventies much of the outside world believed the propaganda that the Chinese had done something good for Tibet by introducing the communist system. But the Chinese have proved equally expert at discrediting themselves. Our voice does not have to be so strong to overpower them, only strong enough to be heard after their latest version of events discredits a previous one.

Foreign tourists have really helped the Tibetan cause. They have no particular obligation, nothing to gain by speaking out on our behalf, but as human beings, as we already discussed, they feel something within when they actually see the suffering of others. That I consider the most precious thing in human life. Strong feelings are very important, for they are also the source of happiness and the source of peace.

As I said to members of the European Parliament in Strasbourg, my country's unique history and profound spiritual heritage render it ideally suited for fulfilling the role of a sanctuary of peace at the heart of Asia. Tibet's historic status as a neutral buffer state, contributing to the stability of the entire continent, can be restored. Peace and security for Asia as well as for the world at large can be enhanced. In the future Tibet need no longer be an occupied land, oppressed by force, unproductive and scarred by suffering. It can become a free haven where humanity and nature live in harmonious balance, a creative model for the resolution of tensions afflicting many areas throughout the world.

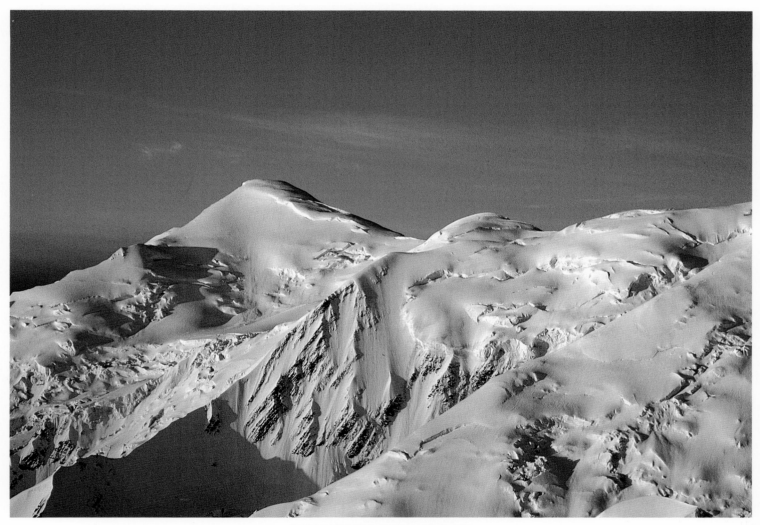

ANYE MACHIN II (20,525 FEET), AMDO; 1981

"Anye Machin is the home of Machin Pomra,
one of the most important deities of Amdo, my home province.
All the people of Amdo consider Machin Pomra
to be their own special friend, and many go around the mountain
on pilgrimage. Lamas who have passed beneath
this mountain have seen visions of special significance
in the clouds and the clear mountain air."

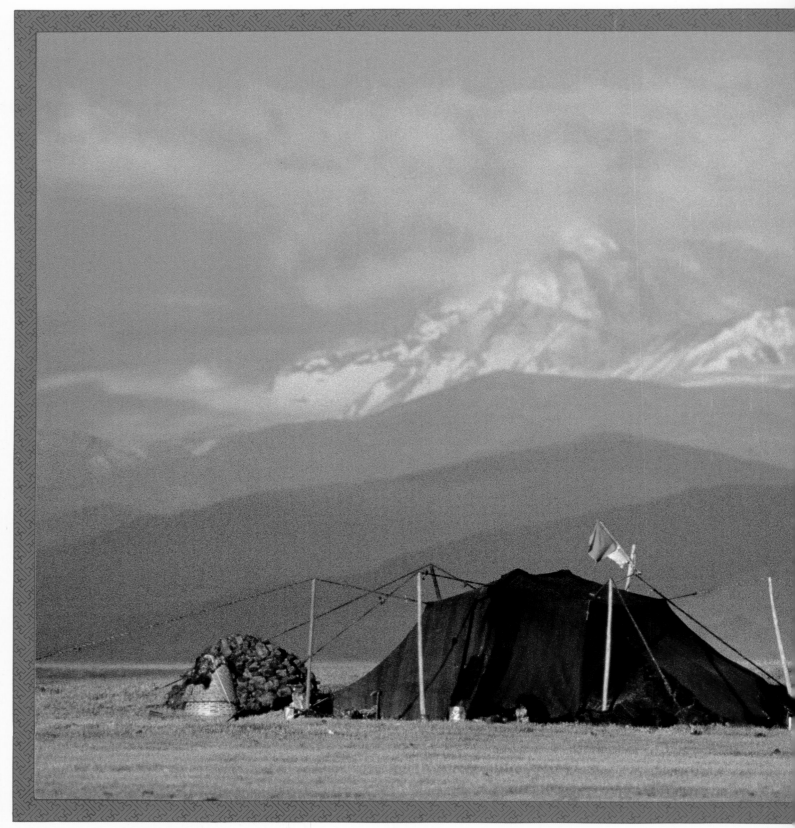

NOMAD CAMP NEAR TRADUN, WESTERN TIBET; 1987

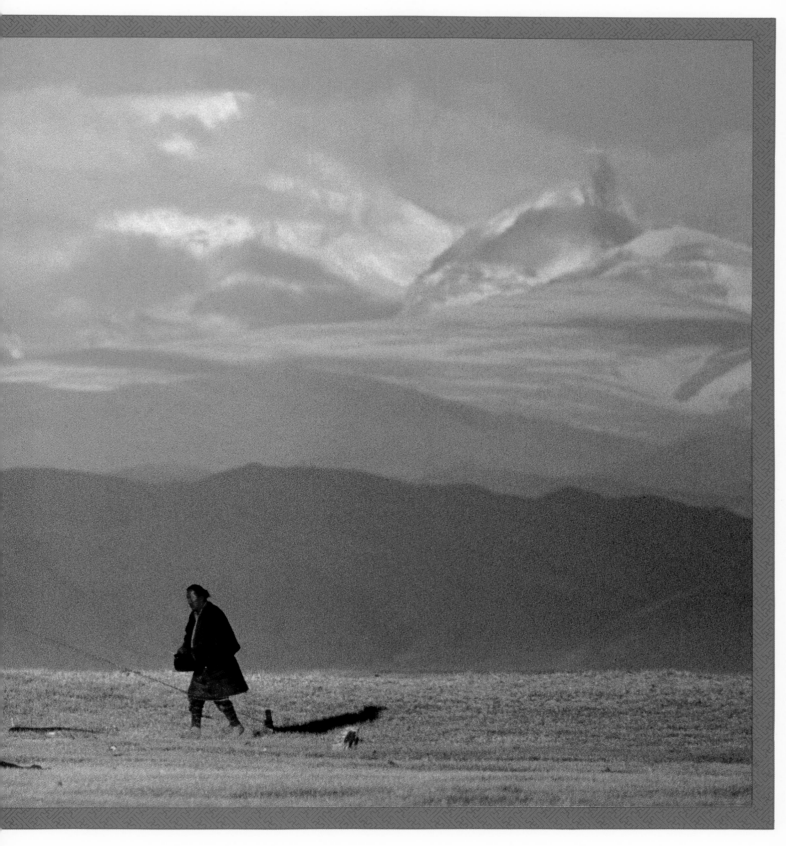

"The life of a nomad is very lonely and very peaceful.
Some live completely independent from society. Their land and their animals give
them everything they need—a diet of cheese, meat, milk, and yoghurt;
clothes of sheepskin, boots of yak leather, and tents of yak hair. They burn dung
in their hearths and move camp by tying everything onto their yaks' strong
backs. Home is wherever they find good pasture."

Nomads—Traditional Life on the High Plains

The nomadic people of Tibet are called *Dropkas* in their own language. Western explorers referred to them as the "people of the black tents." Today the *Drokpas* continue to wander through remote valleys with their herds of yaks and sheep, setting up their portable yak-hair homes wherever they find good grazing. Most *Dropkas* shudder at the mention of a hard-walled home in a fixed location. They value their mobility and self-sufficiency above everything except their devout Buddhist faith. Traditionally, their only means of education was to give a son as a monk to a distant monastery. When the son returned periodically to visit his extended family, he would impart some of his knowledge of writing, religion, history, and philosophy.

After the Chinese occupation, Tibet's monasteries were closed and the *Dropkas'* informal education ceased. Their animals were taken over by the state and the *Drokpas* themselves were herded into communes to raise livestock for export to mainland China. They endured many years of starvation until 1983, when their communes were disbanded and the few remaining animals were returned to them as private possessions.

The *Dropkas* have since resumed most of their timeless ways, living more in the old tradition of Tibet than any of their village-bound counterparts. Although they pay high taxes in wool, their herds have nearly returned to the size they were decades ago. Only by listening to talk around the hearth over a cup of salted, yak-butter tea would a visitor ever know how recently they were on the brink of extinction.—*Galen Rowell*

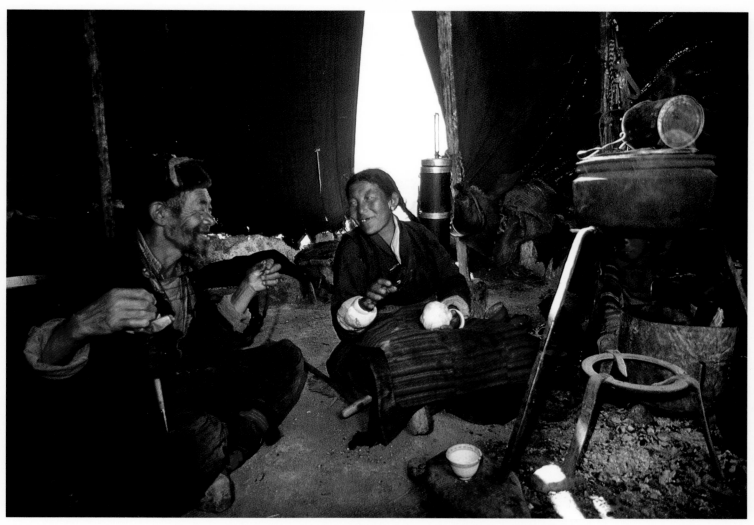

NOMAD COUPLE OF PEKHU TSO, WESTERN TIBET; 1988 (PHOTO: BARBARA CUSHMAN ROWELL)

*"With all the faults of its system, and the
rigor of its climate, I am sure that Tibet was among the happiest of lands.
The system certainly gave opportunities for oppression, but
Tibetans on the whole are not oppressive people."*

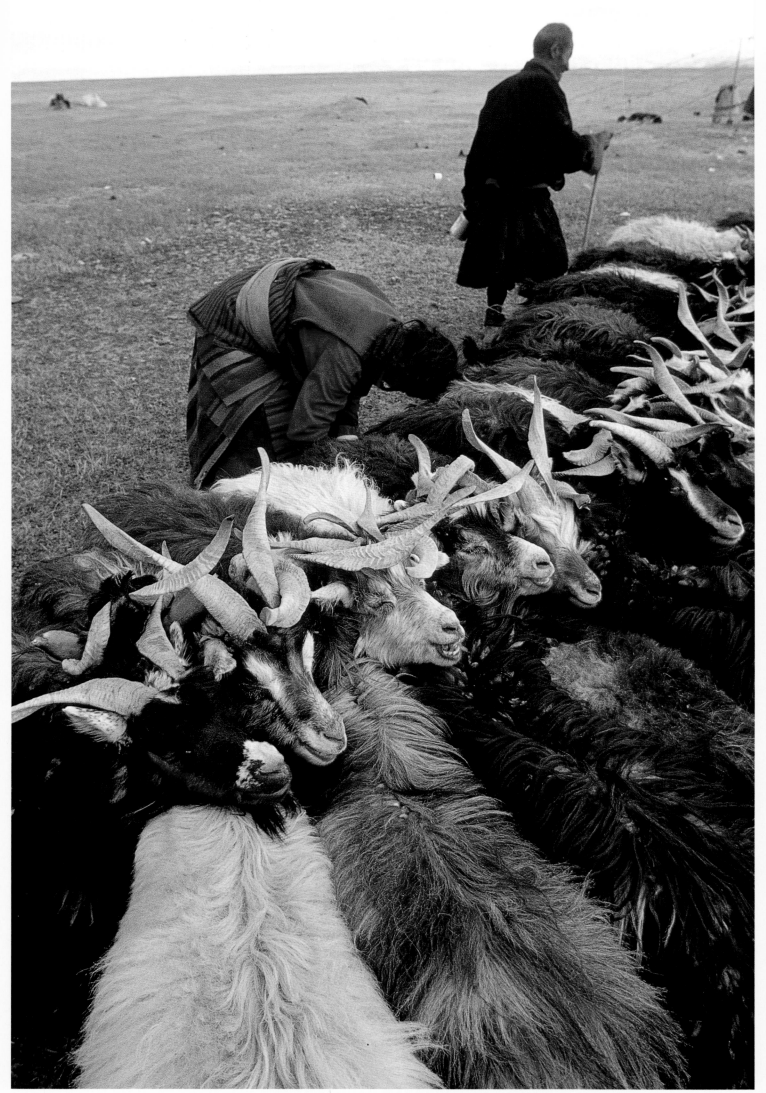

MILKING GOATS IN THE CHEMAYUNGDUNG VALLEY OF WESTERN TIBET; 1987

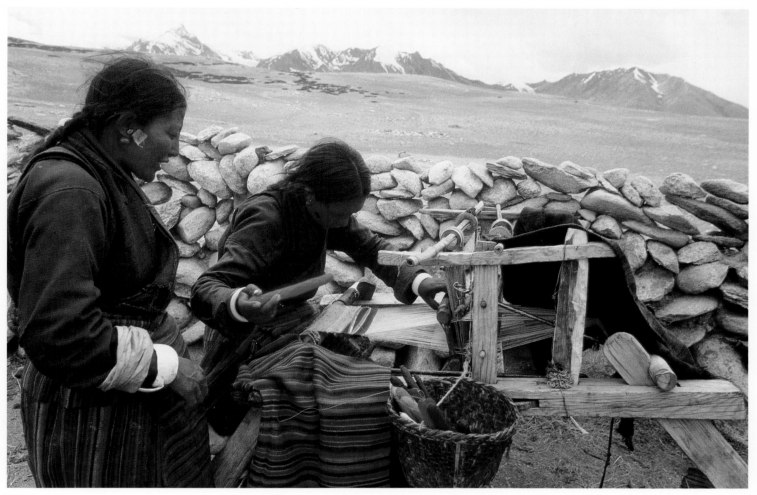

LOOM IN A NOMAD CAMP AT PEKHU TSO, WESTERN TIBET; 1988

*"Material progress alone is not sufficient to
achieve an ideal society. Even in countries where great external
progress has been made, mental problems have increased,
causing additional hardships. No amount of legislation or coercion can
accomplish the well-being of society, for this depends upon the
internal attitude of the people within it."*

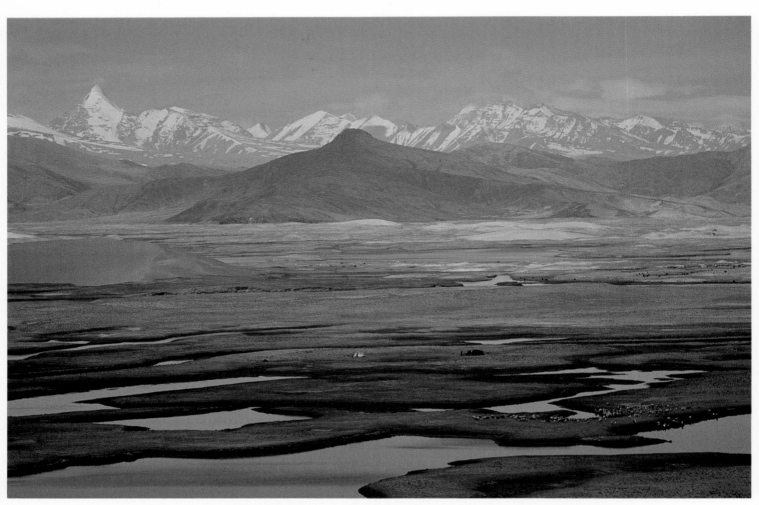

GRAZING LANDS BESIDE THE TSANGPO (BRAHMAPUTRA) RIVER IN THE MARTSANG REGION OF WESTERN TIBET; 1987

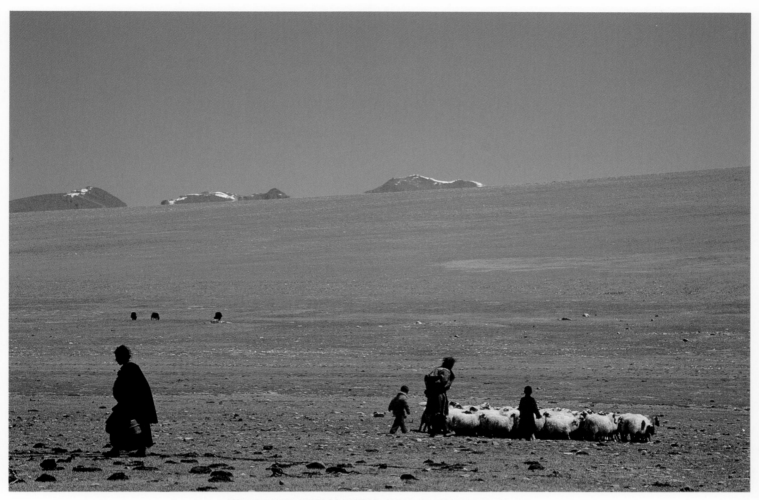

NOMAD FAMILY WITH GOAT HERD, CHEMAYUNGDUNG VALLEY; 1987

"In simplicity among our mountains, there is more peace of mind than in most of the cities of the world."

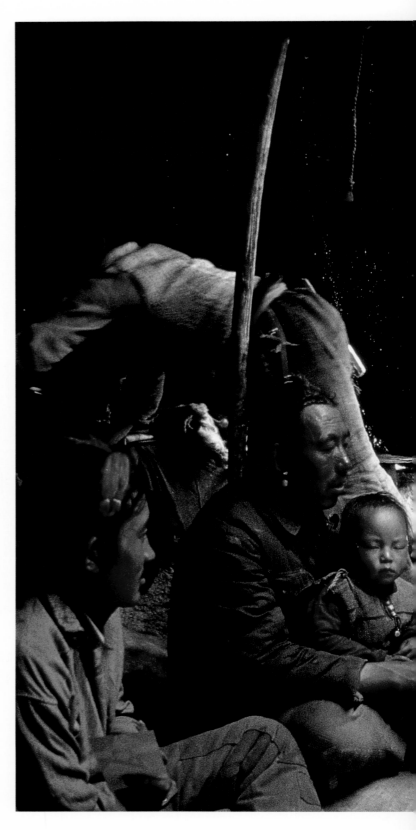

"All six million Tibetans should be on the list of endangered peoples. This struggle is thus my first responsibility."

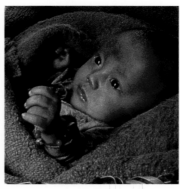

The baby at left didn't cry once during two days of visits with his Drokpa extended family. A brother, sister, parent, aunt, uncle, or grandparent was always looking after him, anticipating his needs, as is happening at the left rear of the tent even during this family portrait session. In a camp exposed to the elements at 15,000 feet, childcare is always a very high priority.

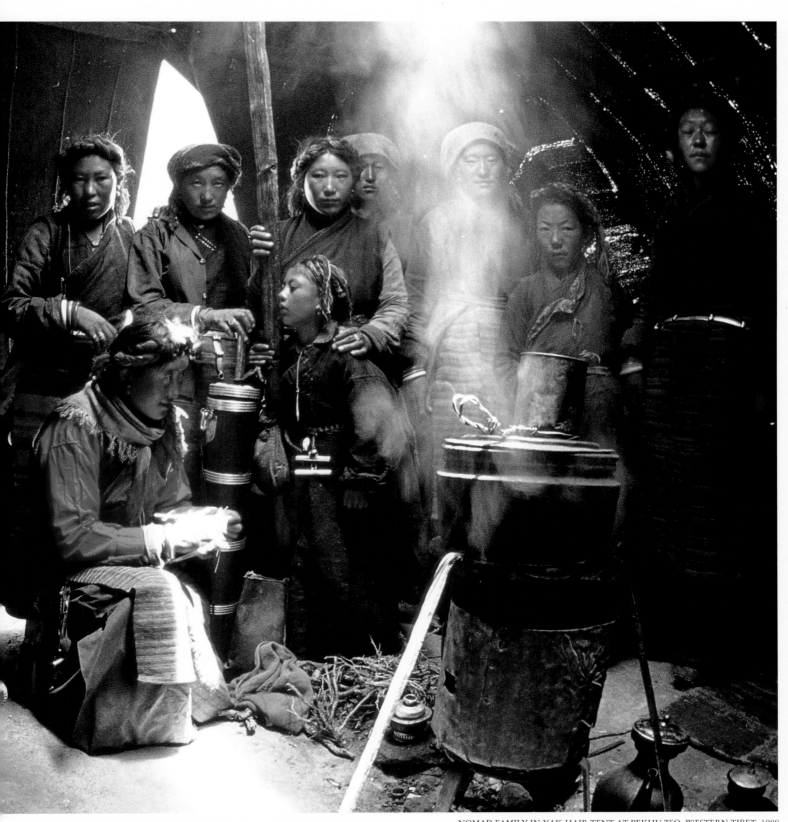

NOMAD FAMILY IN YAK-HAIR TENT AT PEKHU TSO, WESTERN TIBET; 1988

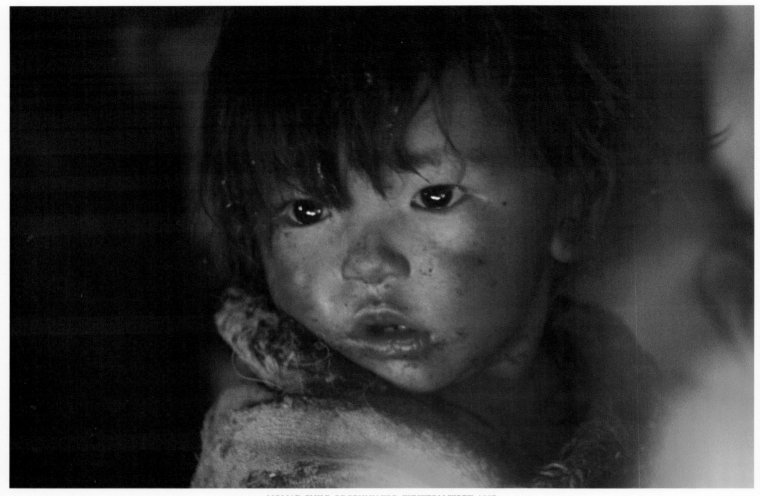

NOMAD CHILD OF PEKHU TSO, WESTERN TIBET; 1987

*"Today the faith, the feeling, of being Buddhist
is very strong, even among members of the younger generation. I think
it is stronger than in the previous generation."*

*Right: "Tibetans are naturally a happy and well-adjusted
people, thus forming a distinct society. These are qualities praised and regarded
as worthy of emulation by sensible people the world over."*

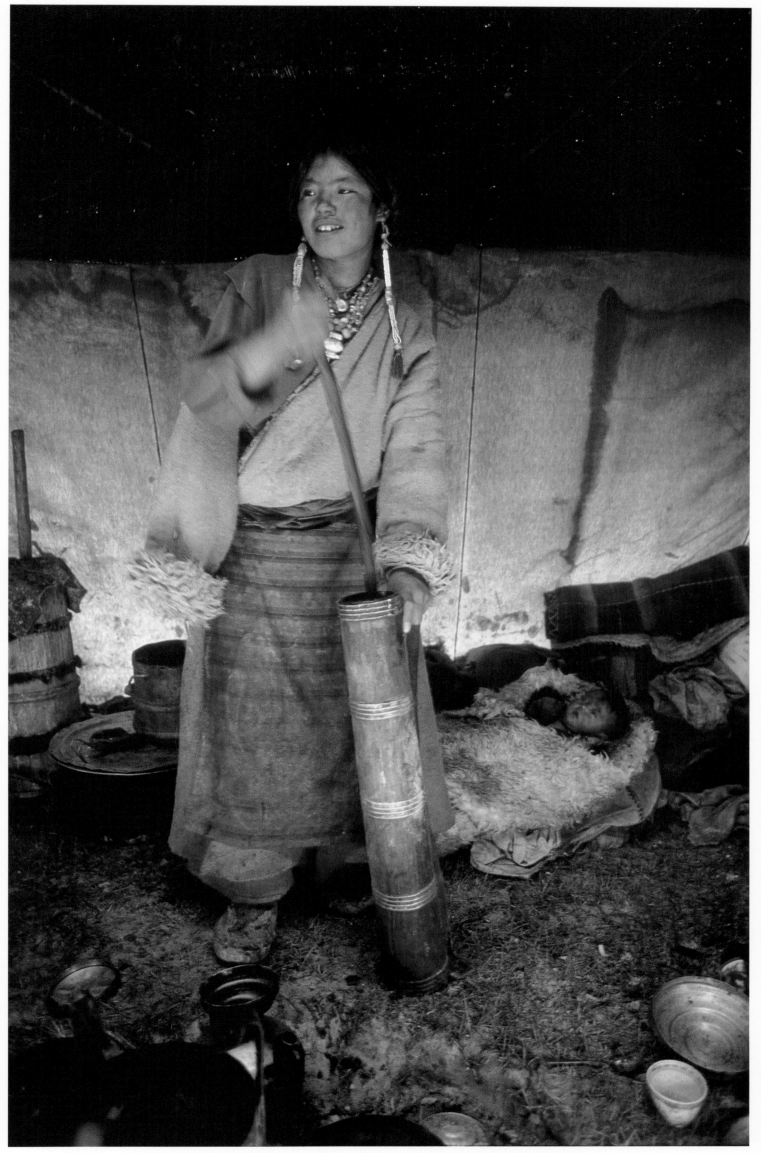

CHURNING YAK-BUTTER TEA IN THE MARTSANG REGION OF WESTERN TIBET; 1987

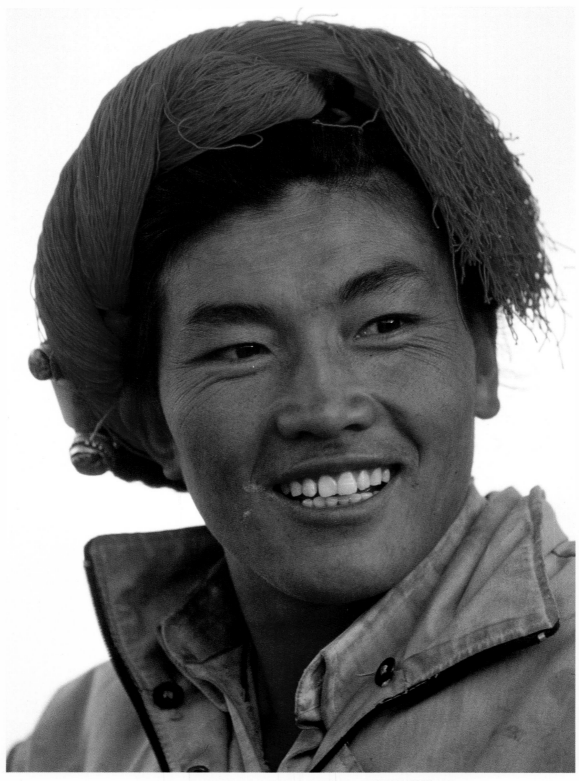

YOUNG KHAMPA ON PILGRIMAGE NEAR PEKHU TSO, WESTERN TIBET; 1988

"This man has great dignity as well as a fine smile.
The men of Kham are noted for their size, strength, and rugged features,
and yet, you see, there is no sign of hardness."

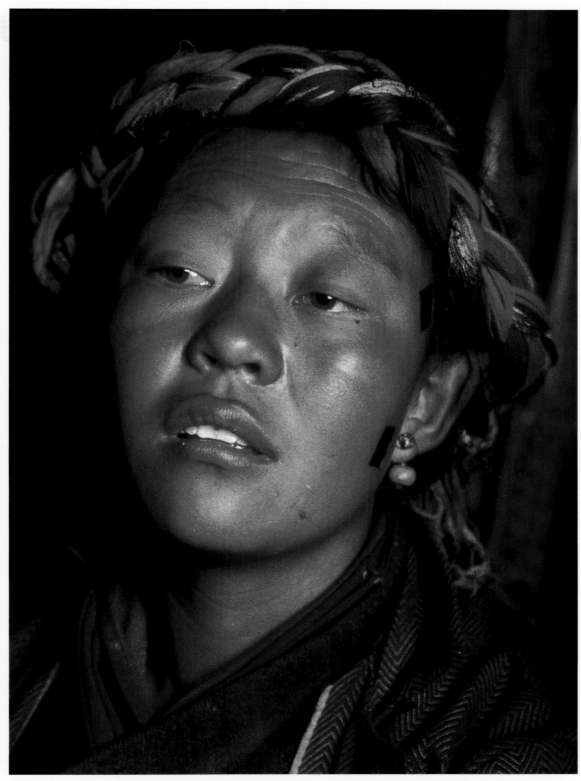

NOMAD WOMAN OF PEKHU TSO, WESTERN TIBET; 1988 (PHOTO: BARBARA CUSHMAN ROWELL)

"Tibet is racially, culturally, and geographically
distinct from any other nation. One of the main reasons for the
distinctive identity of the Tibetan people is our cultural
heritage. We must, therefore, recognize the importance and value of our own
language, literature, and traditions, including our way of
dressing. By cherishing our cultural heritage we must make every
effort to preserve and promote all its aspects."

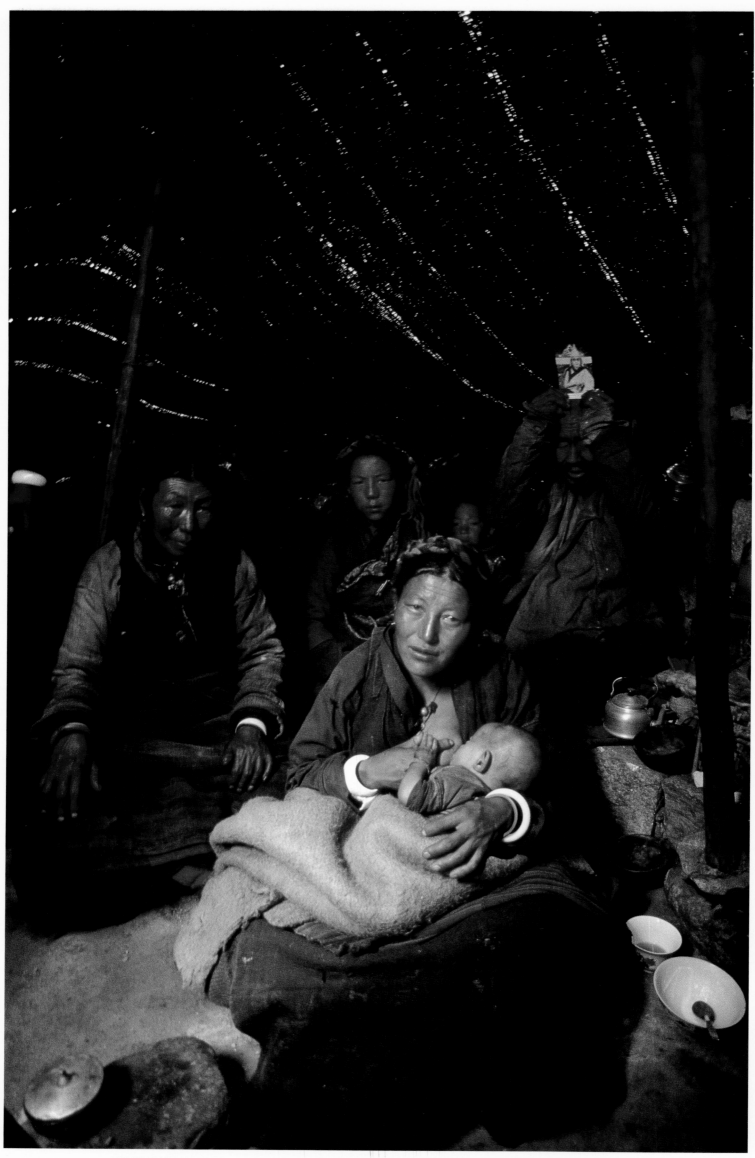

NOMAD FAMILY OF PEKHU TSO RECEIVING BLESSINGS FROM A PHOTOGRAPH OF THE DALAI LAMA, WESTERN TIBET; 1988

Ecology and the Human Heart
By The Dalai Lama

*"The sense of religion pervades the wildest places
and most of the wildest hearts. Even in the poorest nomad tents one
usually sees an altar with a butter lamp before it."*

According to Buddhist teaching, there is a very close interdependence between the natural environment and the sentient beings living in it. Some of my friends have told me that basic human nature is somewhat violent, but I have told them I disagree. If we examine different animals, for example, those whose very survival depends on taking others' lives, such as tigers or lions, we learn that their basic nature provides them with sharp fangs and claws. Peaceful animals, such as deer, which are completely vegetarian, are more gentle and have smaller teeth and no claws. From that viewpoint we human beings have a nonviolent nature. As to the question of human survival, human beings are social animals. In order to survive we need companions. Without other human beings there is simply no possibility of surviving; that is a law of nature.

Since I deeply believe that human beings are basically gentle by nature, I feel that we should not only maintain gentle, peaceful relations with our fellow human beings but also that it is very important to extend the same kind of attitude toward the natural environment. Morally speaking, we should be concerned for our whole environment.

Then there is another viewpoint, not just a question of ethics but a question of our own survival. The environment is very important not only for this generation but also for future generations. If we exploit the environment in extreme ways, even though we may get some money or other benefit from it now, in the long run we ourselves will suffer and future generations will suffer. When the environment changes, climatic conditions also change. When they change dramatically, the economy and many other things change as well. Even our physical health will be greatly affected. So this is not merely a moral question but also a question of our own survival.

Therefore, in order to succeed in the protection and conservation of the natural environment, I think it is important first of all to bring about an internal balance within human beings themselves. The abuse of the environment, which has resulted in such harm to the human community, arose out of ignorance of the importance of the environment. I think it is essential to help people to understand this. We need to teach people that the environment has a direct bearing on our own benefit.

I am always talking about the importance of compassionate thought. As I said earlier, even from your own selfish viewpoint, you need other people. So if you develop concern for other people's welfare, share other people's suffering, and help them, ultimately you will benefit. If you think only of yourself and forget about others, ultimately you will lose. That is also something like a law of nature.

It is quite simple: if you do not smile at people, but frown at them, they respond similarly, don't they? If you deal with other people in a very sincere, open way, they behave similarly. Everybody wants to have friends and does not want enemies. The proper way to create friends is to have a warm heart, not simply money or power. The friend of power and the friend of money are something different; these are not true

friends. True friends should be real friends of heart, shouldn't they? I am always telling people that those friends who come around when you have money and power are not truly your friends, but friends of money and power, because as soon as the money and power disappear, those friends are also ready to leave. They are not reliable.

Genuine, human friends stand by you whether you are successful or unlucky and always share your sorrow and burdens. The way to make such friends is not by being angry, nor by having good education or intelligence, but by having a good heart.

To think more deeply, if you must be selfish, then be wisely selfish, not narrow-mindedly selfish. The key thing is the sense of universal responsibility; that is the real source of strength, the real source of happiness. If our generation exploits everything available—the trees, the water, and the minerals—without any care for the coming generations or the future, then we are at fault, aren't we? But if we have a genuine sense of universal responsibility as our central motivation, then our relations with the environment will be well balanced, and so will our relations with our neighbors, both domestic and international.

Another important question is: What is consciousness, what is the mind? In the Western world during the last one or two centuries there has been great emphasis on science and technology, which mainly deal with matter. Today some nuclear physicists and neurologists say that when you investigate particles in a very detailed way, there is some kind of influence from the side of the observer, the knower. What is this knower? A simple answer is: A human being, the scientist. How does the scientist know? With the brain. But of the hundreds of billions of cells in the brain, Western scientists have identified only a few hundred so far. Now, whether you call it mind, brain, or consciousness, there is a relationship between brain and mind and also mind and matter. I think this is important. I feel it is possible to hold some sort of dialogue between Eastern philosophy and Western science on the basis of this relationship.

In any case, these days we human beings are very much involved in the external world, while we neglect the internal world. We do need scientific development and material development in order to survive and to increase the general benefit and prosperity, but equally as much we need mental peace. Yet no doctor can give you an injection of mental peace, and no market can sell it to you. If you go to a supermarket with millions and millions of dollars, you can buy anything, but if you go there and ask for peace of mind, people will laugh. And if you ask a doctor for genuine peace of mind, not the mere sedation you get from taking some kind of pill or injection, the doctor cannot help you.

Even today's sophisticated computers cannot provide you with mental peace. Mental peace must come from the mind. Everyone wants happiness and pleasure, but if we compare physical pleasure and physical pain with mental pleasure and mental pain, we find that the mind is more effective, predominant, and superior. Thus it is worthwhile adopting certain methods to increase mental peace, and in order to do that it is important to know more about the mind. When we talk about preservation of the environment, it is related to many other things. Ultimately the decision must come from the human heart. The key point is to have a genuine sense of universal responsibility, based on love and compassion, and clear awareness.

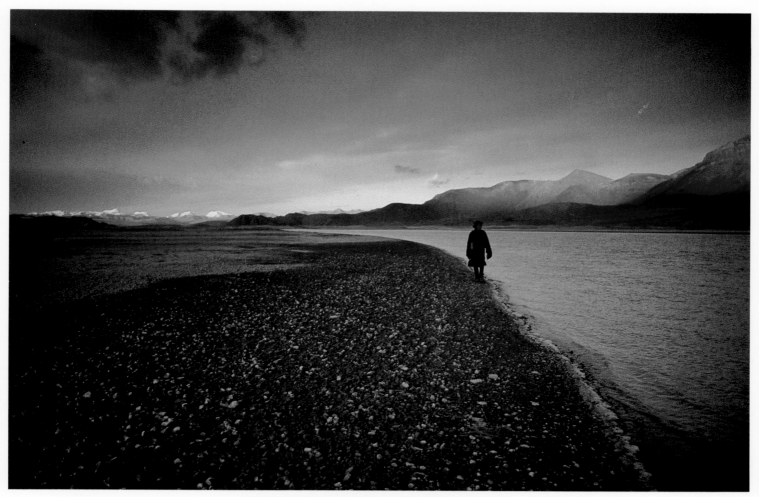

DAWN ON THE UPPER TSANGPO RIVER, WESTERN TIBET; 1987

*"When we talk about preservation of the environment,
it is related to many other things. Ultimately the decision must come
from the human heart, so I think the key point is to have a
genuine sense of universal responsibility."*

*"I have sometimes been asked if we followed
with interest the attempts of the British to climb Mount Everest.
I cannot say that we did. Most Tibetans have to climb too
many mountain passes to have any wish to climb higher than they must.
And the people of Lhasa, who sometimes climbed for pleasure, chose
hills of a reasonable size—and when they came to the top, they burned
incense, said prayers, and had picnics. That is a pleasure
I also enjoy when I have an opportunity."*

SUNRISE ON KANGBOCHEN (23,933 FEET) FROM PEKHU TSO, WESTERN TIBET; 1988

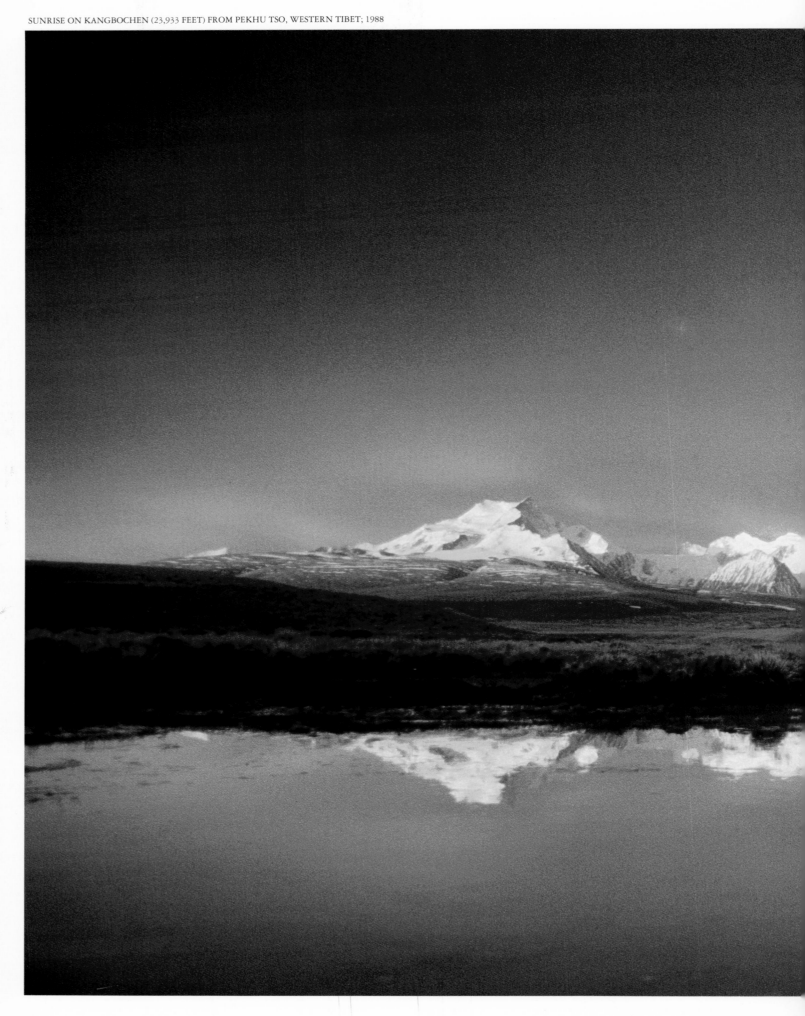

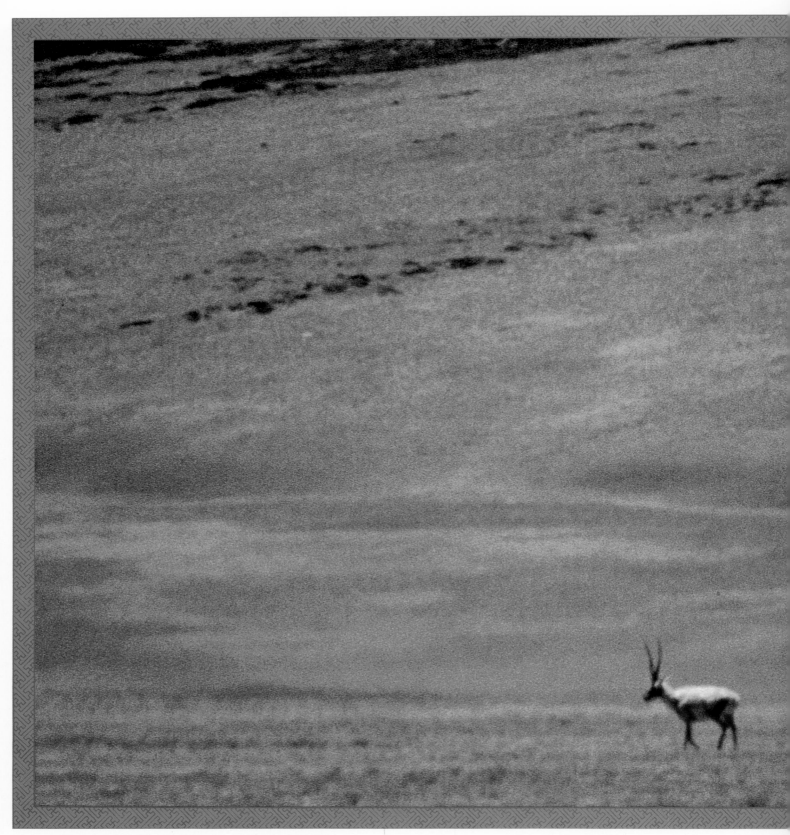

CHIRU (TIBETAN ANTELOPE) ON THE MARYUM LA, WESTERN TIBET; 1987

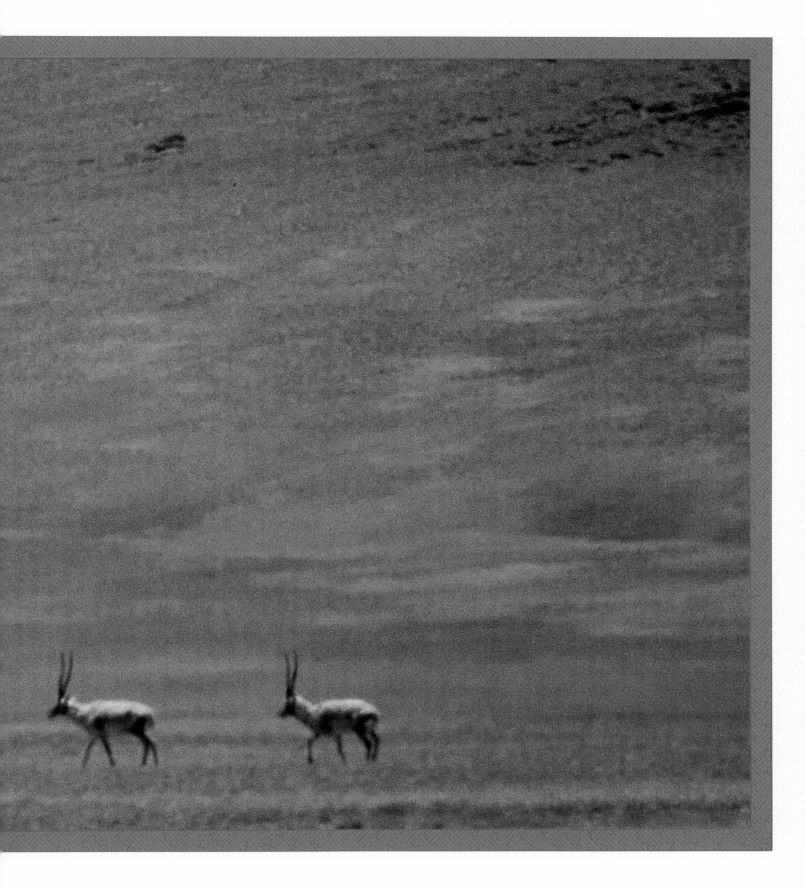

"Central to Buddha's teaching is seeing the equality among human beings and the importance of equality of all sentient beings. Whether you are a Buddhist or not, this is something important to know and to understand."

WILDLIFE—LIVING HERITAGE OF THE ICE AGES

Before the Chinese invasion, every explorer in Tibet reported seeing vast herds of wildlife. "One great zoological garden!" said Joseph Rock in 1930. "Wherever I looked, I saw wild animals grazing contentedly." The animals had almost no fear of humans. Only in the wildest nomadic areas, where no crops were grown, did native Tibetans hunt wild animals.

Since the Chinese occupation, the herds have all but disappeared because of the wholly unregulated shooting by soldiers and the loss of habitat that occurred as the simple subsistence lifestyle of old Tibet was squashed to fit Marxist ideals. As communes were required to raise livestock products for export to China, sensitive winter range in the most temperate valleys became radically overgrazed.

The wildlife of Tibet is a mixture of the unique and the familiar. Firmly bounded to the south by the Himalaya, the Tibetan Plateau is a remnant of the Palaearctic life zone, which encircled the upper latitudes with similar habitat connected by land and ice bridges during the Pleistocene epoch. Thus some of the far-ranging predators of modern Tibet, such as wolves, foxes, and bears, are so closely related to their kin all across America and Europe that they are classified as the same species. Several hoofed mammals, such as the *drong* (wild yak), and the *nyan* (great Tibetan sheep), are uniquely Tibetan. The highly endangered giant panda, now China's national symbol, is a native of the eastern borderlands of old Tibet.

Today Tibet's wild animals are rarely seen except in such remote areas as the northern plains of the Changtang, the arid valleys of western Tibet, and the alpine grasslands of uninhabited parts of Amdo and Kham. With Tibet's low population and tremendous open space, there is great potential for species to recover if the old environmental ethic of Tibetan Buddhism is reestablished.—*Galen Rowell*

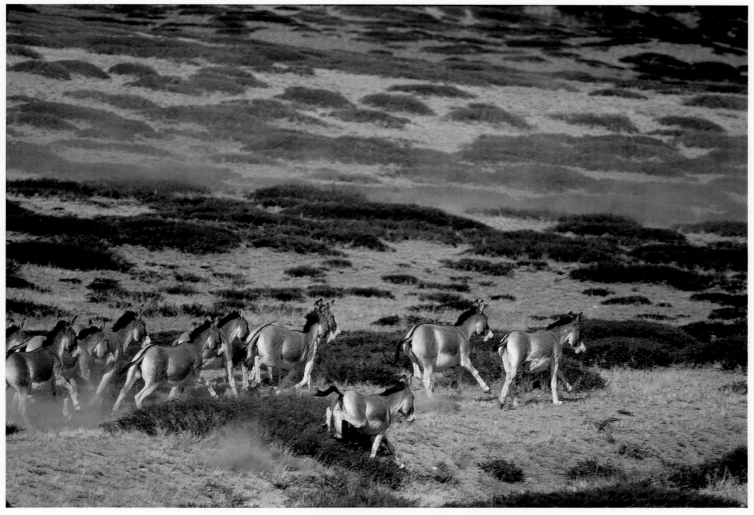

KIANG (TIBETAN WILD ASSES) IN THE PARYANG VALLEY OF WESTERN TIBET; 1987

"We have always considered our wild animals
a symbol of freedom. Nothing holds them back. They run free. So, you see,
without them something is missing from even the most beautiful
landscape. The land becomes empty, and only with the presence of wild living things
can it gain full beauty. Nature and wild animals are complementary.
People who live among wildlife without harming it are in harmony with the
environment. Some of that harmony remains in Tibet, and
because we had this in the past, we have some genuine hope for the future.
If we make an attempt, we can have all this again."

DRONG (WILD YAKS) AT 17,000 FEET IN THE CHEMAYUNGDUNG VALLEY OF WESTERN TIBET; 1987

"Drong *occur only in Tibet. They are the king of all*
yaks and the ancestor of our domestic yak. Their nature is very admirable.
When they're not being hunted, they're peaceful, almost gentle, but if
someone tries to shoot them, they become extremely aggressive. There are many stories
about their charging and killing hunters even after they have been shot several
times. These pictures remind me of something. Both drong *and* kiang *used to be found*
on flat pastures, not in these mountain places. Since the Chinese came,
there has been a lot of hunting. Our wild animals, like some of our people, have
been pushed back into the hills. We used to watch wildlife graze on huge
open spaces of pasture that stretched for days and days."

KIANG (TIBETAN WILD ASSES) AT THE SOURCE OF THE TSANGPO RIVER IN WESTERN TIBET; 1987

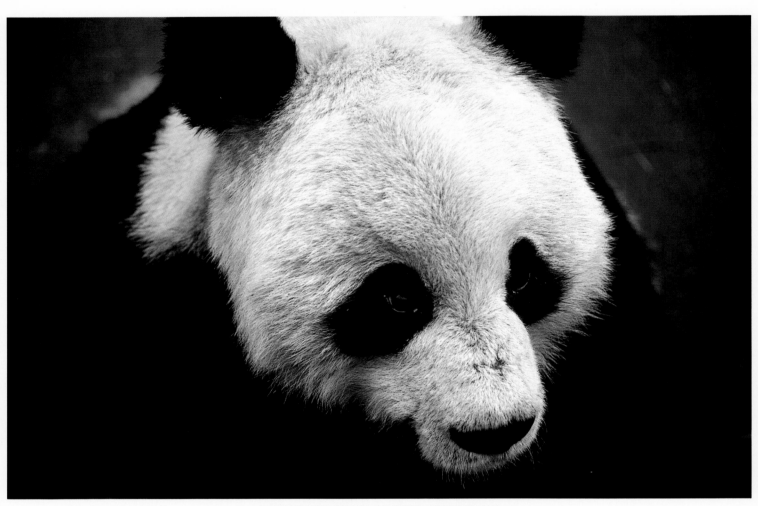

JILAI DHOM (GIANT PANDA) (CAPTIVE), SZECHUAN; 1983

*"The panda is actually a Tibetan
animal. Its original range overlapped the traditional eastern
border of China and Tibet. The local people in those
regions are mostly Tibetan. Some of the captive pandas should
be named Tashi or Tsering instead of
Ling-ling or Mei-mei."*

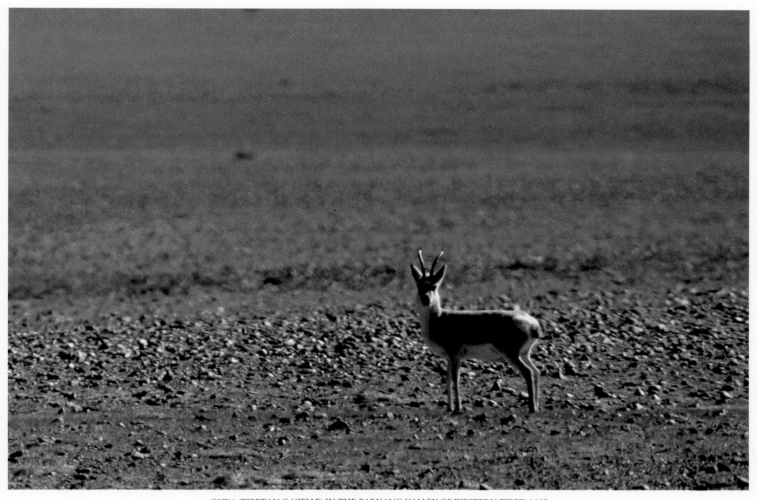

GOWA (TIBETAN GAZELLE) IN THE PARYANG VALLEY OF WESTERN TIBET; 1987

*"As I was traveling from my home village
to Lhasa when I was four years old, some of the men found a baby* gowa
*and presented it to me. I was delighted. I used to watch it for
hours at a time, admiring its spirit and gentle nature. After I reached
Lhasa, I had another* gowa *kept in the garden of the
Norbulingka, my summer palace in Lhasa."*

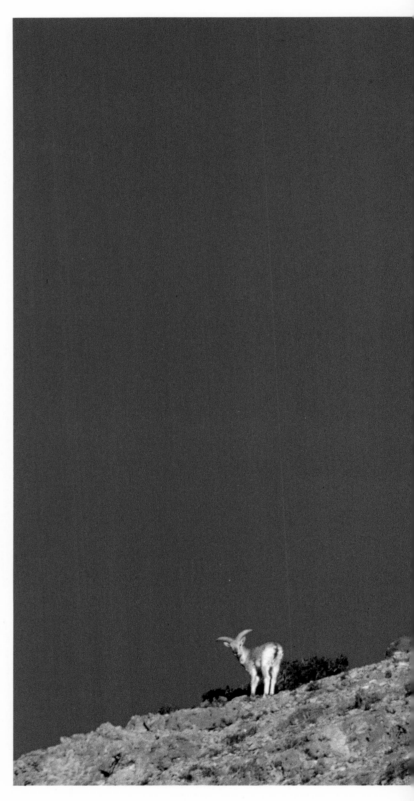

"I used to see the nawa *in the hills during my travels, and we had two or three in the Norbulingka. They were very beautiful and so gentle that we often set them free to roam among the gardens within the outer walls."*

Blue sheep look remarkably like the mountain sheep of other parts of the world, but the name sheep is a misnomer. By 1846 scientists classified them as Pseudois nayaur *in a genus of their own. Recent studies by George Schaller indicate that their behavior and internal structure is basically goatlike. He attributes their sheepish looks to "convergent evolution, the result of the species settling in a habitat which is usually occupied by sheep."*

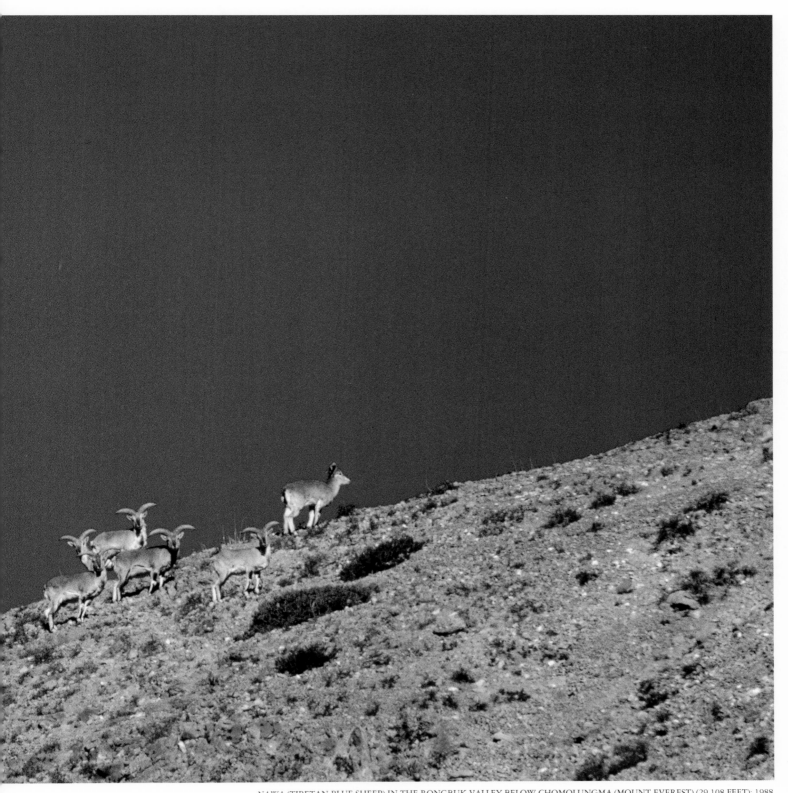

NAWA (TIBETAN BLUE SHEEP) IN THE RONGBUK VALLEY BELOW CHOMOLUNGMA (MOUNT EVEREST) (29,108 FEET); 1988

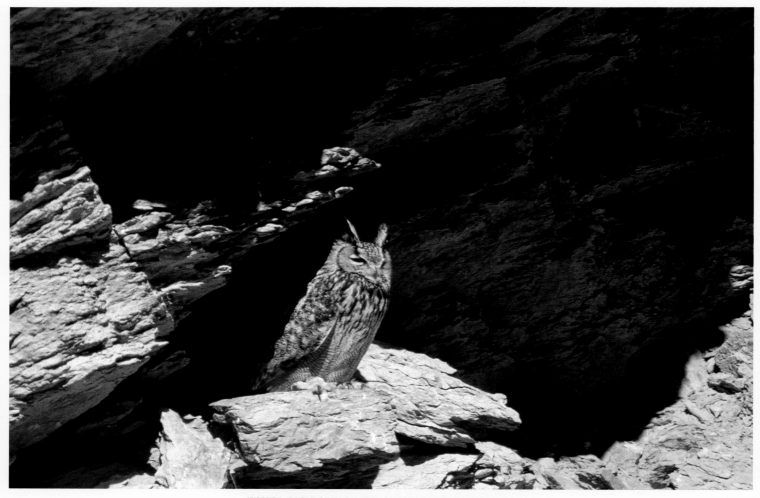

WOOKPA (EAGLE OWL) ON THE NANGPA LA NEAR TINGRI; 1988

"When I was a young boy in Lhasa,
I used to play outside the Potala Palace after my attendants wanted me to come inside
in the evening. Then they told me that a great owl would swoop down
in the night and carry me away if I went out alone in the dark. That was one of their best means
of making me come home early. There were many owls around the Potala, and we
noticed that they seemed to make more noise just at the time that special prayers were being
performed to a protective deity related to the owl."

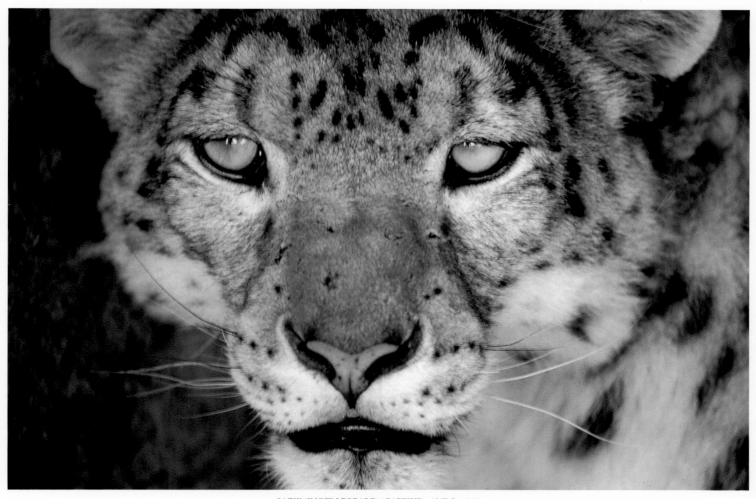

SAZIK (SNOW LEOPARD) (CAPTIVE), AMDO; 1981

*"If basic human nature were aggressive,
we would have gotten animal claws and huge teeth—but ours are very short, very
pretty, very weak! So that means we are not well equipped
to be aggressive beings. Even the size of our mouth is very limited. So I think
the basic nature of the human being should be gentle."*

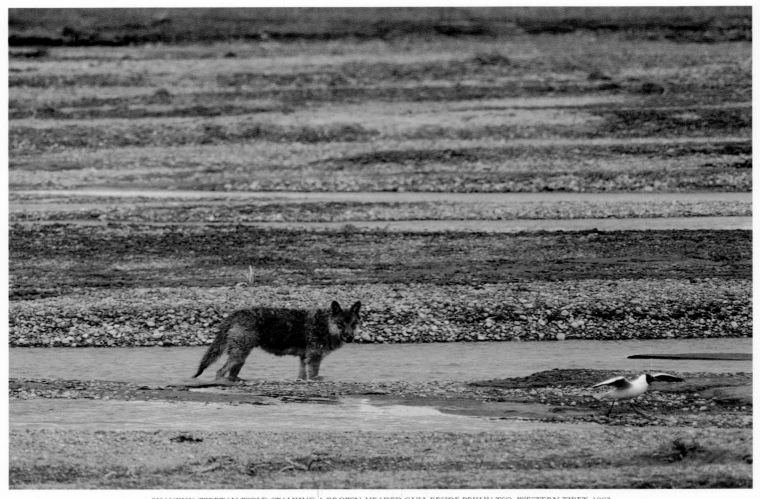

CHANKHU (TIBETAN WOLF) STALKING A BROWN-HEADED GULL BESIDE PEKHU TSO, WESTERN TIBET; 1987

"Is the wolf really stalking the bird,
or is the bird teasing the wolf, leading him on a little bit at
a time? In old Tibet hunting wildlife was strictly
prohibited with two exceptions: the wolf and the rat. The wolf was
very bad for goats, and the rat was very bad for crops.
Though Buddhists, my people have always been at the same
time very practical."

Right: "When I was a boy, my dearest friend,
a sweeper at the Potala, taught me a song about the grace and
dexterity of the flight of water birds. I still remember
some of the words. We admire all wild animals, and their special
skills are a part of our legends and songs."

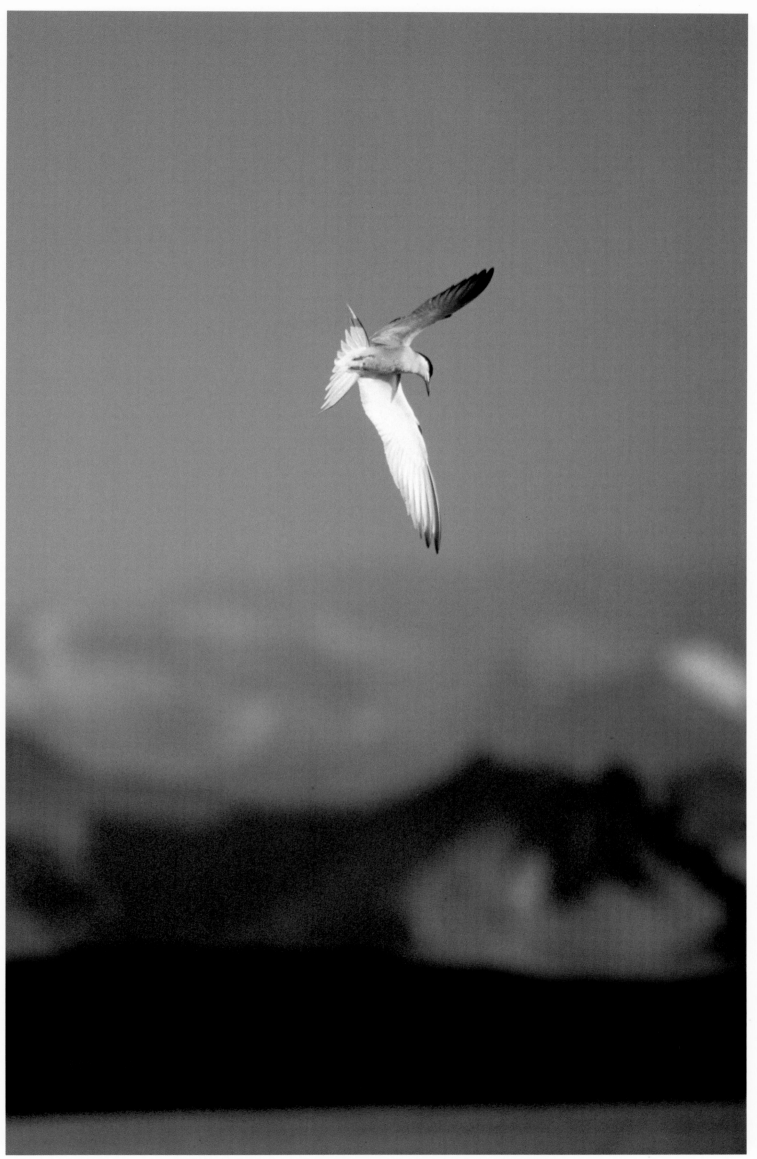

CHAKYAR (BLACK-HEADED GULL) DIVING INTO THE TSANGPO RIVER IN WESTERN TIBET; 1987

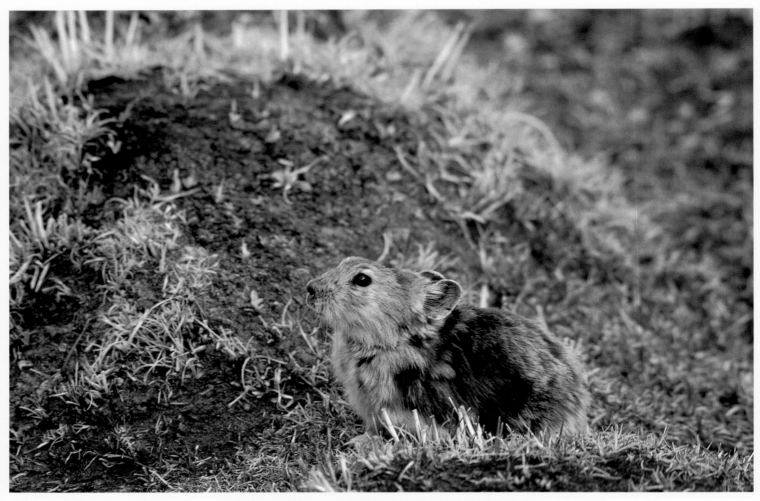

RIBONG DO (PIKA) IN THE MARTSANG REGION OF WESTERN TIBET; 1987

*"Tibetan people regard life, any life, as something
very sacred, something holy and important, so even when a small insect
is killed, we immediately respond with some feeling of compassion.
This remains a force in our society."*

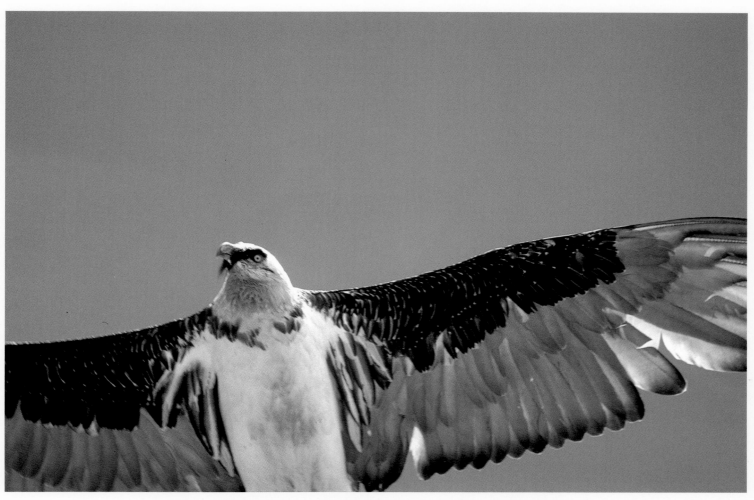

GHO (LAMMERGEIER) HOVERING AROUND KANGRINPOCHE (MOUNT KAILAS) (22,028 FEET); 1987

*"These birds prefer high altitudes and are
very dignified, unlike ordinary vultures. They like to soar around
monasteries, while the vultures stay around the burial grounds.
I used to see them from the Potala."*

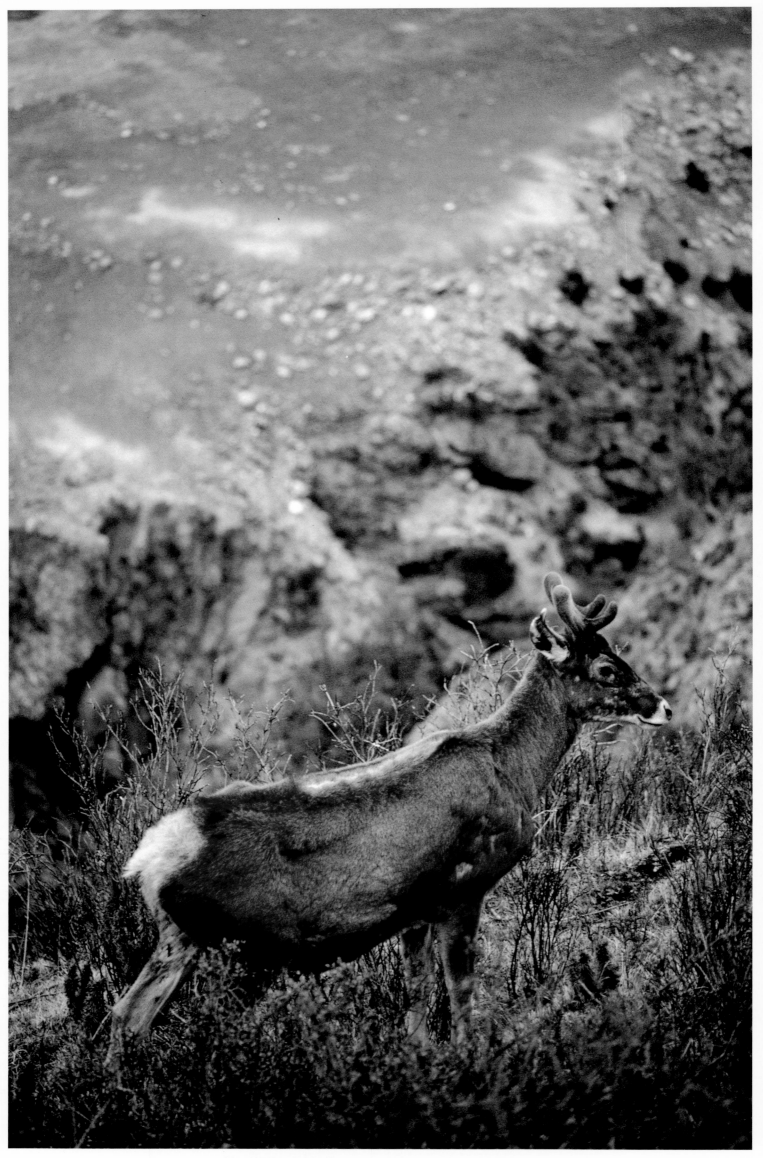

SHA (WHITE-LIPPED DEER) IN THE ANYE MACHIN RANGE OF AMDO; 1981

74

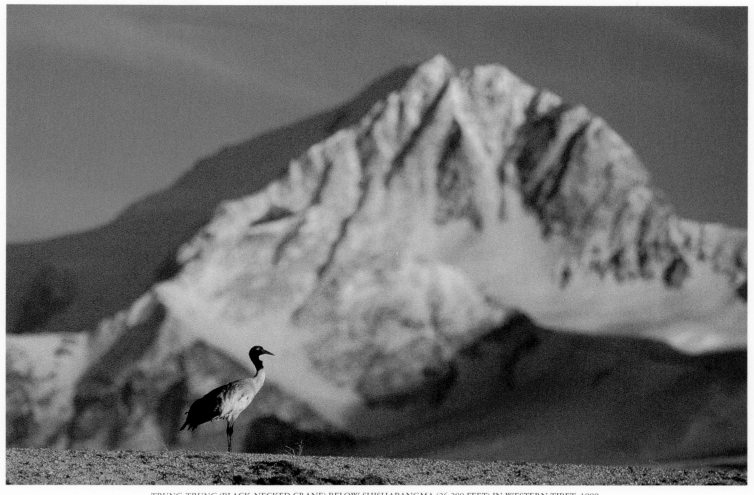

TRUNG-TRUNG (BLACK-NECKED CRANE) BELOW SHISHAPANGMA (26,289 FEET) IN WESTERN TIBET; 1988

"A solitary crane at sunset gives me a feeling of sadness.
They usually travel in pairs, striding gracefully across the land in the evening or early morning.
In some of our songs we symbolize them as sacred. Although they are quite large,
they exemplify gentleness and grace, both on land and in flight. In the old days I used to see many pairs
of cranes nesting in Lhasa in the marshes behind the Norbulingka.
I have heard they are gone now."

Left: "Statues of deer appear on the tops of monasteries.
We depict them on either side of a dharma wheel, which symbolizes the teachings of Buddha.
Because they have such an attraction to sound, we show them with their heads lifted up,
looking at the wheel and listening to the teachings of Buddha."

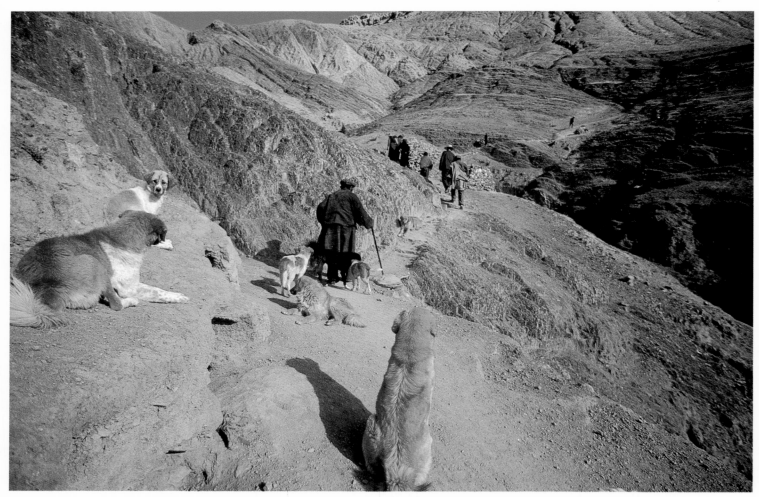

OLD MAN AND DOGS CIRCLING TASHILHUNPO MONASTERY IN SHIGATSE; 1987

"There are many different levels of the Whole Person.
For example, if he sees a dog beaten by someone, a Whole Man,
on a certain level, feels a kind of pain. Although he is not
beaten physically, he himself gets some kind of blow. If one sees
a bug killed, one feels a shiver of identification."

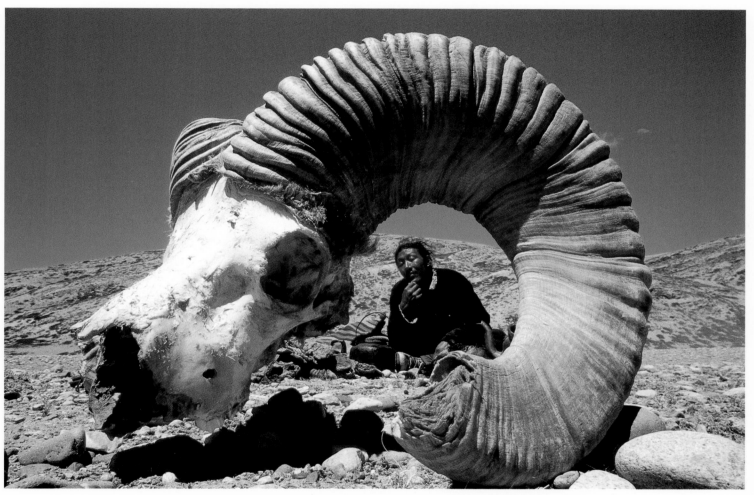

NOMAD AND SKULL OF A *NYAN* (GREAT TIBETAN SHEEP) ON THE MARYUM LA OF WESTERN TIBET; 1987

"The world grows smaller and smaller,
more and more interdependent . . . today more than ever before
life must be characterized by a sense of universal
responsibility, not only nation to nation and human to human
but also human to other forms of life."

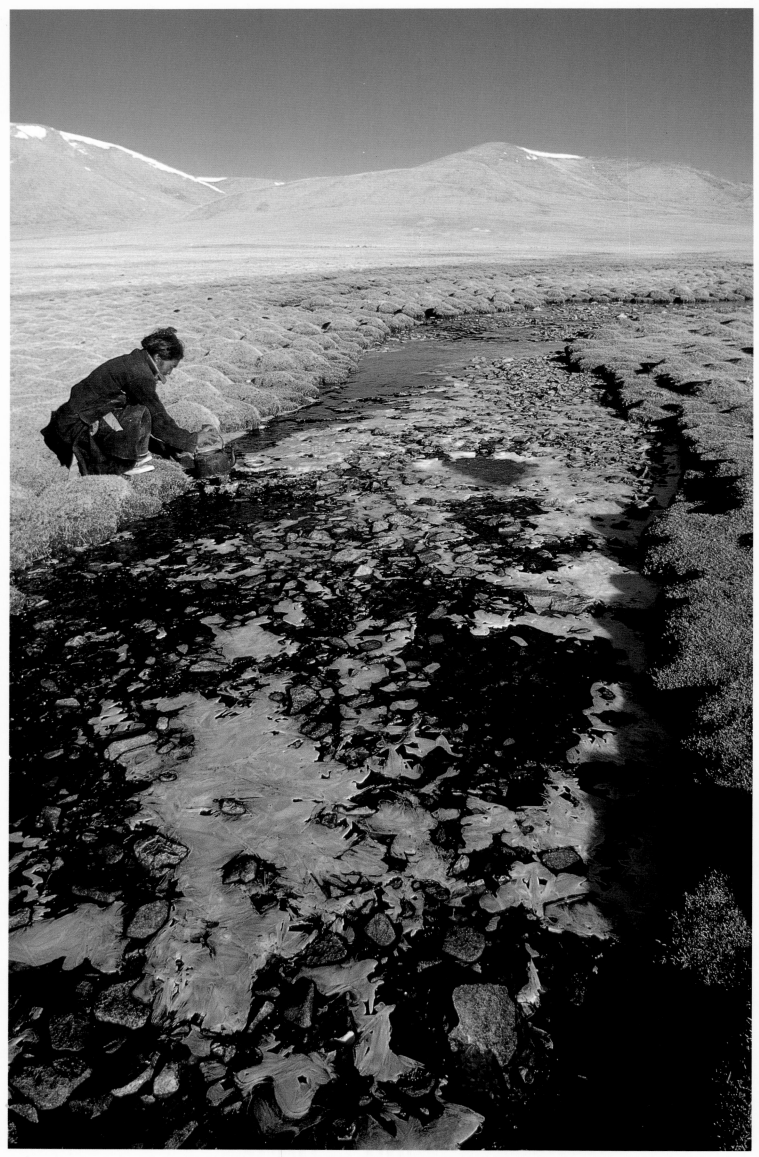

FROZEN STREAM NEAR THE SOURCE OF THE TSANGPO RIVER IN WESTERN TIBET; 1987

Universal Responsibility and the Environment
By The Dalai Lama

"If our generation exploits everything available—the trees, the water,
or the minerals—without any care for the coming generations and the future, then we are at fault,
aren't we? But if we have a genuine sense of universal responsibility as our central
motivation, then our relating with the environment will be well balanced."

As a boy studying Buddhism, I was taught the importance of a caring attitude toward the environment. Our practice of nonviolence applies not just to human beings but to all sentient beings—any living thing that has a mind. Where there is a mind, there are feelings such as pain, pleasure, and joy. No sentient being wants pain; all want happiness instead. I believe that all sentient beings share these feelings at some basic level.

In Buddhist practice we get so used to this idea of nonviolence and the ending of all suffering that we become accustomed to not harming or destroying anything indiscriminately. Although we do not believe that trees or flowers have minds, we treat them also with respect. Thus we share a sense of universal responsibility for both mankind and nature.

Our belief in reincarnation is one example of our concern for the future. If you think that you will be reborn, you are likely to say to yourself, I have to preserve such and such because my future reincarnation will be able to continue with these things. Even though there is a chance you may be reborn as a different creature, perhaps even on a different planet, the idea of reincarnation gives you reason to have direct concern about this planet and future generations.

In the West when you speak of "humanity," you usually mean only our existing generation of human beings. Past humanity is already gone. The future, like death, has yet to come. Western ideas usually deal with the practical side of things for only this present generation of human beings.

Tibetan feelings about the environment are not based entirely on religion. They are derived from the whole Tibetan way of life, not just from Buddhism. For example, consider Buddhism in Japan or Thailand, in environments different from ours. Their culture and their attitudes are not the same as ours. Our unique environment has strongly influenced us. We don't live on a small, heavily populated island. Historically, we have had little anxiety with our vast area, low population, and distant neighbors. We haven't felt as oppressed as people in many other human communities.

It is very possible to practice the essence of a faith or culture without practicing a religion. Our Tibetan culture, although highly influenced by Buddhism, did not gain all its philosophy from Buddhism. I once suggested to an organization dealing with Tibetan refugees that it would be interesting to do some research on how much our people have been affected by their approach to life itself in Tibet. What are the factors that make Tibetans generally happy and calm? People are always looking for answers in our unique religion, forgetting that our environment is just as unusual.

Concern for the environment is not necessarily holy, nor does it always require compassion. We Buddhists express compassion for all sentient beings, but this compassion is not necessarily extended to every rock or tree or house. Most of us are somewhat concerned about our own house, but not really compassionate about it. We keep it in order so that we can live and be happy. We know that to have happy

feelings in our house we must take care of it. So our feelings may be of concern rather than compassion.

Similarly, our planet is our house, and we must keep it in order and take care of it if we are genuinely concerned about happiness for ourselves, our children, our friends, and other sentient beings who share this great house with us. If we think of the planet as our house or as our mother—Mother Earth—we automatically feel concern for our environment. Today we understand that the future of humanity very much depends on our planet, and that the future of the planet very much depends on humanity. But this has not always been so clear to us. Until now, you see, Mother Earth has somehow tolerated sloppy house habits. But now human use, population, and technology have reached that certain stage where Mother Earth no longer accepts our presence with silence. In many ways she is now telling us, "My children are behaving badly." She is warning us that there are limits to our actions.

The Tibetan Buddhist attitude is one of contentment, and there may be some connection here with our attitude toward the environment. We don't indiscriminately consume. We put a limit on our consumption. We admire simple living and individual responsibility. We have always considered ourselves as part of our environment, but not just any part. Our ancient scriptures speak of the container and the contained. The world is the container—our house—and we are the contained—the contents of the container. From these simple facts we deduce a special relationship, because without the container, the contents cannot be contained. Without the contents, the container contains nothing. It's meaningless.

In my Five Point Peace Plan I have proposed that all of Tibet become a sanctuary, a zone of peace. Tibet was that once, but with no official designation. Peace means harmony: harmony between people, between people and animals, between sentient beings and the environment. Visitors from all over the world could come to Tibet to experience peace, harmony. Instead of building big hotels with many stories and many rooms, we would make small buildings, more like private homes, that would be in better harmony with nature.

It is not at all wrong for humans to use nature to make useful things, but we must not exploit nature unnecessarily. It is good to live in a house, to have medicines, and to be able to drive somewhere in a car. In the right hands, a machine is not a luxury, but something very useful. A camera, for example, can be used to make pictures that promote understanding.

But everything has its limit. Too much consumption or effort to make money is no good. Neither is too much contentment. In principle, contentment is a goal, but pure contentment becomes almost like suicide, doesn't it? I think the Tibetans had, in certain fields, too much contentment. And we lost our country. These days we cannot afford too much contentment about the environment.

Peace and survival of life on earth as we know it are threatened by human activities that lack a commitment to humanitarian values. Destruction of nature and natural resources results from ignorance, greed, and lack of respect for the earth's living things. This lack of respect extends even to the earth's human descendants, the future generations who will inherit a vastly degraded planet if world peace does not become a reality and if destruction of the natural environment continues at the present rate.

Our ancestors viewed the earth as rich and bountiful, which it is. Many people in the past also saw nature as inexhaustibly sustainable, which we now know is the case only if we care for it. It is not difficult to forgive destruction in the past that resulted from ignorance. Today, however, we have access to more information. It is essential that we reexamine ethically what we have inherited, what we are responsible for, and what we will pass on to coming generations.

Clearly this is a pivotal generation. Global communication is possible, yet confrontations take place more often than meaningful dialogues for peace. Our marvels of science and technology are matched, if not outweighed, by many current tragedies, including human starvation in some parts of the world and extinction of other life-forms. Exploration of outer space takes place at the same time the earth's own oceans, seas, and freshwater areas grow increasingly polluted, and their life-forms are still largely unknown or misunderstood. Many of the earth's habitats, animals, plants, insects, and even microorganisms that we know as rare may not be known at all by future generations. We have the capability and the responsibility. We must act before it is too late.

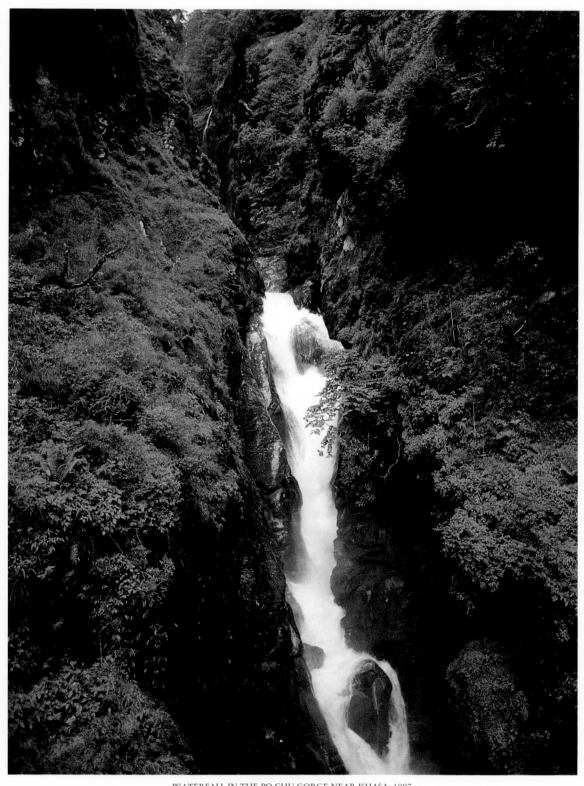

WATERFALL IN THE PO CHU GORGE NEAR KHASA; 1987

*"Both science and the teachings of the Buddha tell
us of the fundamental unity of all things. This understanding is crucial
if we are to take positive and decisive action on the pressing
global concern with the environment."*

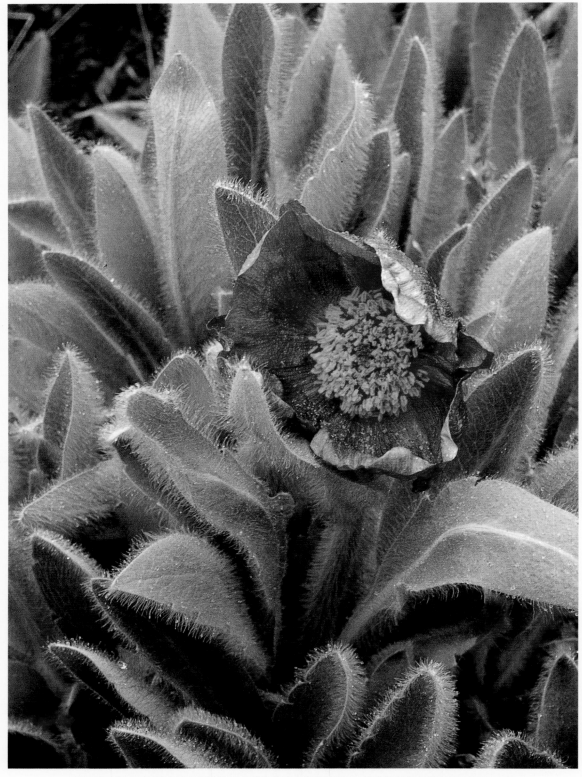

TSONGA (POPPY) IN THE KAMA VALLEY, EAST OF CHOMOLUNGMA (MOUNT EVEREST) (29,108 FEET); 1988

*"I have seen two kinds of this Himalayan blue poppy,
one quite tall, and this very beautiful smaller one that grows close to the
ground in the hills behind Drepung Monastery in Lhasa. It is used in
Tibetan medicines for lung and liver ailments."*

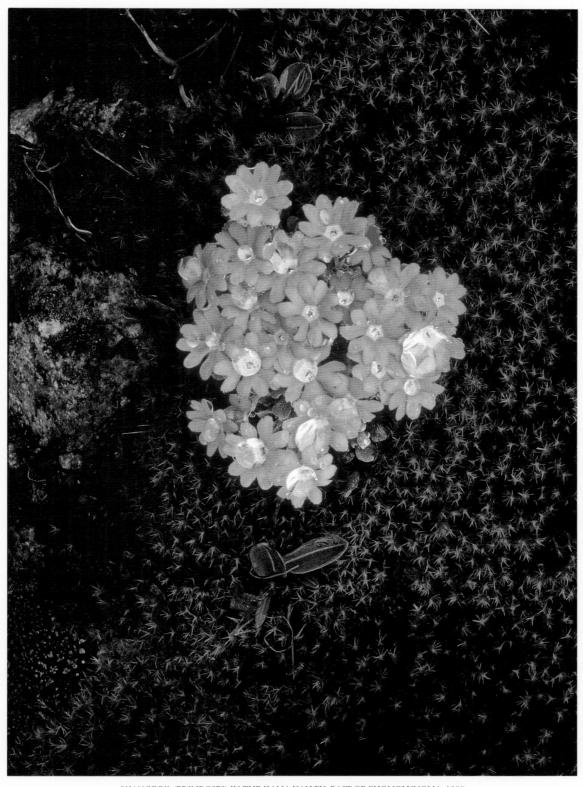

SHANGDRIL (PRIMROSES) IN THE KAMA VALLEY, EAST OF CHOMOLUNGMA; 1988

"Our ancestors viewed the earth as rich
and bountiful, which it is. Many people in the past also saw
nature as inexhaustibly sustainable, which we now know
is the case only if we care for it."

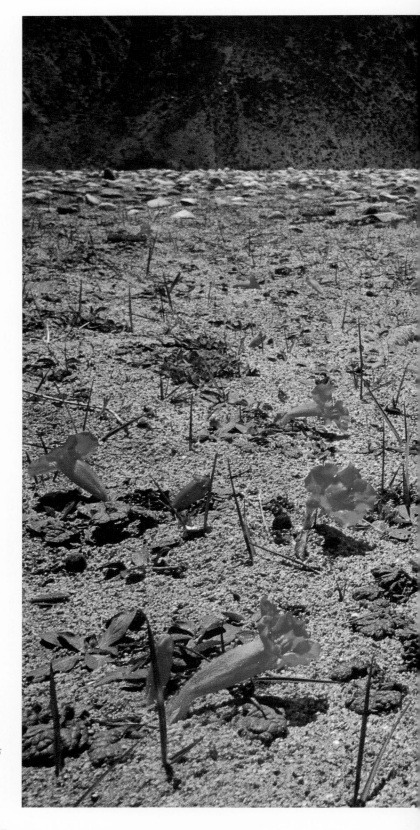

"If I see, smell, or even think about wildflowers,
I feel especially happy. I remember when I first arrived in Lhasa as
a four-year-old boy I felt as though I were in a dream . . . as if
I were in a great park covered with beautiful flowers while soft breezes
blew across it and peacocks elegantly danced before me.
There was an unforgettable scent of wildflowers and a song of
freedom and happiness in the air."

When, decades after fleeing into exile, an
old lama was asked to recount his favorite
memory of Tibet, he spoke of millions of
purple flowers erupting each spring from
seemingly lifeless plains. Their scientific
name, Incarvillea younghusbandi,
immortalizes Sir Francis Younghusband,
the amateur naturalist and professional
soldier who led the British invasion of
Lhasa in 1904.

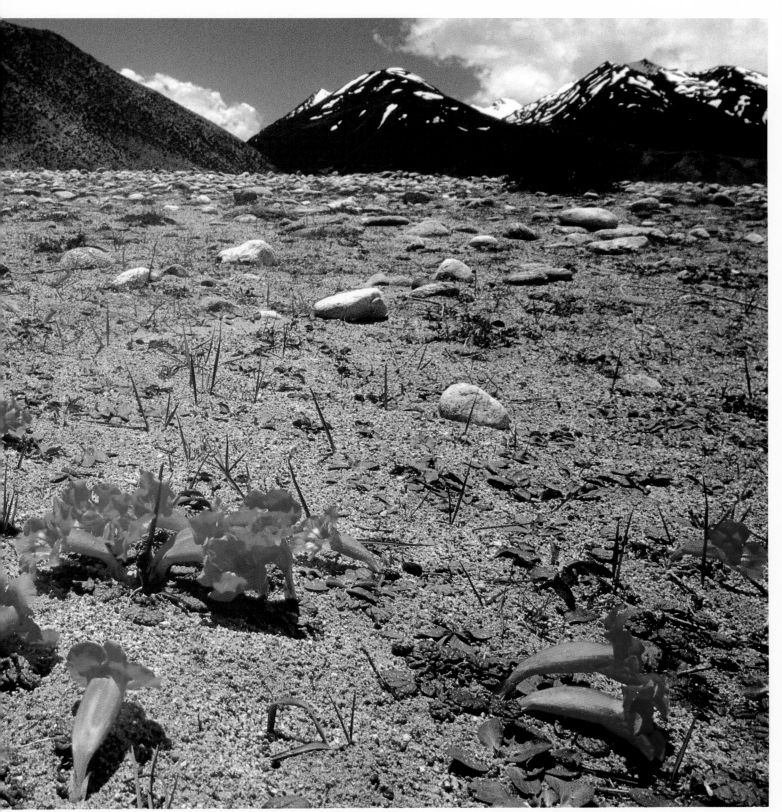

OOKCHOE (INCARVILLEA) ON THE KHARTA PLAINS, PHUNG CHU VALLEY; 1988

85

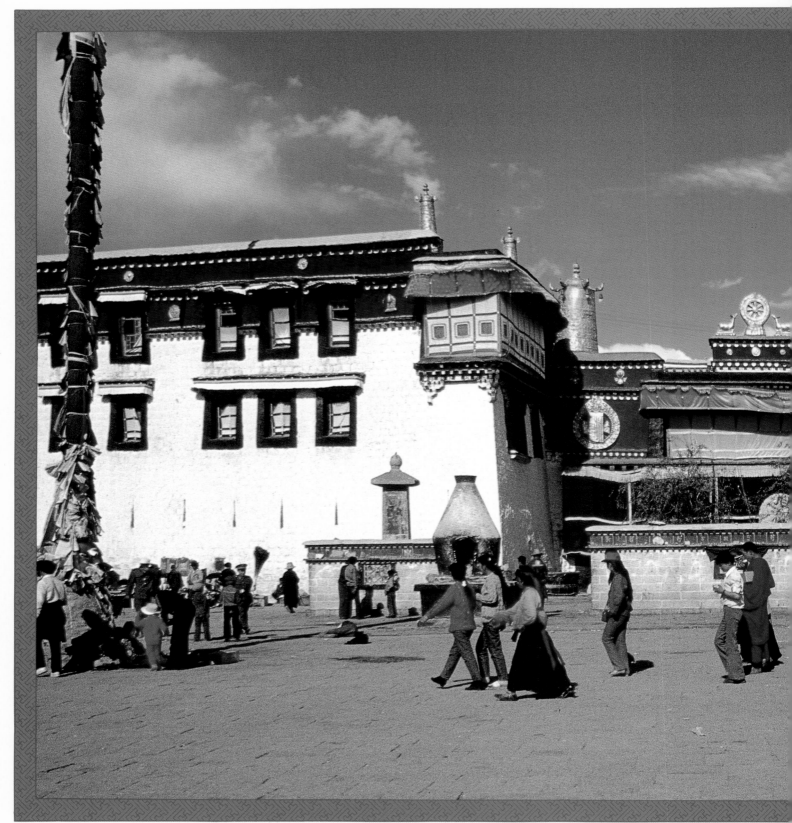

THE BARKHOR PATH IN FRONT OF THE JOKHANG TEMPLE, LHASA; 1988

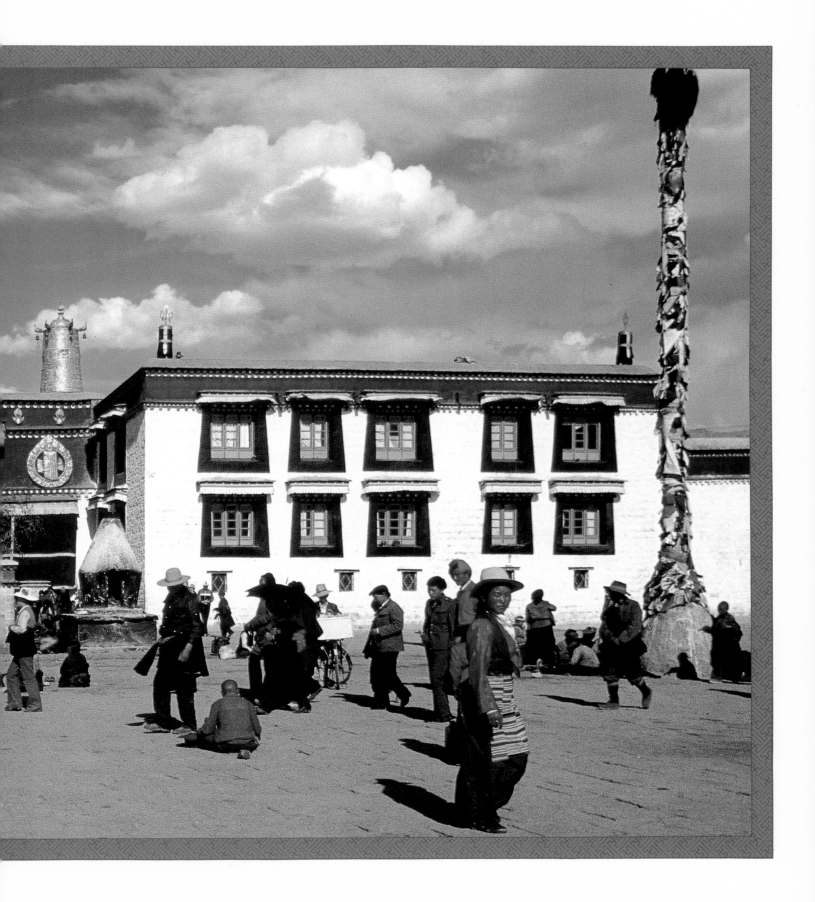

"Most people in the distant marches of Tibet had never been to Lhasa,
or even perhaps met anyone else who had been there. From year to year they tilled
the earth and bred their yaks and other animals, and neither heard nor saw
what happened in the world beyond their own horizon."

LHASA—THE SPIRITUAL CENTER

Lhasa is the spiritual and political capital of Tibet. There the ancient kings and successive incarnations of the Dalai Lama lived and ruled from the Potala, a great 1,100-room winter palace, and the Norbulingka, a smaller, more intimate summer palace within a walled and forested park with gardens where tame wildlife was allowed to run free.

At a mere twelve thousand feet above the sea, Lhasa's climate is unusually temperate for Tibet. The air is dry, and the summers resemble winters in Arizona. During most years there are four frost-free months, when fruits and vegetables prosper. It comes as no surprise that within the greater Lhasa area are three of the country's largest and most important monasteries. Until 1959, Ganden, Sera, and Drepung were separate monastic cities, each housing thousands of monks and uncounted cultural treasures.

At the heart of Lhasa is the holiest shrine in all Tibet, the Jokhang (Tsuglakhang) Temple, established by Songtsen Gampo (609-649), the first king of Tibet to practice Buddhism. It was built to house a statue of the Buddha given as dowry by Queen Trisun, his Nepalese wife. That statue was later moved elsewhere, and today pilgrims come to the Jokhang from all corners of the country to worship the even more sacred statue of Jowo Rinpoche, believed to have been blessed by the Buddha himself. It was brought overland as dowry by another of Songtsen Gampo's wives, Queen Wen Cheng of China. The statue is believed to have been made in India about twenty-five hundred years ago.

Pilgrims visiting the Jokhang traditionally circumambulate the Barkhor, a half-mile sacred path around the temple. A longer path, called the Lingkhor, circles nearly five miles around the perimeter of the ancient city, passing through the grounds of the Potala Palace. The Lingkhor, now well within the sprawling modern city of Lhasa, provides an especially good sense of the original dimensions of the holy city.—*Galen Rowell*

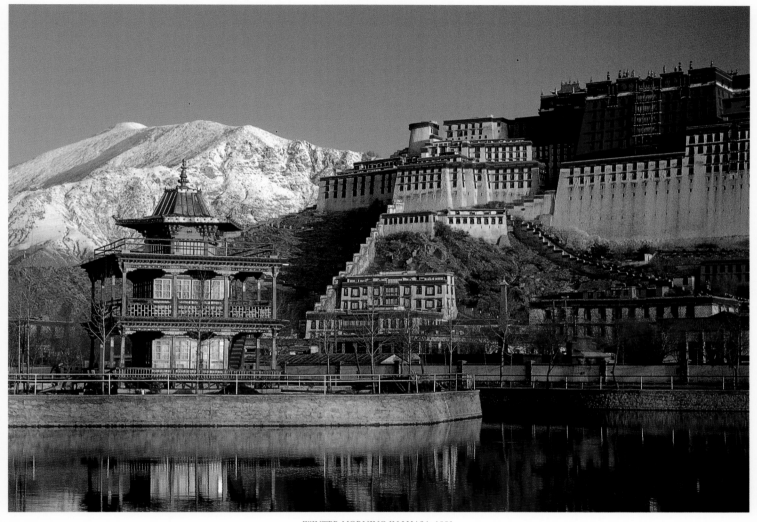

WINTER MORNING IN LHASA; 1983

"I found living in the Potala quite comfortable.
Because its walls are very thick, it stays cool in summer and is not
very cold in winter. Also the Lhasa air is so dry that the
cold doesn't feel so bad, even though the ground is frozen more than a
foot deep. Where I live now, in Dharamsala, the
ground freezes only one inch or so, but the moist air makes it
feel colder than in Lhasa."

DOOR IN THE POTALA PALACE, LHASA; 1981

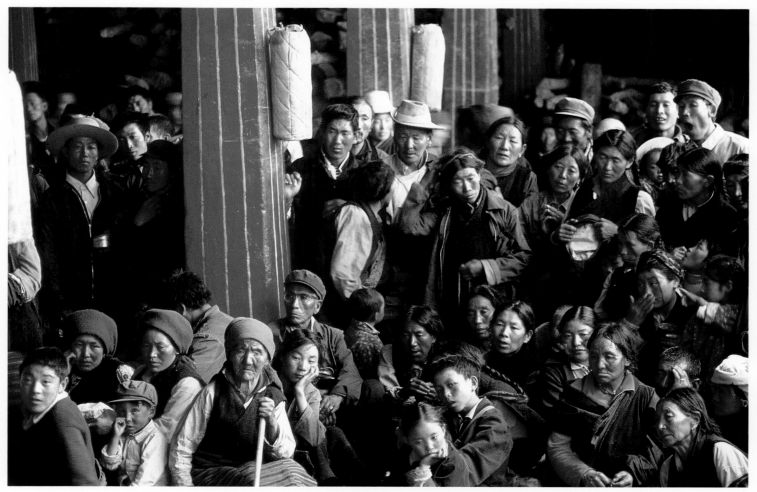

WORSHIPPERS IN THE JOKHANG TEMPLE, LHASA; 1983

*"I have always felt that if I had been born in a rich or
aristocratic family I would not have been able to appreciate the feelings
and sentiments of the humble classes of Tibetans. But owing
to my lowly birth, I can understand them and read their minds, and that
is why I feel for them so strongly and have tried my best
to improve their lot in life."*

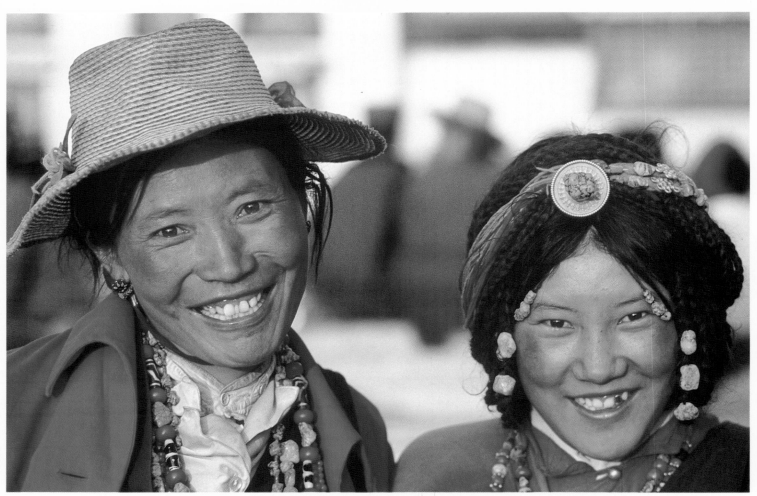

KHAMPA MOTHER AND DAUGHTER OF DERGE, KHAM; 1987

"We Tibetans love all ceremonial and elegant dress;
and, perhaps even more important, as a national characteristic, we love a joke.
I do not know if we always laugh at the same things as Westerners,
but we can almost always find something to laugh about. We are what Westerners call
easygoing and happy-go-lucky by nature, and it is only in the most desperate
circumstances that our sense of humor fails us."

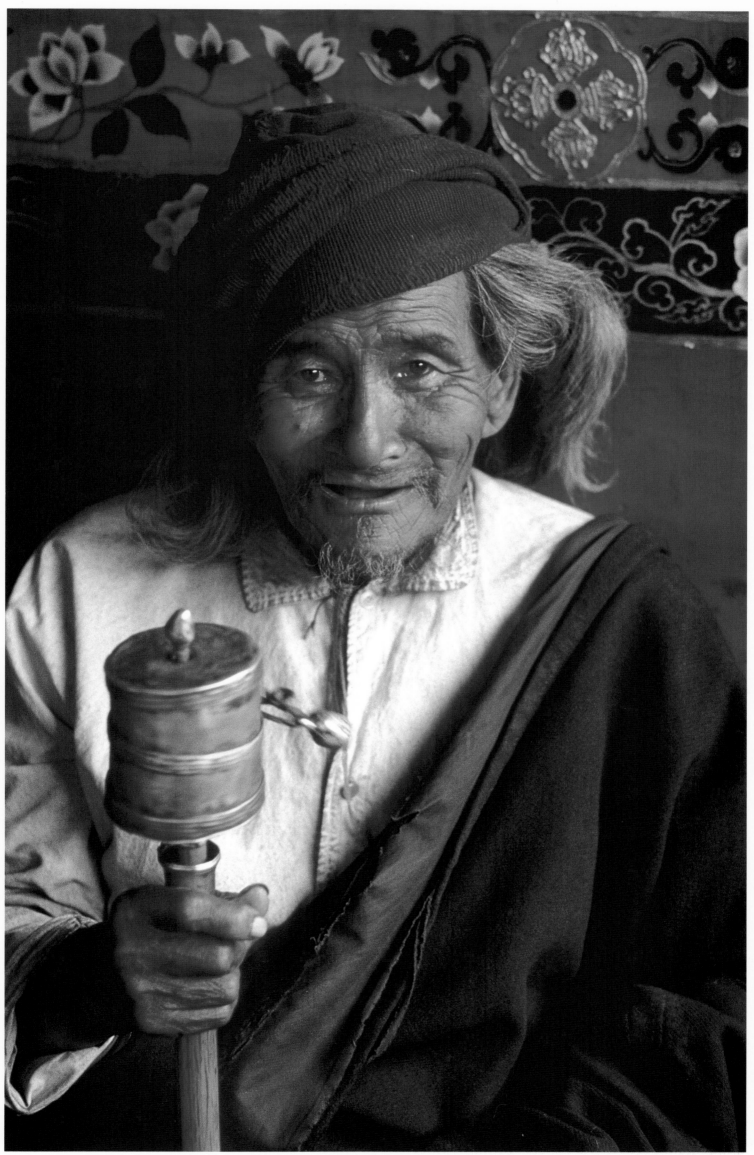

PILGRIM AT THE JOKHANG TEMPLE, LHASA; 1988

"When I first looked at this scene, I wondered what was happening here. The people's attitude does not appear normal even though their faces show compassion. I sense an urgency. I might guess that these people are having some sort of prayer-wheel-spinning competition, and, in a sense, they are."

The spinning prayer wheel is an omnipresent sign of Tibetan Buddhism. Each rotation sends forth prayers from both the engraved surface and the papers stored within. A favorite prayer, Om mani padme hum, *roughly means "Hail to the jewel in the lotus," a metaphor for the compassion within every sentient being. The prayer is an invocation for Chenrezi, the Buddha of compassion, and his earthly manifestation, the Dalai Lama.*

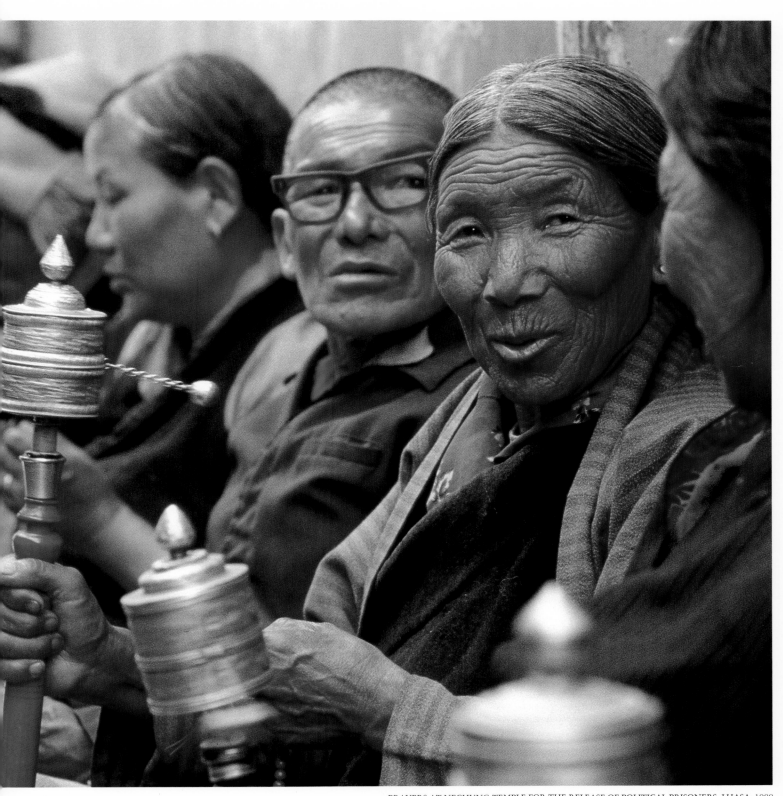

PRAYERS AT NECHUNG TEMPLE FOR THE RELEASE OF POLITICAL PRISONERS, LHASA; 1988

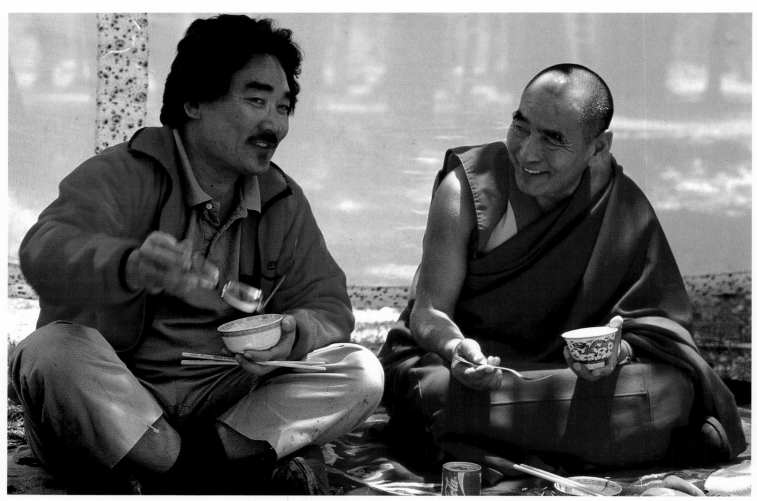

A BUSINESSMAN FROM MANHATTAN AND A TEACHER FROM WISCONSIN PICNICKING IN THE NORBULINGKA, LHASA; 1987

*"Both these men are known to me; they are
educated Tibetans living in exile in America. Their jobs and choice
of dress seem very different, but their roots are in Tibet. I'm
not surprised to see them together and happy in the garden of my old summer
palace, which I remember so well. I have long thought that
Western science and Eastern philosophy should join together to create
a really complete and full-fledged human being for the
modern world. Only in this way will we emerge strengthened from
our present condition and become whole."*

MODERN TIBETAN BOY OF LHASA GIVING ALMS TO A PROSTRATING PILGRIM; 1987

*"In Lhasa the external appearance of our culture
has changed in many ways, but, you see, internally it has remained the
same. Faith and motivation have been kept intact."*

"I try to make a distinction between the essence of Buddhism and the cultural part of Tibetan Buddhism. The essential part would be more or less the same everywhere, while the cultural part may change from country to country. So I think it may not succeed if a Westerner tries to adopt Tibetan Buddhism in its complete form, as practiced by Tibetans, in a Western society. The essence needs to be adapted to the existing condition."

The golden dharma wheel symbolizes the eight-fold path revealed by the Buddha to end suffering. Dharma is the path itself, the Buddhist way, constantly in forward motion. The eight spokes leading inward to the hub indicate that suffering is an internal rather than an external condition. They represent right understanding, aspiration, speech, conduct, vocation, effort, alertness, and concentration.

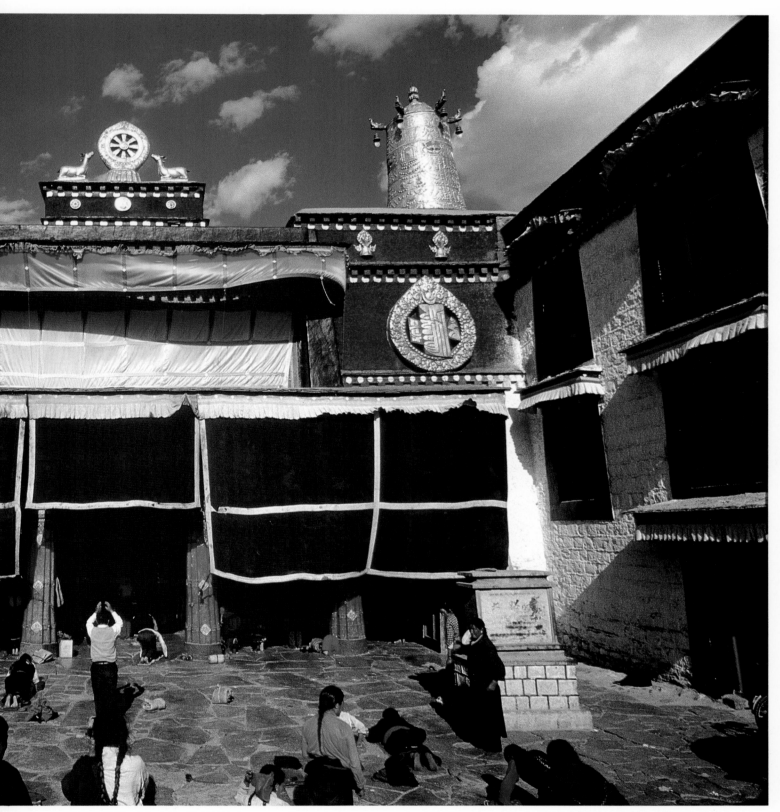

COURTYARD OF THE JOKHANG TEMPLE, LHASA; 1987

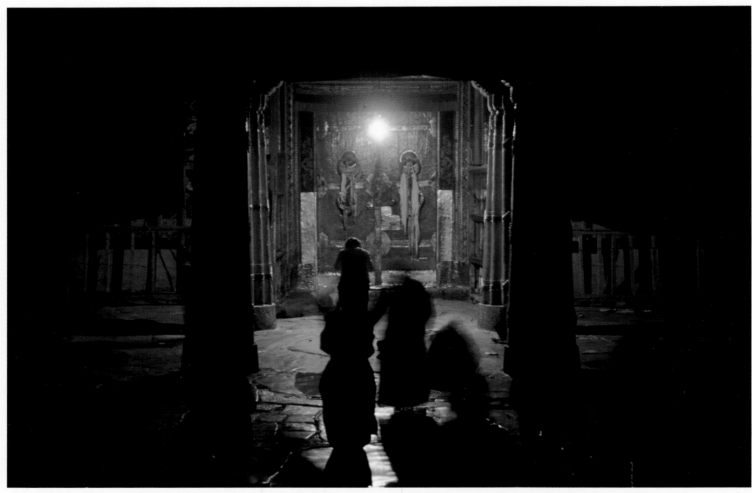

NIGHT WORSHIPPERS PROSTRATING BEFORE THE CLOSED DOORS OF THE JOKHANG TEMPLE, LHASA; 1987

"Ours is a nonviolent struggle, and it must remain so."

*Right: "We have deities that protect each of the four directions.
They date back to Buddha's time. This one, Yulkhorsoong, plays a lute
and guards the Jokhang Temple from the east."*

WALL PAINTING IN THE ENTRANCE TO THE JOKHANG TEMPLE, LHASA; 1988

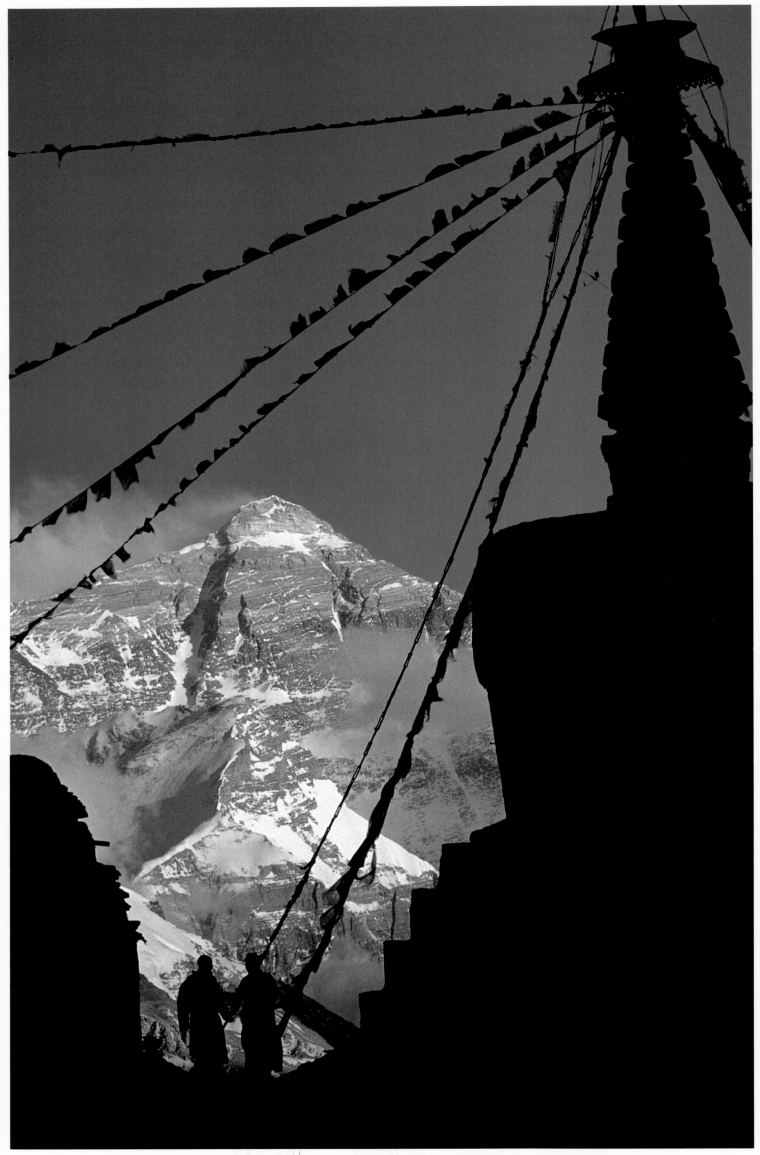

MONKS AT RONGBUK MONASTERY, BENEATH THE NORTH FACE OF CHOMOLUNGMA (MOUNT EVEREST) (29,108 FEET); 1988

TIBET AS I KNEW IT
By The Dalai Lama

"Our experience with outside contact had been disruptive.
We wanted to be left alone. It was a successful philosophy for one thousand
years, but it failed us in the mid-twentieth century."

Tibet has many neighbors: China, Mongolia, East Turkestan in the east and north, and India, Burma, and the states of Nepal, Sikkim, and Bhutan in the south. Pakistan, Afghanistan, and the Soviet Union are also close to us. For many centuries we have had relationships with several of these neighbors. With India, in particular, we have had strong religious ties during the past thousand years; indeed, our alphabet was derived from Sanskrit, because when Buddhism was brought to Tibet from India there was no Tibetan script, and a script was needed so that religious works could be translated and read by Tibetans. We also had religious and political ties with Mongolia and China. And in earlier times we had connections with Persia and eastern Turkey; there is still a resemblance between Persian and Tibetan dress. More recently, about the beginning of the twentieth century, we had political relations with Russia, and after that, for a longer period, with Britain.

But despite these neighborly relationships, Tibetans are a distinct and separate race. Our physical appearance and our language and customs are entirely different from those of any of our neighbors. We have no ethnological connection with anyone else in our part of Asia.

Perhaps the best-known quality of Tibet in the recent past was its deliberate isolation. In the world outside, Lhasa was often called the Forbidden City. There were two reasons for this withdrawal from the world. The first, of course, was that the country is naturally isolated. Until the last decade, the route from the borders of India or Nepal to Lhasa was a journey of two months across high Himalayan passes which were blocked for a large part of the year. From my birthplace in the borderland between Tibet and China, the journey to Lhasa was even longer, and that borderland itself is over a thousand miles from the sea coast and ports of China.

Isolation was therefore in our blood. We increased our natural isolation by allowing the fewest possible foreigners into our country, simply because we had had experience of strife, especially with China, and had no ambition whatever except to live in peace and pursue our own culture and religion. We thought that to hold ourselves entirely aloof from the world was the best way of ensuring peace. I must say at once that I think this policy was always a mistake, and my hope and intention are that in the future the gates of Tibet will be kept wide open to welcome visitors from every part of the world.

Tibet has been called the most religious country in the world. I cannot judge if that is so or not, but virtually all Tibetans regarded spiritual matters as no less important than material matters, and the most remarkable thing about Tibet was the enormous number of monasteries in it. There are no exact figures, but probably 10 percent of the total population were monks or nuns. This gave a dual nature to the whole of our social system. In fact, it was only in my position as Dalai Lama that lay and monastic authority were combined. I had two prime ministers, one a monk and one a layman, and below them most other offices were duplicated.

The *Khashag* (Cabinet) normally had four members, of whom one was a monk and three were lay officials. Below the Cabinet in rank were two separate offices: the *Yig-tsang* (Secretariat), headed by four monk officials who were responsible directly to the Dalai Lama and who were in charge of religious affairs, and the *Tse-khang* (Finance Office), headed by four laymen who were in charge of lay affairs of state.

The departments that any government requires—foreign affairs, agriculture, taxation, posts and telegraphs, defense, the army, and so on—were each under two or three chairmen. There were also two chief justices, and the city courts had two judges. Finally, several of the provinces of Tibet had two governors.

Outside the monasteries, our social system was feudal. There was inequality of wealth between the landed aristocracy at one extreme and the poorest peasants at the other. It was difficult to move up into the class of aristocracy, but not impossible. For example, a soldier could be awarded a title and land for bravery; both became hereditary.

However, promotion to higher ranks in the monasteries and among the monk officials was democratic. A boy could enter a monastery from any social class, and his progress there would depend on his own ability. Indeed, it might also be said that the reincarnation of high lamas had a democratic influence, because incarnate lamas often chose to be reborn in humble families, as the Thirteenth Dalai Lama did, so that men from lowly surroundings, like myself, were found in the highest positions in the monastic world.

I have mentioned soldiers. We had an army, but it was very small. Its main work was to man the frontier posts and to stop unauthorized foreigners from coming into the country. This army also formed our police force, except in the city of Lhasa, which had its own police, and in the monasteries. In Lhasa the army added military color to ceremonies and lined the route whenever I left the palaces. It had a curious history. Early in the century, when we were having trouble with the Chinese, my predecessor decided to bring the army up-to-date by employing a few foreign instructors for a short while. Nobody could tell which was the best foreign army to model it on, so he had one regiment trained by Russians, one by the Japanese, and one by the British. The British system turned out to be the most suitable, so the whole army was organized along British lines. The British instructors left Tibet during the time of the Thirteenth Dalai Lama, but up till 1949 the army still used British words of command in its drill, since there had been no such martial words in our language, and among the Tibetan marches played by its military bands were the melodies of "It's a Long Way to Tipperary," "Auld Lang Syne," and "God Save the King." But the words of these tunes, if any Tibetan ever knew them, were forgotten long ago. However, I do not want to give the impression that our army was anachronistic or absurd; it was not. It had never been brought up-to-date by being mechanized, because that was impossible. It was far too small to defend our large country against attack, but for its own limited purposes it was quite effective, and its men were brave.

I think everyone who is interested in Tibet has been able to read about life in old Lhasa, because most of the foreign travelers who have visited Tibet have made Lhasa their objective and have written books about it, so I need not dwell upon it. They have described the almost continuous round of celebrations and ceremonies from one year's end to the next; the elaborate parties given by the richer people, their beautiful and decorative dress; the holy walks around the ring road called Lingkhor; and the picnics by the river in the summer, which were perhaps the most popular pastime of all. Indeed, the travelers may have been able to describe these affairs in greater detail than I could offer from my own experience, because of course I did not share in many of them myself. Whenever I took part in ceremonies, I naturally became the focal point of them, and the essence of those ceremonies was the reverence that the people showed to me. Therefore, whenever I watched ceremonies in which I had no part, such as religious dances in the Potala or dramatic performances in the Norbulingka gardens, I watched from behind gauze curtains so that I could see without being seen. But I would like to add one general comment to the travelers' tales. We Tibetans love all ceremonial and elegant dress; and, perhaps even more important, as a national characteristic, we love a joke. I do not know if we always laugh at the same things as Westerners, but we can almost always find something to laugh about. We are what Westerners call easygoing and happy-go-lucky by nature, and it is only in the most desperate circumstances that our sense of humor fails us.

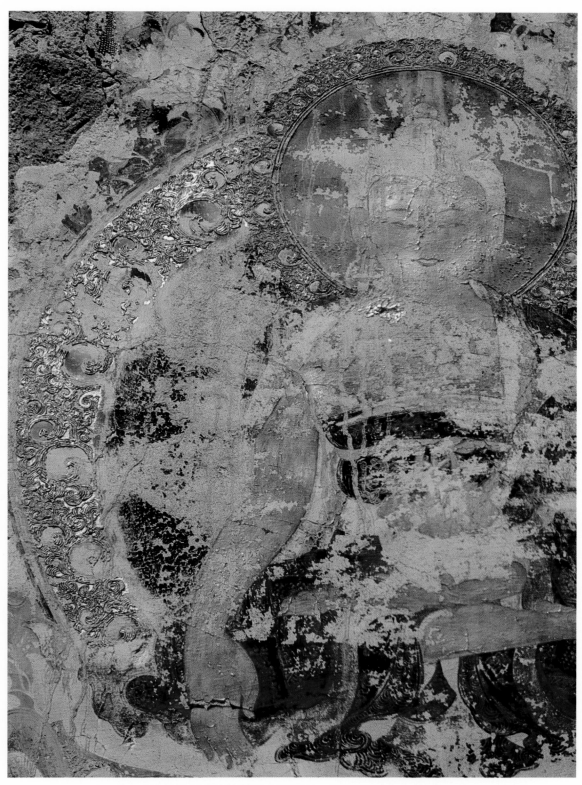

GILDED WALL PAINTING IN THE RUINS OF RONGBUK MONASTERY, BENEATH CHOMOLUNGMA (MOUNT EVEREST); 1988

*"We believe that every living thing, human
or animal, comes back to life after death. If you don't believe in
the theories of reincarnation, there is no explanation for
creation or the existence of the universe or the galaxies. Millions of
galaxies come and go. Why? What is this thing we call
consciousness or spirit? What is its source? Its basic reason? If you
accept the continuity of consciousness, you'll find
answers to these questions."*

But Lhasa was the only place where social life was so elaborate. Most people in the distant marches of Tibet had never been to Lhasa, or even perhaps met anyone else who had been there. From year to year they tilled the earth and bred their yaks and other animals, and neither heard nor saw what happened in the world beyond their own horizon. I believe there are many such people, not only in Tibet but in all poorer countries in the world, whatever their system of government.

I do not pretend that every single Tibetan was a gentle and kindly person—of course we had our criminals and sinners. To mention a single example, we had many nomads, and though most of them were peaceful, some of their clans were not above brigandage. Consequently, settled people in certain neighborhoods had to take care to arm themselves, and travelers in such places preferred to go in large companies for protection. The people who lived in the eastern district where I was born, including the Khampas, were law-abiding on the whole, but they were the kind of people to whom a rifle is almost more important than any other possession, as a symbol of manly independence. Yet the sense of religion pervaded even the wildest places and most of the wildest hearts. One would often see its symbol, too, in the poorest tents of nomads: the altar with the butter lamp before it.

During my education, I learned very little of any other social system but our own. Tibetans in general, I think, regarded it as the natural state of affairs and never gave a thought to any theories of government. But as I grew up, I began to see how much was wrong with it. Yet with all the faults of its system, and the rigor of its climate, I am sure that Tibet was among the happiest of lands. The system certainly gave opportunities for oppression, but Tibetans on the whole are not oppressive people. There was very little of the cruelty of one human to another that used to arise in the past from feudal systems, for in every class, and in all vicissitudes, religion was both a controlling influence and a constant comfort and support.

It is often said by people of other religions that belief in rebirth—the law of karma—tends to make people accept inequalities of fortune, perhaps accept them too readily. This is only partly true. A poor Tibetan peasant was less inclined to envy or resent his rich Tibetan landlord, because he knew that each of them was reaping the seed he had sown in his previous life. However, there is nothing whatever in the law of karma to discourage people from trying to improve their lot in this life. And of course our religion encourages every attempt to improve the lot of others. All true charity has a double benefit—to the receiver in his present life, and to the giver in his present life or in his life to come. In this light, Tibetans accepted our social system without any question.

And feudal though the system was, it was different from any other feudal system, because at the apex of it was the incarnation of Chenrezi, a being whom all the people, for hundreds of years, had regarded with the highest reverence. The people felt that above all the petty officials of state there was a final appeal to a source of justice that they could absolutely trust; and, in fact, no ruler with the traditions and training and religious grace of a Dalai Lama could possibly have become an unjust tyrant.

So we were happy. Desire brings discontent; happiness springs from a peaceful mind. For many Tibetans, material life was hard, but they were not victims of desire; and in simplicity among our mountains, there was more peace of mind than there is in most of the cities of the world.

WOMAN IN THE POTALA PALACE, LHASA; 1981

*"Inner peace is the key. In that state of
mind you can deal with situations with calmness and reason,
while keeping your inner happiness."*

YOUNG MONK OF SERA MONASTERY, LHASA; 1988

*"This boy might be dead now. There has been much
trouble for the monks of Sera recently. But let me look at him another way. What is
the source of his inner peace and hope? I think mainly Buddhism—the
teaching of love, kindness, tolerance, and especially the Buddhist theory that all things are relative,
which is very helpful when we are facing tragedy or any negative thing. Since each thing
is relative, there are many different aspects. If you look at only one aspect, it may be very sad, very
negative. But, at the same time, if you look at it from another aspect, you may be
able to say, 'Not so bad, not so bad, is it?'"*

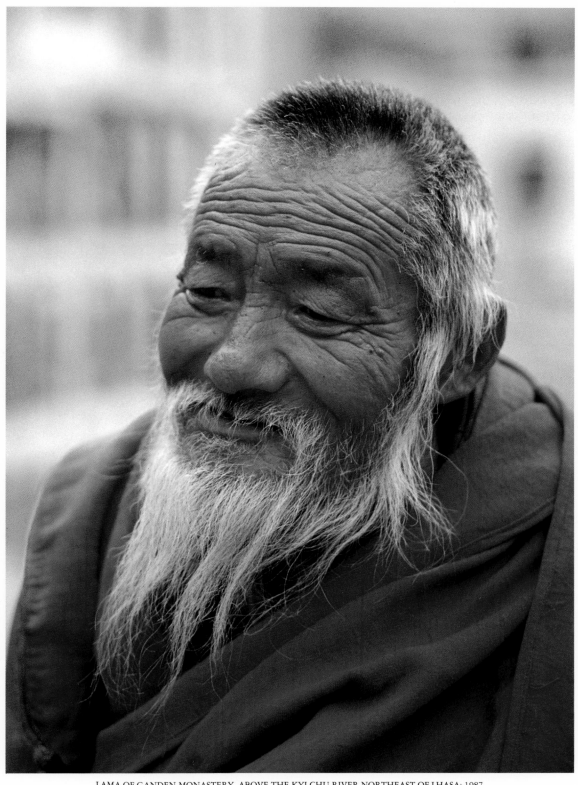

LAMA OF GANDEN MONASTERY, ABOVE THE KYI CHU RIVER NORTHEAST OF LHASA; 1987

"If we ourselves remain always angry and then sing world peace,
it has little meaning. So, you see, first our individual self must learn peace.
This we can practice. Then we can teach the rest of the world."

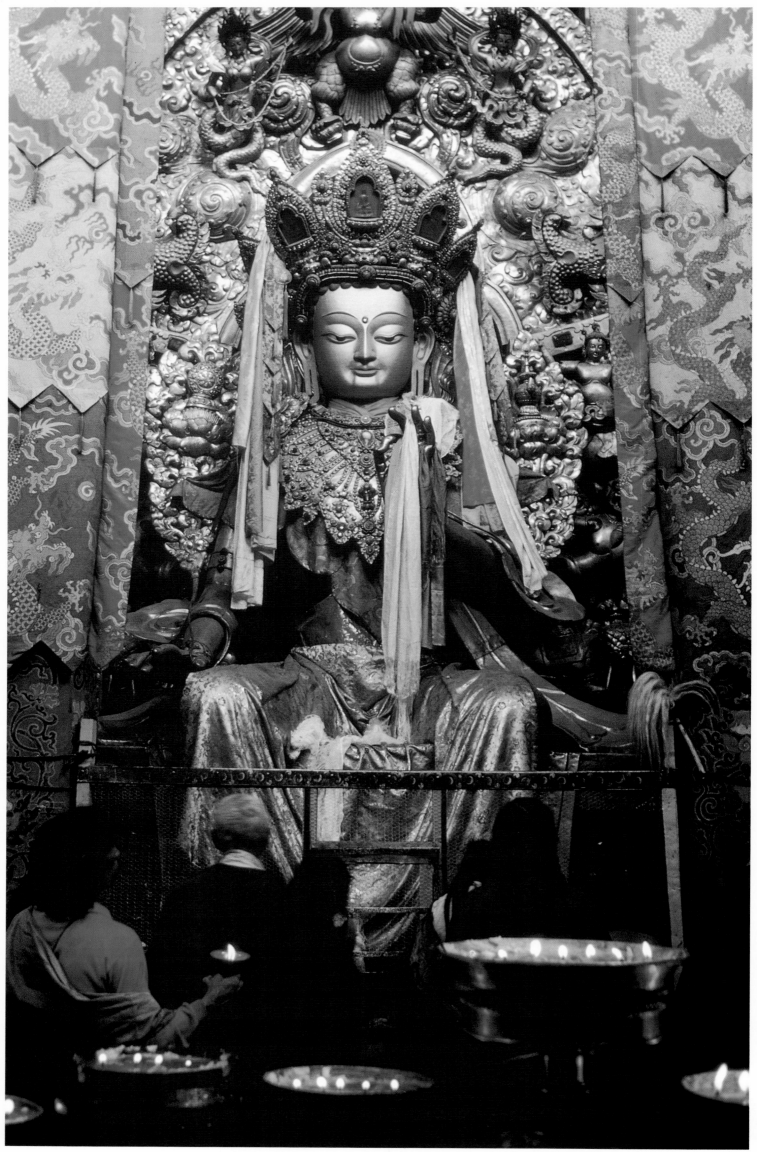

INTERIOR OF THE JOKHANG TEMPLE, LHASA; 1987

My Life in Lhasa
By The Dalai Lama

"I believe that human determination and willpower are quite
sufficient to challenge outside pressure and aggression. No matter how strong the evil
force is, the flame of truth will not diminish. No doubt you feel I am talking
of an impractical dream. However, we human beings have a developed brain and limitless
potential. Since even wild animals can gradually be trained with patience,
the human mind also can gradually be trained, step by step."

I worked hard at my religious educa- tion as a boy, but my life was not all work. I am told that some people in other countries believe the Dalai Lamas were almost prisoners in the Potala Palace. It is true that I could not go out very often because of my studies; but a house was built for my family between the Potala and the city of Lhasa, and I saw them at least every month or six weeks, so that I was not entirely cut off from family life. Indeed, I saw my father frequently, for one of the minor daily ceremonies (either in the Potala or the Norbulingka, the summer palace) was the morning tea ceremony, when all the monk officials met for their early bowls of tea—and both my father and I often attended this meeting. Despite our changed circumstances, he still kept up his interest in horses. He would still go out to feed his own horses every morning before he took any food himself, and now that he could afford it, he gave them eggs and tea to strengthen them. And when I was in the summer palace—where the Dalai Lama's stables were situated—and my father came to see me there, I think he often went to call on my horses before he came to call on me.

Most of my boyhood was spent in the company of grown-up men, and inevitably there must be something lacking in a childhood without the constant company of one's mother and other children. However, even if the Potala had been a prison for me, it would have been a spacious and fascinating prison. It is said to be one of the largest buildings in the world. Even after living in it for years, one could never know all its secrets. It entirely covers the top of a hill; it is a city in itself. It was begun by a king of Tibet thirteen hundred years ago as a pavilion for meditation, and it was greatly enlarged by the Fifth Dalai Lama in the seventeenth century of the Christian era. The central part of the present building, which is thirteen stories high, was built on his orders, but he died when the building had reached only the second story. When he knew that he was dying, he told his prime minister to keep his death a secret, because he feared that if it were known that he was dead, the building would be stopped. The prime minister found a monk who resembled the Dalai Lama and succeeded in concealing the death for thirteen years, until the work was finished, but he secretly had a stone carved with a prayer for a reincarnation and had it built into the walls. It can still be seen on the second story today. This central part of the building contained the great halls for ceremonial occasions, about thirty-five chapels richly carved and painted, four cells for meditation, and the mausoleums of seven Dalai Lamas—some thirty feet high and covered in solid gold and precious stones.

The western wing of the building, which is of a later date, housed a community of 175 monks, and in the eastern wing were the government offices. My own apartments were above the rooms there. The one which I used most often was about twenty-five feet square, and its walls were entirely covered by paintings depicting the life of the Fifth Dalai Lama, so detailed that the individual portraits were not more than an inch high. When I grew tired of my reading, I often used to sit and follow the story told by this great and elaborate mural that surrounded me.

Apart from its use as an office, temple, school, and habitation, the Potala was also an enormous storehouse. There were rooms full of thousands of priceless scrolls, some a thousand years old. There were strong rooms filled with the golden regalia of the earliest kings of Tibet, dating back a thousand years, and the sumptuous gifts they received from the Chinese or Mongol emperors, and the treasures of the Dalai Lamas who succeeded the kings. There also were stored the armor and armament from the whole of Tibetan history. In the libraries were all the records of Tibetan culture and religion, seven thousand enormous volumes, some of which were said to weigh eighty pounds. Some were written on palm leaves imported from India a thousand years ago. Two thousand illuminated volumes of the scriptures were written in inks made of powdered gold, silver, iron, copper, conch shell, turquoise, and coral, each line in a different ink.

Down below the building there were endless underground storehouses and cellars, containing government stocks of butter, tea, and cloth that were supplied to the monasteries, the army, and government officials. At the eastern end was a prison for wrongdoers of high rank—corresponding perhaps to the Tower of London. And on the four corners of the building were defensive turrets where the Tibetan army used to keep watch.

In these unique surroundings I pursued my studies and also pursued my childish interests. I was always fascinated by mechanical things, but there was nobody who could tell me anything about them. When I was small, kind people who knew of this interest sometimes sent me mechanical toys, such as cars and boats and airplanes. But I was never content to play with them for long—I always had to take them to pieces to see how they worked. Usually I managed to put them together again, though sometimes, as might be expected, there were disasters. I had a set of Mecanno, and I built cranes and railroad cars with it long before I had ever seen such things. Later on, I was given an old movie projector that was operated by turning a handle, and when I took that to pieces I found the batteries that worked its electric light. It was my first introduction to electricity, and I puzzled over the connections all alone until I found the way to make it go. I had a success, though this was later, with my wristwatch. I took that entirely to pieces, to study its principles, and it still worked when I put it together again.

In the Potala, each year began with a ceremony on the highest roof before sunrise on New Year's Day (a bitterly cold occasion, when I was not the only one who thought with longing of the tea ceremony later in the morning), and religious activities continued day by day throughout the year until the great Dance of the Lamas the day before New Year's Eve. But in the spring I, myself, and my tutors and attendants and some of the government departments moved to the Norbulingka, in a procession that all the people of Lhasa came to see. I was always happy to go to the Norbulingka. The Potala made me proud of our inheritance of culture and craftsmanship, but the Norbulingka was more like a home. It was really a series of small palaces, and chapels, built in a large and beautiful walled garden. Norbulingka means "The Jewel Park." It was started by the Seventh Dalai Lama in the eighteenth century, and successive Dalai Lamas have added their own residences to it ever since. I built one there myself. The founder chose a very fertile spot. In the Norbulingka gardens we grew a radish weighing twenty pounds, and cabbages so large you could not put your arms around them. There were poplars, willows, junipers, and many kinds of flowers and fruit trees: apples, pears, peaches, walnuts, and apricots. We introduced plums and cherry trees while I was there.

There, between my lessons, I could walk and run among the flowers and orchards, and the peacocks and the tame musk deer. There I played on the edge of the lake and twice nearly drowned myself. And there, also in the lake, I used to feed my fish, which would rise to the surface expectantly when they heard my

LIBRARY AT DREPUNG MONASTERY, LHASA; 1981

*"After 1959, much of Drepung's library of scriptures
was saved by one local leader, who remained devout and absolutely loyal
to Buddhism through the hardest times. Besides translations of the
108 volumes of the Kangyur, there were 225 other volumes translated from
Sanskrit. But, you see, I was not so lucky. In my library in the
Potala I had more than fifty irreplaceable Indian manuscripts that were
more than one thousand years old. When I left suddenly
in 1959, they disappeared. No copies, no hope."*

footsteps. Thinking about them, I sometimes also wonder whether my fish were so unwise as to rise to the surface when they first heard the boots of Chinese soldiers in the Norbulingka. If they did, they have probably been eaten.

One of the minor pleasures of the Norbulingka was that it had a motor generator for electric light, which often broke down, so that I had every excuse to take it to pieces. From that machine I discovered how internal combustion engines work, and also noticed how the dynamo created a magnetic field when it turned—and I must say that I managed to mend it more often than not.

I tried to make use of this knowledge on three old motor cars, the only ones in Lhasa. There were two 1927 Baby Austins, one blue and the other red and yellow, and a large 1931 Dodge, painted orange. They had been presented to my predecessor and carried over the Himalaya in pieces and then reassembled. However, they had not been used since his death and had stood and been allowed to rust. I longed to make them work. At last I found a young Tibetan who had been trained as a driver in India, and with my eager assistance he managed to put the Dodge in working order, and also one of the Austins, by borrowing parts from the other. These were exciting moments.

I was curious also about the affairs of the world outside Tibet, but naturally much of that curiosity had to go unsatisfied. I had an atlas, and I pored over maps of distant countries and wondered what life was like in them, but I did not know anyone who had ever seen them. I started to teach myself English out of books, because Britain was the only country beyond our immediate neighbors with which we had friendly ties. My tutors read in a Tibetan newspaper, which was published in Kalimpong in India, of the progress of the Second World War, which started in the year I was taken to Lhasa, and they told me about it. Before the end of the war, I was able to read such accounts myself. But few world events affected us in Lhasa. I have sometimes been asked if we followed with interest the attempts of the British to climb Mount Everest. I cannot say that we did. Most Tibetans have to climb too many mountain passes to have any wish to climb higher than they must. And the people of Lhasa, who sometimes climbed for pleasure, chose hills of reasonable size—and when they came to the top, burned incense, said prayers, and had picnics. That is a pleasure I also enjoy when I have an opportunity.

All in all, it was not an unhappy childhood. The kindness of my teachers will always remain with me as a memory I shall cherish. They gave me the religious knowledge that has always been and will always be my greatest comfort and inspiration, and they did their best to satisfy what they regarded as a healthy curiosity in other matters. But I know that I grew up with hardly any knowledge of worldly affairs, and it was in that state, when I was sixteen, that I was called upon to lead my country against the invasion of communist China.

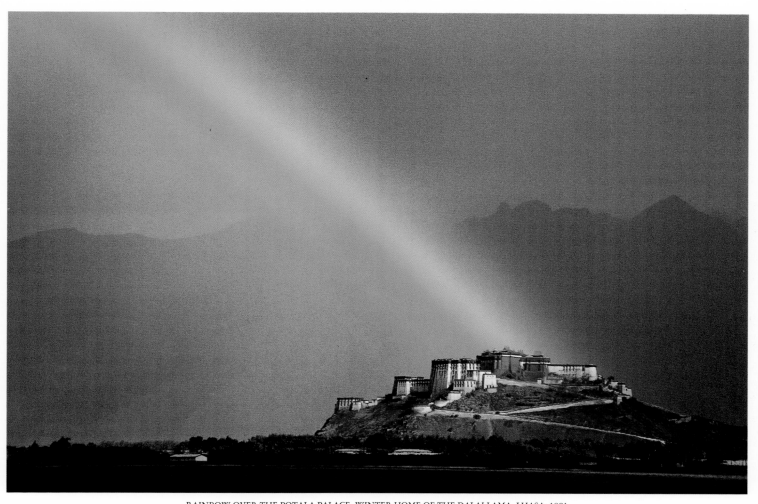

RAINBOW OVER THE POTALA PALACE, WINTER HOME OF THE DALAI LAMA, LHASA; 1981

*"That's the hill where my cars
broke down. The steep road up to the palace stopped all
three of them—two Austins and a Dodge."*

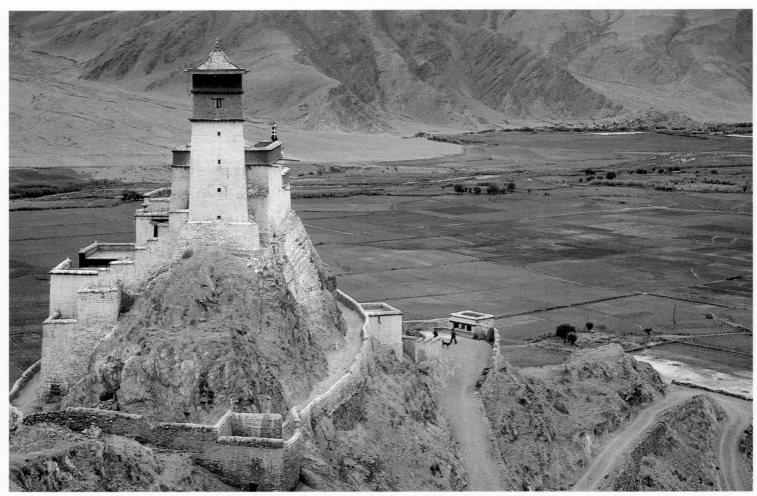

YAMBULAKANG, HOME OF THE YARLUNG KINGS, NEAR TSETHANG; 1987

*"Tibetan history goes back at least four thousand years.
There were more than twenty kings before Buddhism came, but our knowledge of them
is very sketchy. Because there has been so much emphasis on Buddhism—
too much, I think—our history mainly records events after Buddhism came, not before.
Yambulakang is our oldest known building, the first fort in Tibet. Many kings
lived there before, according to legend, the first Buddhist scriptures fell out of the sky onto
the roof of the fort. I'm not sure it happened that way. You see, the scriptures
may have been brought from India. At that time, though, it might have been difficult to
explain why Tibetans should heed words brought from a foreign land,
so it was said that they fell out of the sky."*

*Right: "Throughout Tibet, monasteries are
being rebuilt by volunteer labor. Donations for supplies come from ordinary Tibetan
people, who often live far away. Amdo people have been paying to rebuild
places in Lhasa, for example. As a* chorten *or temple nears completion, the government
often adds a small grant and takes the credit in the press."*

116

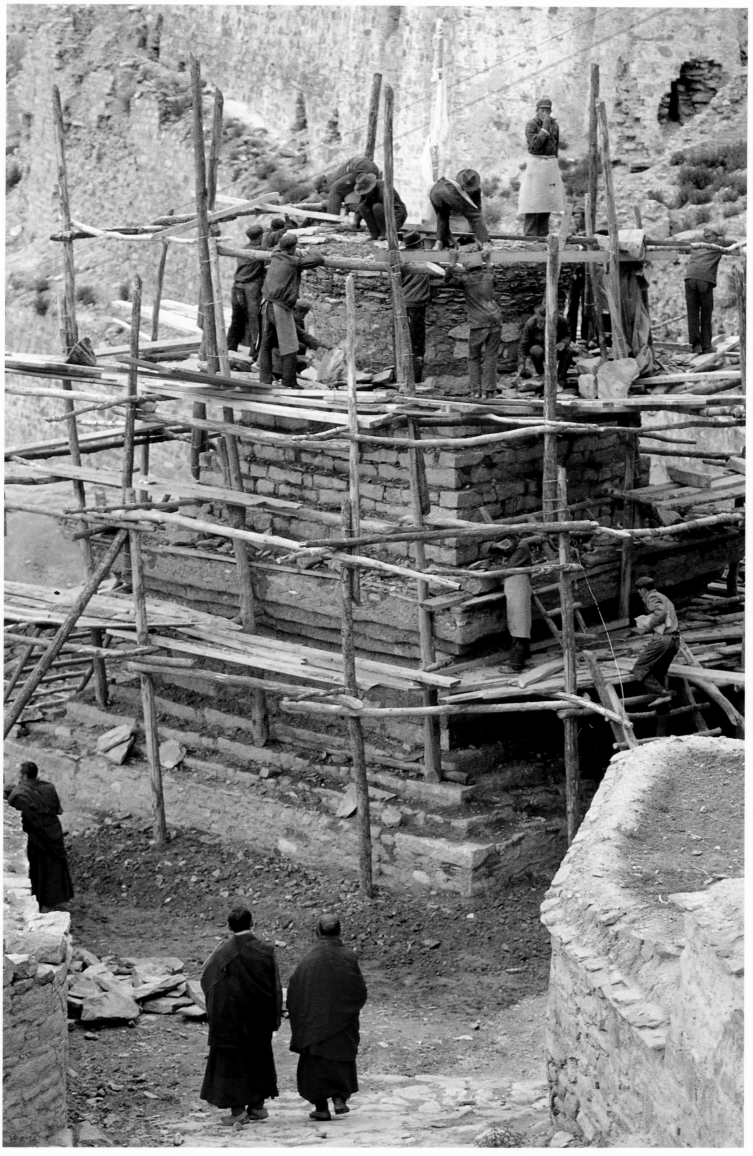

VOLUNTEERS REBUILDING THE MAIN *CHORTEN* OF GANDEN MONASTERY, NORTHEAST OF LHASA; 1987

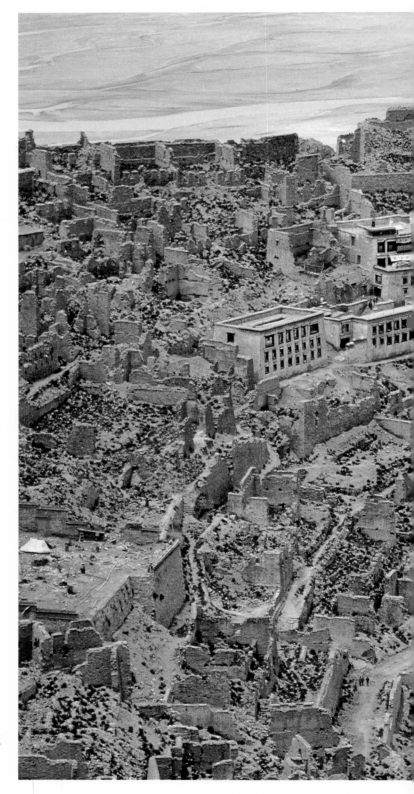

*"I went to Ganden twice. One of our biggest
monasteries, it was founded by Lama Tsongkhapa, who was born at
Kumbum, near my birthplace. Beside the big red building,
the main meeting hall, is a smaller red one, where I stayed when I visited.
It is the residence of the Ganden Tipa, head of the Gelukpa sect.
Originally, it was the abode of Tsongkhapa."*

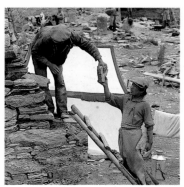

*When edicts banning religious expression
were relaxed in the early 1980s, Tibetan
volunteers started to rebuild Ganden.
During a new bout of repression in 1983,
troops converged on Ganden, where they
seized 370 workers and monks. Several
Tibetans were killed as they were beaten
and thrown into trucks. At left daring
volunteers continue the rebuilding effort
in 1987.*

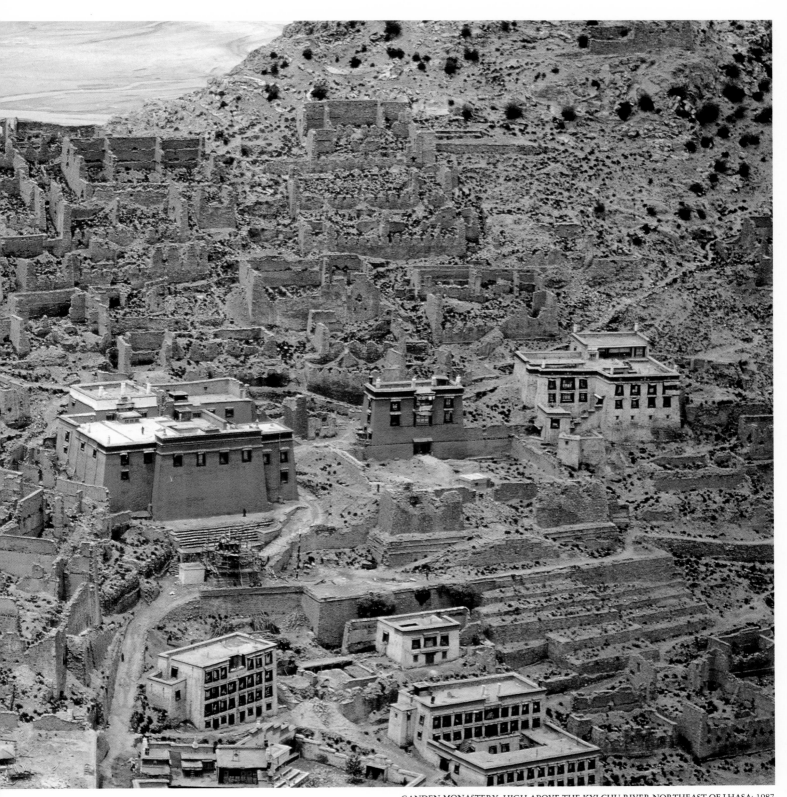

GANDEN MONASTERY, HIGH ABOVE THE KYI CHU RIVER NORTHEAST OF LHASA; 1987

SUNBEAMS POUR INTO SAMYE MONASTERY, NEAR TSETHANG, DURING A CEREMONY; 1987

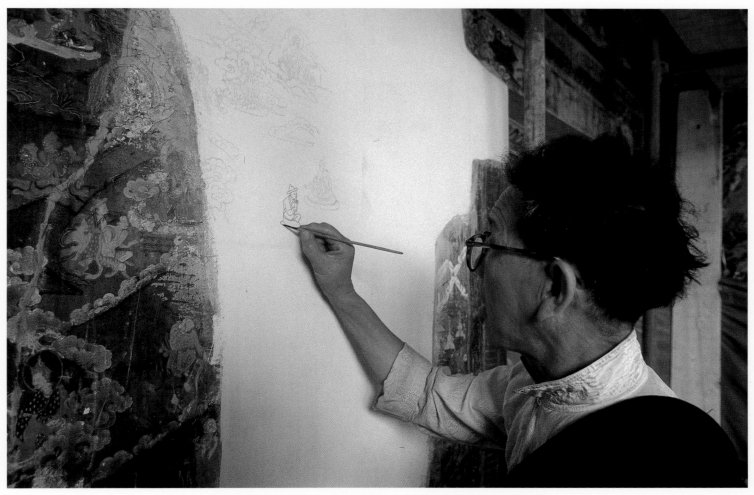

RESTORING WALL PAINTINGS AT SAMYE MONASTERY, NEAR TSETHANG; 1987

*"Samye was the first monastery in Tibet,
founded by two Indian scholars, Padmasambhava and Shantarakshita
in the year 770. Although Buddhism had already begun
to spread in Tibet, during Padmasambhava's era it became established.
Tibetan translations from Sanskrit began, and monastic
institutions were introduced. Thus we consider Samye the place where
the establishment of Buddhism in Tibet took a firm grounding."*

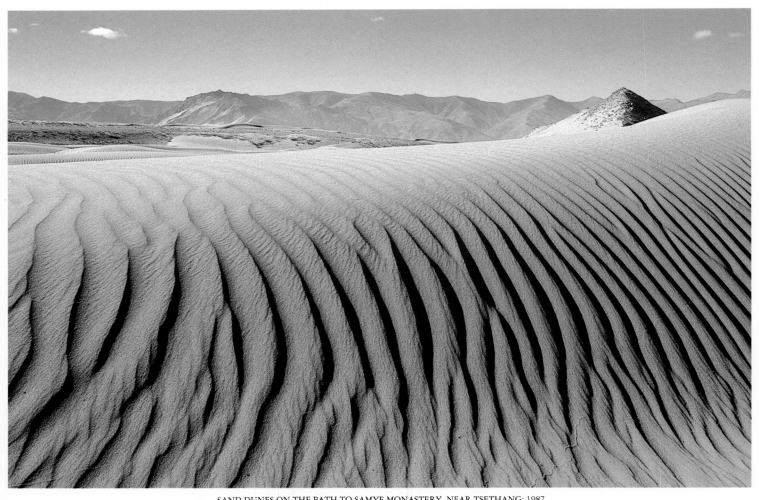

SAND DUNES ON THE PATH TO SAMYE MONASTERY, NEAR TSETHANG; 1987

"When Tsongkhapa came to Samye in the
fourteenth century, he mentioned how he slid down the sand
dunes on his way downhill. As I was escaping from
Tibet in 1959, I remembered Tsongkhapa and tried the same thing.
Except for some sand in my shoes, it was a fast and
most enjoyable mode of travel."

SAND DUNES AT SUNRISE ALONG THE TSANGPO RIVER BETWEEN SAMYE MONASTERY AND TSETHANG; 1987

*"This part of Tibet makes you think that my
country should be called the Land of the Sands instead of the
Land of the Snows. I crossed the Tsangpo near here in a
yak-skin boat on my way to India in 1959. I had always wanted to
visit Samye Monastery, and I was sad that we were in
too much of a hurry to do so."*

"When I crossed the Tsangpo near here in 1959,
it was cloudy with strong winds, and the sky was filled with dust.
The river had waves the way an ocean does."

STORM OVER THE TSANGPO RIVER, NEAR TSETHANG; 1987

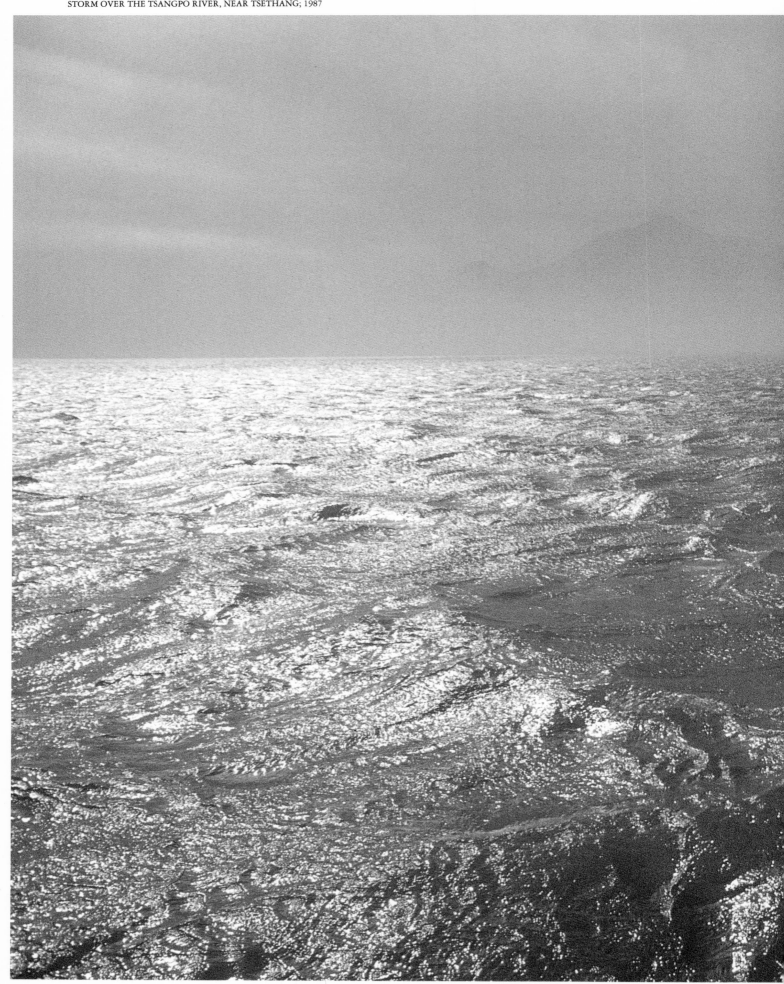

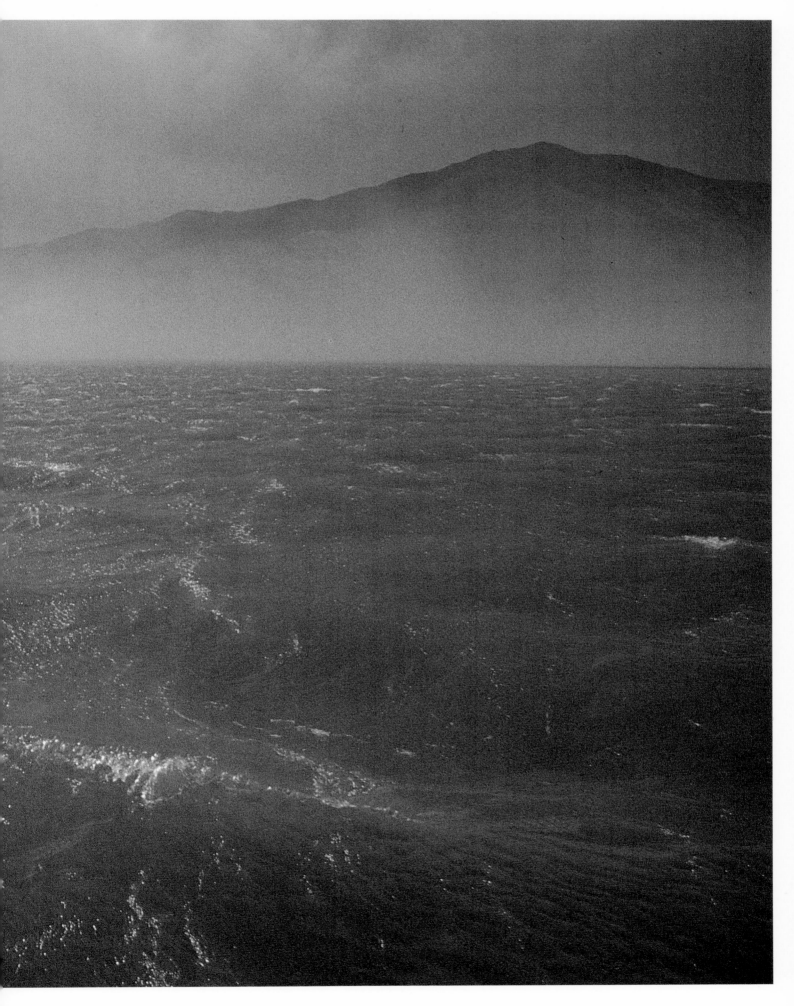

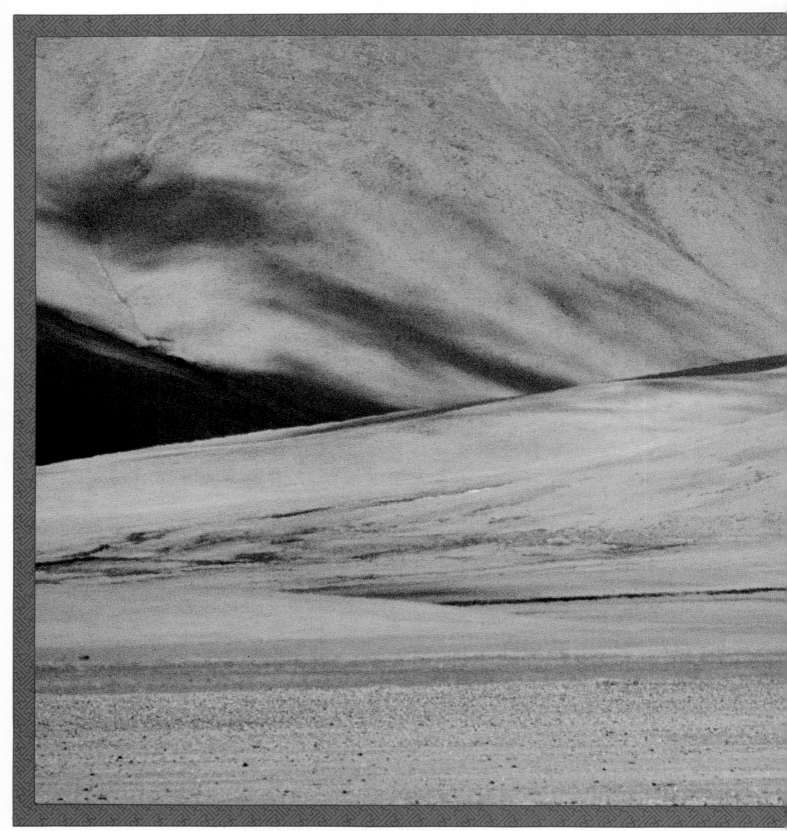

PILGRIM CARAVAN BOUND FOR KANGRINPOCHE (MOUNT KAILAS) (22,028 FEET), WESTERN TIBET; 1987

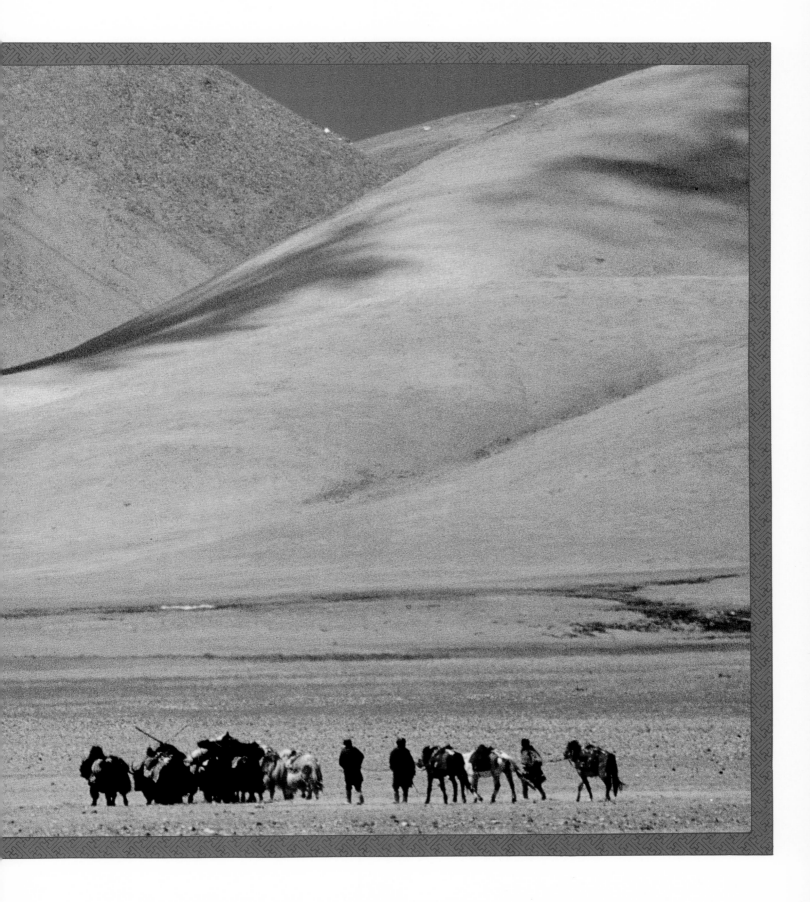

*"Everything depends on one's own karma. This means that
one's life situation in the present depends on one's actions and motivations in
the past and that one's future is thus capable of being molded through
one's actions and motivations in the present."*

Mount Kailas—The Center of the Universe

Kangrinpoche, known to the outside world as Mount Kailas, has been considered sacred by Buddhists, Hindus, Jains, and Bonpos for thousands of years. For Hindus it is the center of the universe. A pilgrimage to the mountain and around it is such a supreme goal for the faithful that India's first prime minister, Jawaharlal Nehru, expressed regret on his deathbed that he would never reach Kailas. The Buddhist center of the universe is the mythical Mount Meru, and its earthly representation is Kangrinpoche.

After 1959, the Chinese stopped all pilgrimages for two decades, but today thousands of pilgrims once again trek overland for months, carrying only a few possessions, to reach the base of the peak. From there they begin the sacred *kora*, or circumambulation, along a thirty-four-mile path that climbs to 18,600 feet. Some pilgrims do more than one *kora*, and legend has it that a person who makes 108 *koras* achieves nirvana, the ultimate clear state of Buddhahood.

Kangrinpoche dominates an auspicious part of western Tibet in a bold and unique way, though it is only a middle-sized peak of 22,028 feet. The geography of Kangrinpoche reinforces its spirituality. As I approached it, I wrote in my journal: "We seem to be riding on the bones of the earth, elevated above the soft body of the world. It is easy to understand how pilgrims, walking overland for weeks or months, feel they are approaching the center of the universe." Since ancient times, Kangrinpoche has been revered as the source of four of the great rivers of Asia, fueled by the waters of nearby Lake Manasarovar. Indeed, four great rivers that cut through the Himalaya and go their separate ways—the Indus, Brahmaputra (Tsangpo), Karnali (which eventually becomes the sacred Ganges), and Sutlej—have their sources within sixty miles of the mountain.—*Galen Rowell*

MOONRISE OVER KANGRINPOCHE (MOUNT KAILAS) (22,028 FEET), WESTERN TIBET; 1987

*"A pilgrimage is not a required act. Many ordinary
people, especially those who find religion difficult to practice in a devout
way in their normal lives, set off on long journeys with the
hope of communicating virtue and gaining merit."*

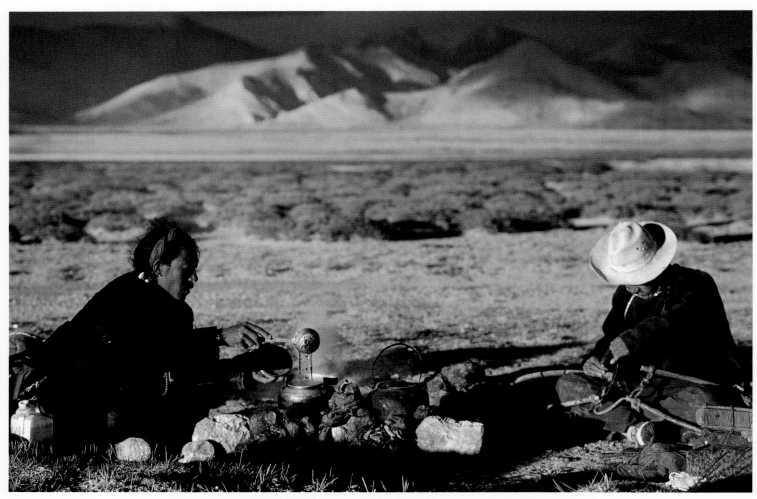

PILGRIM CAMP EN ROUTE TO KANGRINPOCHE (MOUNT KAILAS) (22,028 FEET), WESTERN TIBET; 1987

*"Tibetans going long distances usually
leave very early in the morning and camp before the afternoon winds come up.
They sit down, have tea, and enjoy the land."*

Right: "He is reciting a mantra until his tea boils."

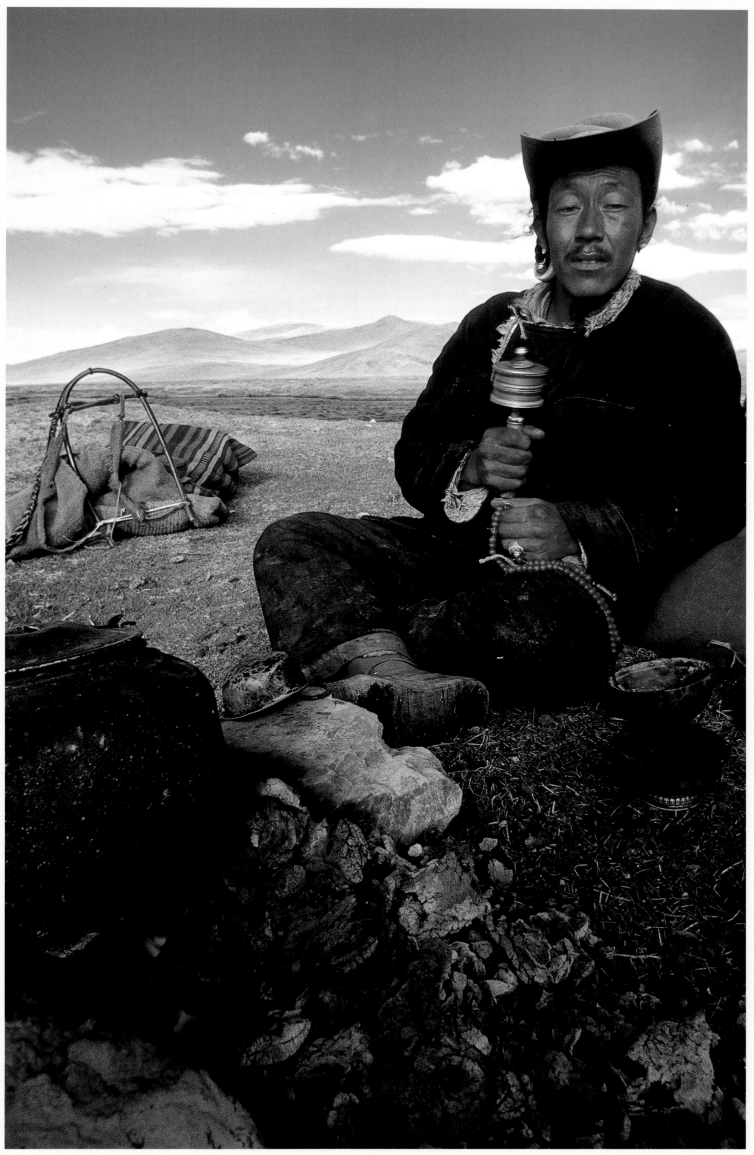

PILGRIM TRAVELING TO KANGRINPOCHE, WESTERN TIBET; 1987

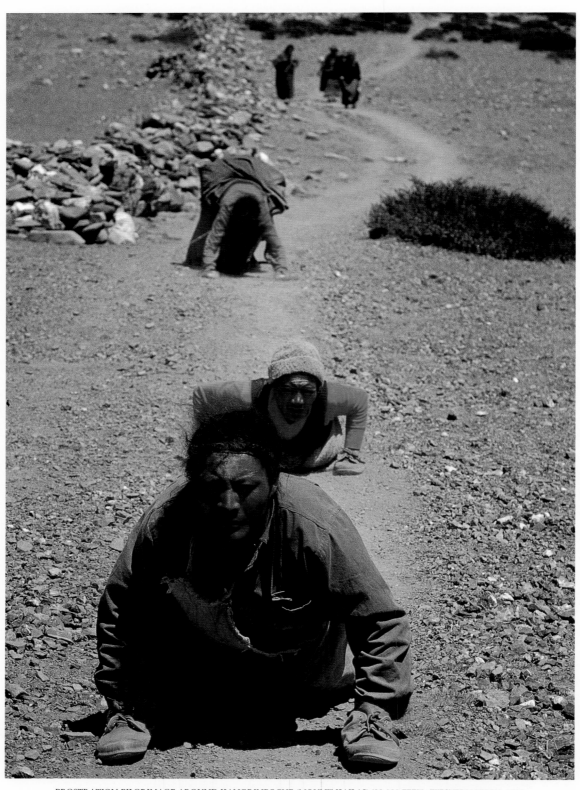

PROSTRATION PILGRIMAGE AROUND KANGRINPOCHE (MOUNT KAILAS) (22,028 FEET), WESTERN TIBET; 1987

"Pilgrimage by prostration takes a strong sense of motivation
and purpose, which results in great accumulation of merit for the pilgrim. Khampas
from eastern Tibet sometimes take years to complete a long pilgrimage,
prostrating every foot of the way. When you walk a circular pilgrimage route, such as this one around
Mount Kailas, your feet touch the earth with big spaces between them, but when
you prostrate, your whole body connects with the sacred ground to close the circle. So, you see,
it is not just the hardship that brings the extra reward."

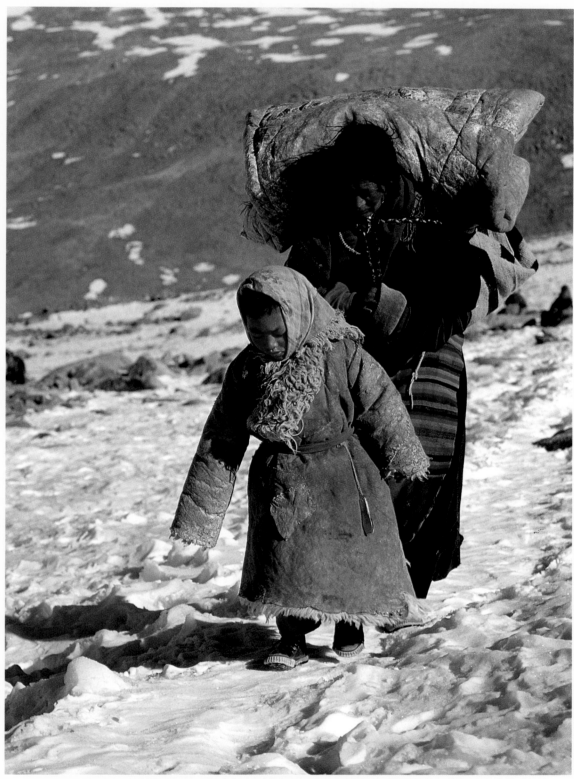

MOTHER AND CHILD CRESTING THE DOLMA LA AT 18,600 FEET ON THE PATH AROUND KANGRINPOCHE, WESTERN TIBET; 1987

*"This child of western Tibet may not have much understanding
of what a pilgrimage is about, but, you see, we Buddhists believe that merit is accumulated when
you take part in something religious even though it may be without full understanding.
Internally, the proper attitude is being shaped."*

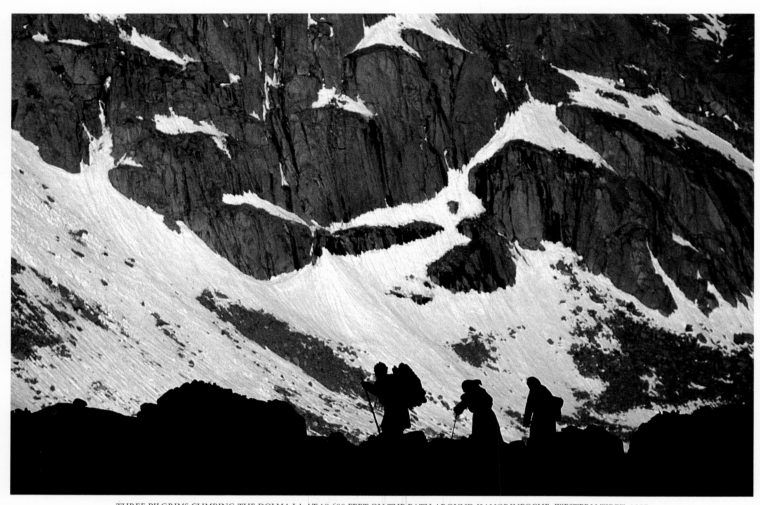

THREE PILGRIMS CLIMBING THE DOLMA LA AT 18,600 FEET ON THE PATH AROUND KANGRINPOCHE, WESTERN TIBET; 1987

"We are visitors on this planet. We are here for ninety
or one hundred years at the very most. During that period, we must try to do something
good, something useful, with our lives. Try to be at peace with yourself,
and help others share that peace. If you contribute to other people's happiness, you will find
the true goal, the true meaning of life."

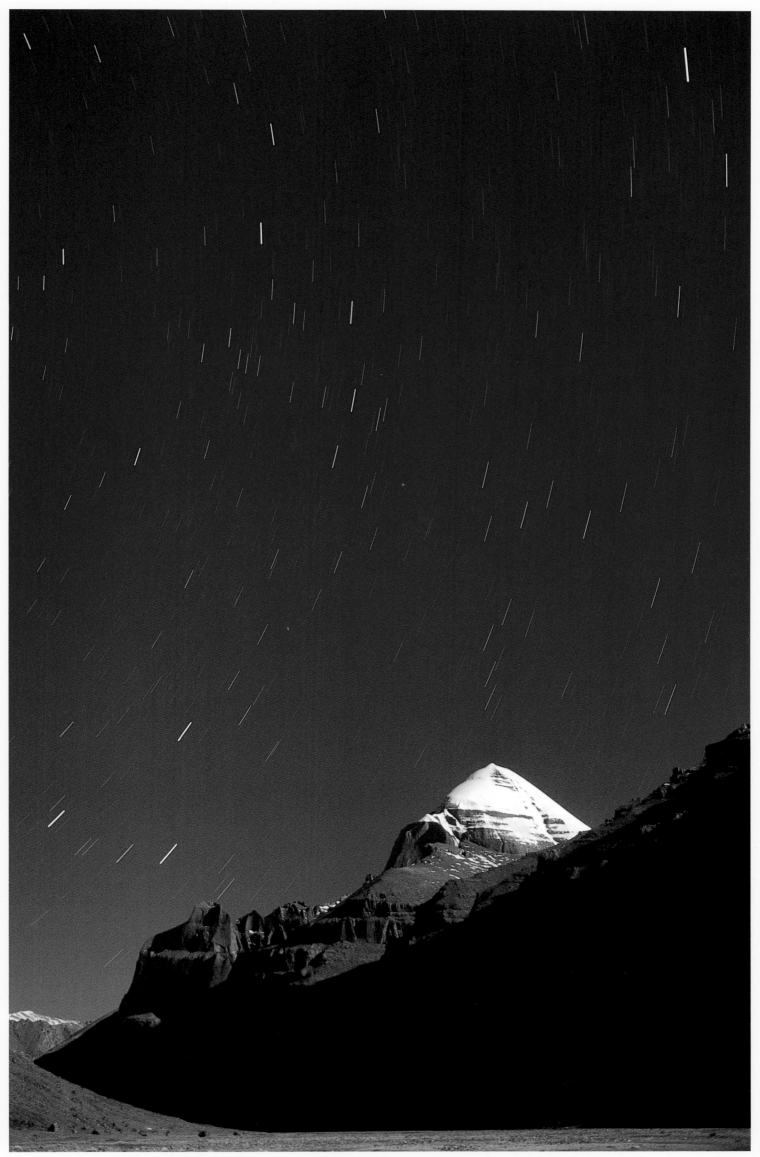

STAR STREAKS OVER MOONLIT KANGRINPOCHE (MOUNT KAILAS) (22,028 FEET), WESTERN TIBET; 1987

*"Since the practice of Buddhism
involves seeing external phenomena as empty of inherent existence,
as in a dream, it is helpful to be in a place
where one can see vast, empty space."*

MOONRISE OVER THE PARYANG VALLEY OF WESTERN TIBET; 1987

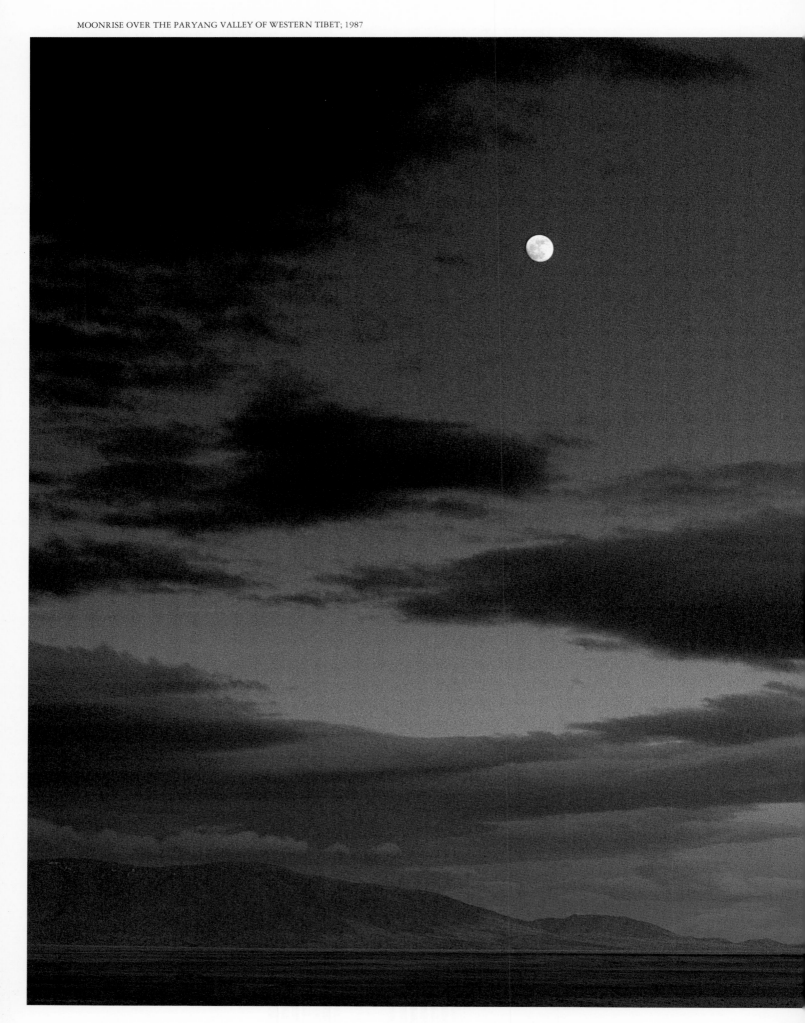

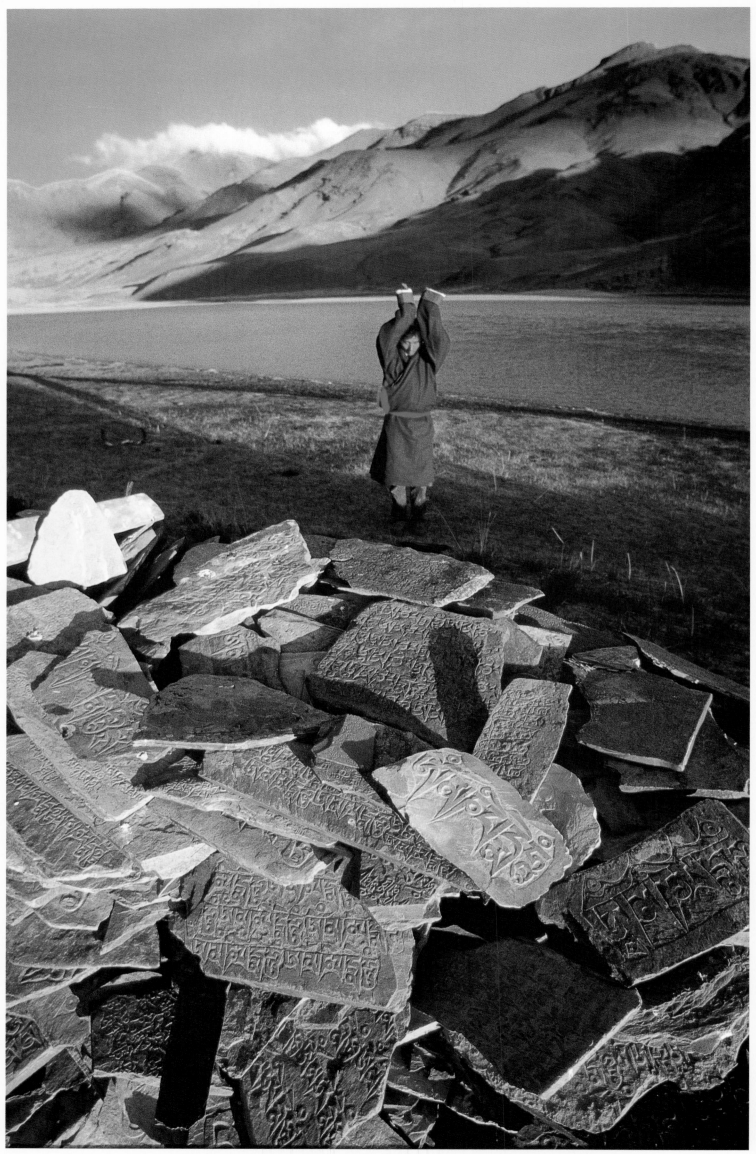

PILGRIM PRAYING AT A *MANI* WALL BESIDE THE TSANGPO RIVER IN WESTERN TIBET; 1987

THE MEANING OF PILGRIMAGE
By The Dalai Lama

"Nobody can understand Tibet without some
understanding of our religion."

Motivation is what separates a pilgrimage from ordinary travel. Take, for example, two Tibetans from the Kham area of eastern Tibet traveling months overland to reach Lhasa. They may look much the same, eat the same food, and expend the same amount of energy over the same long period of time, but if one man is motivated mainly to do business, to buy and sell things, his every stop, his every movement, is different from that of the other man, whose motivation is mainly spiritual. This other person is undertaking hardship for no material reward. In his mind he may be seeing Lhasa's main cathedral, the Jokhang. His every step, his every movement, will communicate virtue and allow him to accumulate religious merit.

A pilgrimage is not a required act. It comes from the heart. Each person knows his or her own motivation. Proper religious practice is not always necessary. To the contrary, if people are so highly developed spiritually that they can practice their religions effectively by staying in one place, even in some unholy place, then a pilgrimage may not be important for them. Such extremely devout and spiritually developed persons are already on the right track without seeking out a pilgrimage path.

Many ordinary people, however, especially those who find religion difficult to practice in a devout way in their normal lives, set off on long journeys with the hope of communicating virtue and gaining merit. Sometimes they do some business along the way. There is no problem with that so long as their primary motivation is pilgrimage.

Many pilgrims from remote areas arrive in Lhasa with butter to sell. A key indication of their earnestness in undertaking the pilgrimage is that once they reach Lhasa they usually abstain from drinking tea or selling their goods until they have gone to the Jokhang, the main cathedral, to receive blessings from the statue of Jowo Rinpoche.

Deep faith and religious knowledge are not necessary when making a pilgrimage. A child may not have much understanding of what a pilgrimage is about, but, you see, we Buddhists believe that merit is accumulated when you take part in something religious even without full understanding. Internally, the proper attitude is being shaped.

Some pilgrimages are journeys to and from a holy place, but many of the most traditional routes are circumambulations around a holy place. These can be very long, such as a path around a holy mountain, or very short, such as a circle around a small shrine.

My senior tutor once visited a stupa where many people do *koras*, or circles around the shrine, usually in their bare feet. He decided to perform one hundred thousand *koras* around the stupa. Being quite heavily built and not used to walking in his bare feet, the poor man developed serious blisters. During the days, as he walked with his concentration held away from direct awareness of self and surroundings, he didn't feel the blisters much at all, but each evening after he stopped, they became very painful.

He completed the one hundred thousand barefoot *koras* by controlling suffering through his mind. The purpose of going barefoot and doing so many repetitions was to experience more hardship, express more virtue, and gain more *sonam*, or spiritual merit.

Another way to gain more merit is to make the pilgrimage by prostration instead of ordinary walking. This not only increases hardship, but also closes the entire circle on the ground with contact from the pilgrim's whole body, rather than with just footsteps, which have open spaces between them.

With the right motivation, any journey to or around a spiritual place becomes a pilgrimage. Some of the places of pilgrimage are ancient and well known, such as Lhasa or Kailas, but others gradually evolve through local tradition. Travelers in Tibet traditionally place piles of stones at the top of hills or passes. Later, *mani* stones carved with prayers and other important scriptures may be added along with prayer flags. Eventually, the place itself could become a shrine where travelers circumambulate or say prayers before continuing on their journeys. Then the shrine may become the sole object of the journey.

Many pilgrims visit places where highly devout spiritual masters spent time in the past. The presence of that person makes the place seem somehow blessed or charged, as if there is some kind of electricity around it. Pilgrims come to feel these mysterious vibrations and to try to see some of the same visions the devout master saw.

Since the practice of Buddhism involves seeing external phenomena as empty of inherent existence, as in a dream, it is helpful to be in a place where one can see vast, empty space. From a high mountain, much empty space is easily seen. Similarly, a pilgrimage through wild, open lands provides visions that help shape the proper attitude and inner awareness for religious practice. Many of our monasteries and shrines are built in auspicious places. In some cases the certain shape of a mountain or the curve of a river provides, as we say, a positive indication of negative significance. This is particularly true of small monasteries or hermitages built where people were more concerned with practice than study. So, you see, our tradition of pilgrimage is related both to Buddhism and to the special character of Tibet's environment.

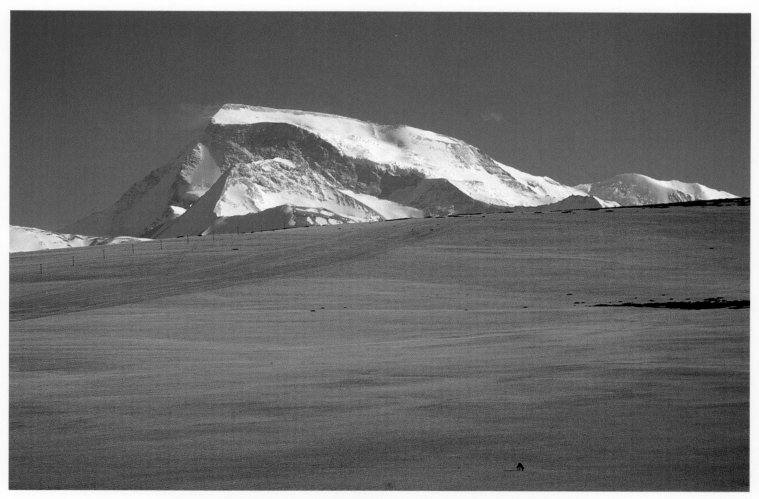

GURLA MANDHATA (25,355 FEET), FROM THE PLAINS NEAR DARCHEN IN WESTERN TIBET; 1987

*"A pilgrimage through wild, open lands
provides visions that help shape the proper attitude and inner
awareness for religious practice."*

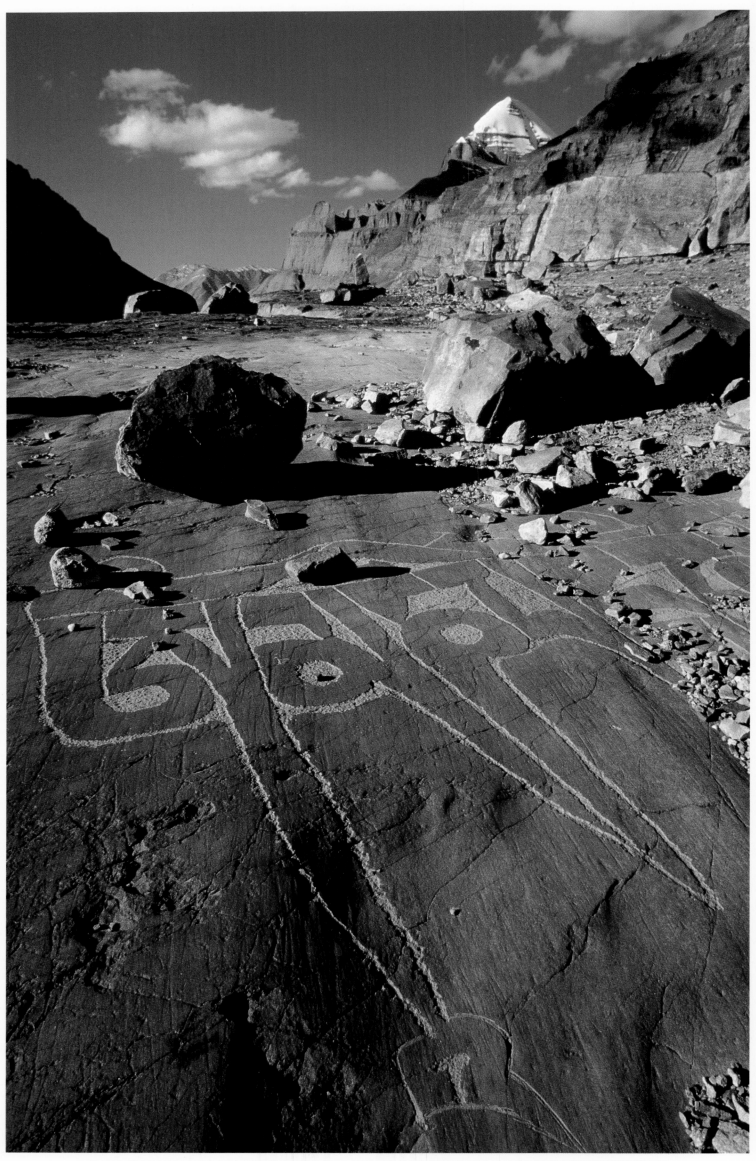

PRAYER CARVED IN GLACIER-POLISHED BEDROCK BENEATH KANGRINPOCHE (MOUNT KAILAS) (22,028 FEET) IN WESTERN TIBET; 1987

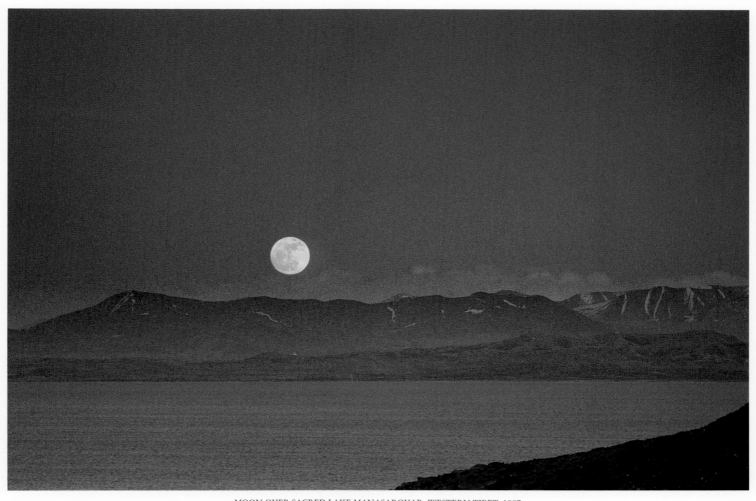

MOON OVER SACRED LAKE MANASAROVAR, WESTERN TIBET; 1987

"In this modern picture I can clearly see the beauty
of the moon—a symbol of peace—rising over the tranquil waters of a large lake,
but, in the past, people in central and eastern Tibet had no way of
knowing of the lake's beauty except by word of mouth from hardy pilgrims. The great saint Milarepa
(1040 to 1123) spent years living as a hermit beside this legendary lake known as the
Turquoise Sea. He composed lyrics about its charm and power. When he came to the city, someone teased him,
saying that the lake might be very famous at a distance, but when you come close,
maybe you would see only a small, dirty pond. Why? Because Milarepa himself was legendary
and all-powerful at a distance, but when people met him personally,
he looked like an ordinary beggar."

Left: "In the majestic beauty of Tibet's natural surroundings,
the people developed their culture."

"When Buddhism first came from India
to Tibet, no one had the authority to say: Now Buddhism has come
to a new land; from now on we must practice it in this
way or that way. There was no such decision. It gradually evolved,
and in time a unique tradition arose. Such may be the
case for Westerners; gradually, in time, there may be a Buddhism
combined with Western culture."

Kumbum *is the common name for both
the Palkhor* chorten *of Gyantse and the
major monastery in Amdo; it means one
hundred thousand images. The mysterious
eyes painted on the* chorten *are only a
hint of the monumental work done inside
by fifteenth-century Nepalese artists. A
picture story of the Buddhist universe has
been integrated with unique Tibetan
architecture for the edification of the
faithful.*

144

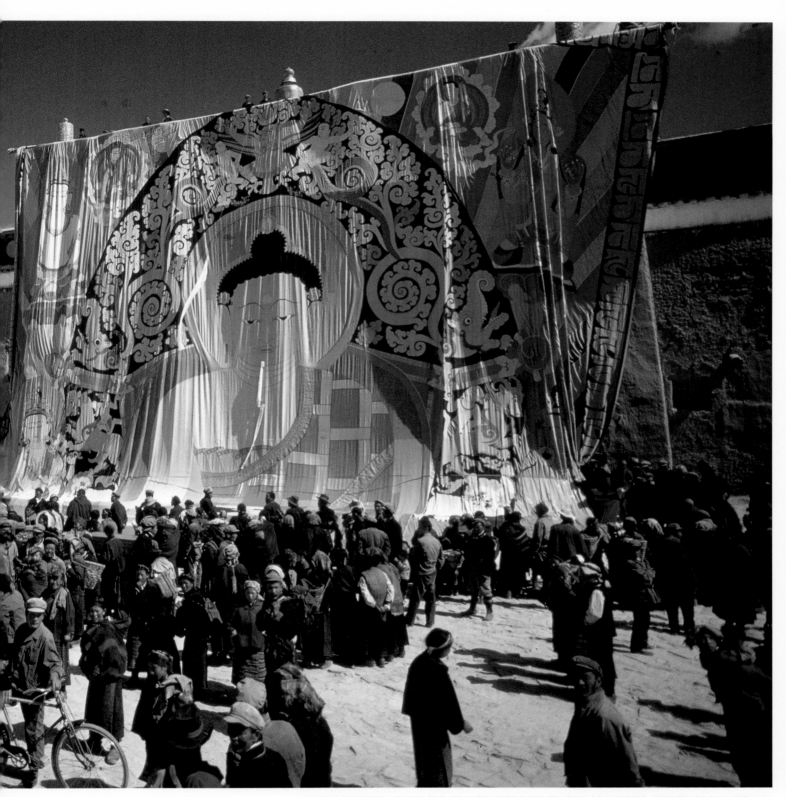

FESTIVAL BENEATH A GIANT SILK *THANGKA* BESIDE THE *KUMBUM* OR PALKHOR *CHORTEN* OF GYANTSE; 1981

145

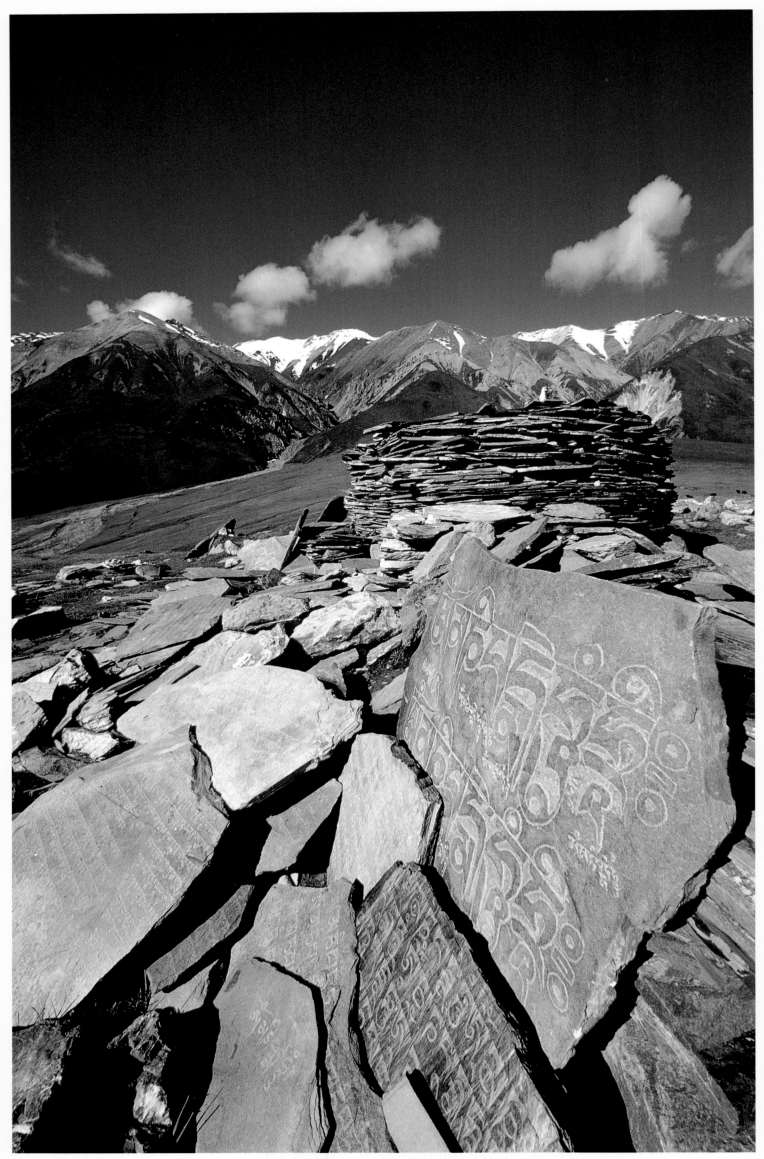

A HILLTOP SHRINE, OR *LAPCHE*, IN THE ANYE MACHIN RANGE, AMDO; 1981

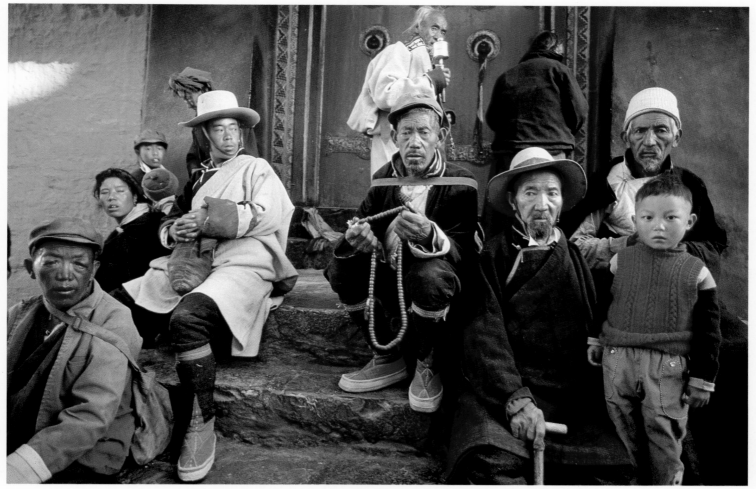

WORSHIPPERS WAITING FOR THE TASHILHUNPO MONASTERY TO OPEN, SHIGATSE; 1987

*"I am not interested in converting other people
to Buddhism but in how we Buddhists can contribute to human society according to
our own ideas. Just as Buddha showed an example of contentment, tolerance,
and serving others without selfish motivation, so did Jesus Christ. Almost all the great teachers
lived a saintly life—not luxuriously like kings or emperors but as simple
human beings. Their inner strength was tremendous, limitless, but the external appearance
was of contentment with a simple way of life."*

*Left: "Mani stones carved with prayers
and other important scriptures are placed around holy places and wherever
the land is elevated at the top of a hill or pass. Sometimes the piles of stones become so large
that the place itself becomes a shrine where travelers circumambulate
before continuing on their journeys."*

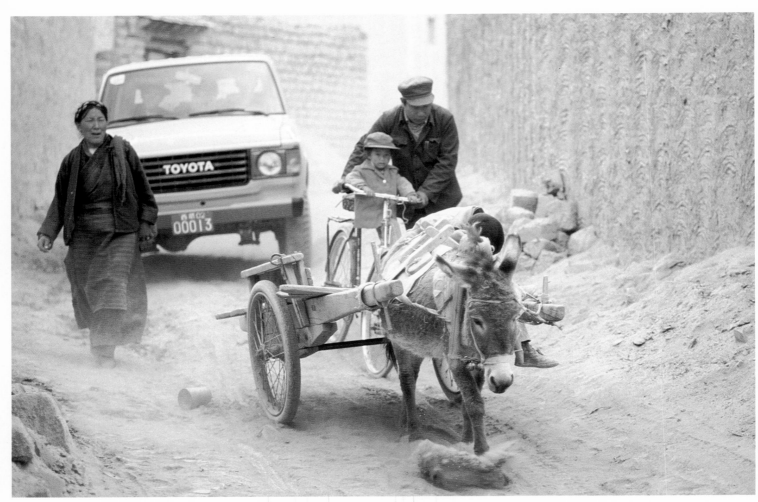

CHANGING MODES OF TRANSPORTATION, SHIGATSE; 1987

*"Nowadays the world is becoming increasingly
materialistic, and people are reaching toward the very zenith of
external progress, driven by an insatiable desire for power
and vast possessions. Yet by this vain striving for perfection in a world
where everything is relative, they wander ever further away
from inward peace and happiness of the mind."*

PRAYERS AT TASHILHUNPO MONASTERY, SHIGATSE; 1983

*"I am laughing because I was trying to imagine
what this woman might be praying for, and I thought maybe
she is praying about a bicycle, like the one behind her.
The poor woman could be saying: One of my children is pestering
me to buy a bicycle. I can't buy it, so please give me the
compassion I need to be a good mother."*

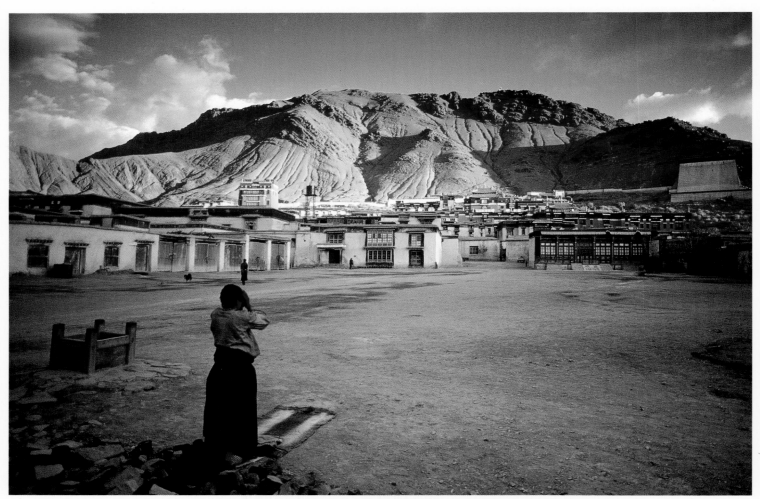

PILGRIM AT DAWN IN THE COURTYARD OF TASHILHUNPO MONASTERY, SHIGATSE; 1981

*"These days we human beings are very much
involved in the external world, while we neglect the internal world.
We do need scientific development and material development
in order to survive and increase general benefit and prosperity. But, equally, we need
mental peace. Yet no doctor can give you an injection of mental peace,
and no market can sell it to you. If you go to a supermarket with millions and
millions of dollars, you can buy anything, but if you go there
and ask for peace of mind, people will laugh."*

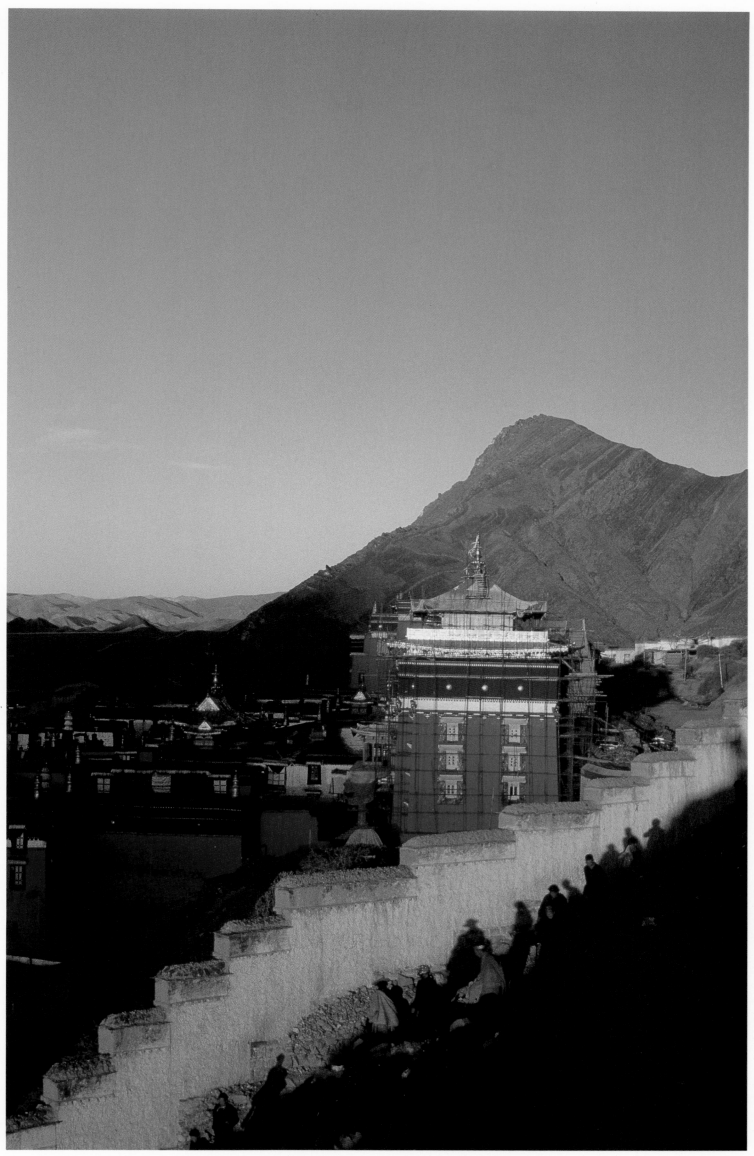

PILGRIMS CIRCUMAMBULATING TASHILHUNPO MONASTERY, SHIGATSE; 1987

151

"The perfection of enlightenment is Buddhahood. Buddhas are reincarnated solely to help others, since they themselves have already achieved the highest of all levels. They are not reincarnated through any active volition of their own; such an active mental process has no place in nirvana. They are reincarnated, rather, as the result of this same innate wish to help others that allowed them to achieve Buddhahood."

TWILIGHT AT LAKE MANASAROVAR, WESTERN TIBET; 1987

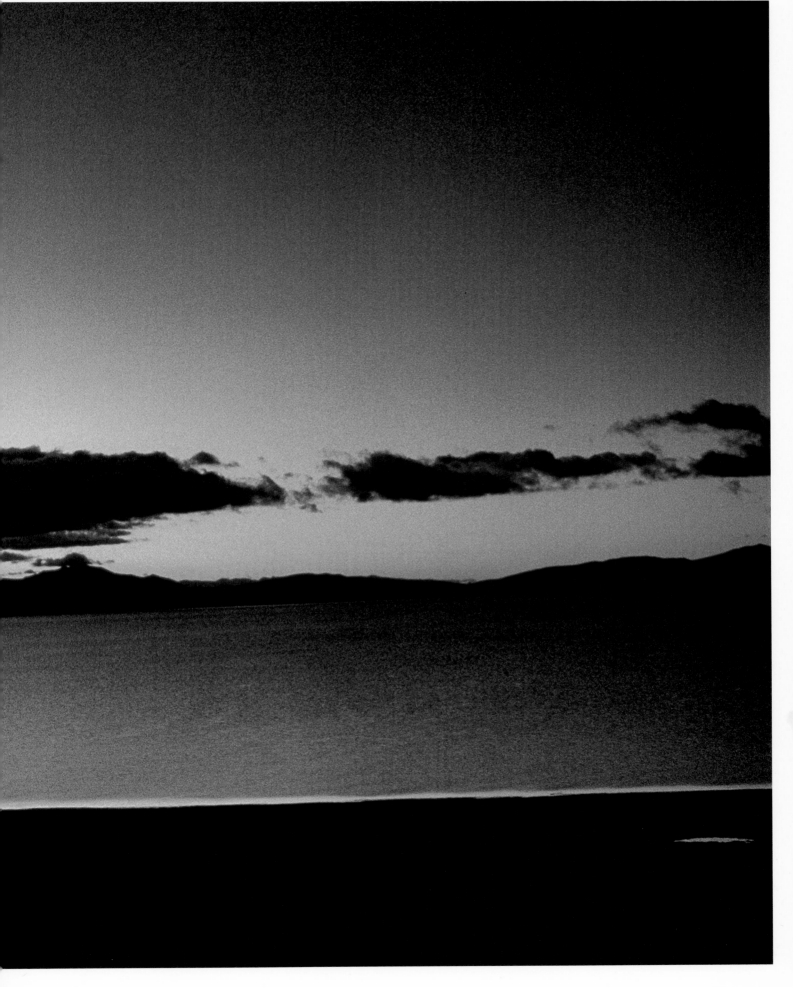

*"Reincarnations of Buddhas occur whenever conditions are suitable and do not
mean that the Buddhas themselves leave their state in nirvana. In simile, it is rather as reflections of the
moon may be seen on earth in placid lakes and seas when conditions are suitable, while the moon
itself remains on its course in the sky. By the same simile, the moon may be reflected in many different places at
the same moment, and a Buddha may be incarnate simultaneously in many different bodies."*

MOONLIGHT ON THE TINGRI PLAIN NEAR THE NEPAL BORDER; 1988

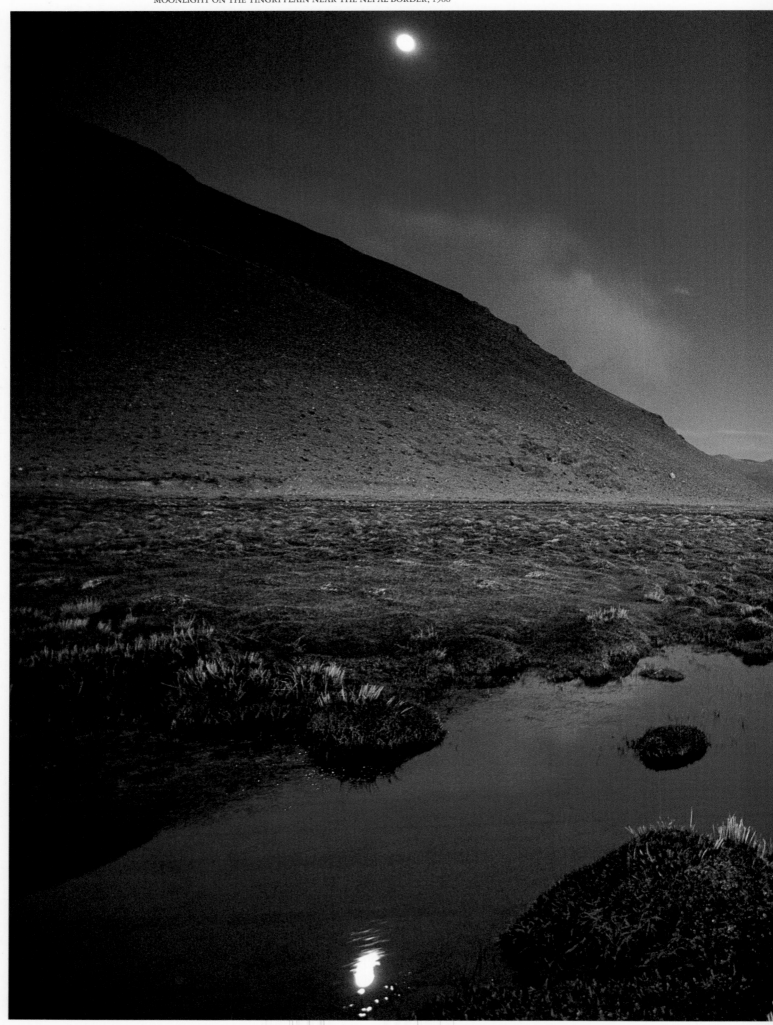

154

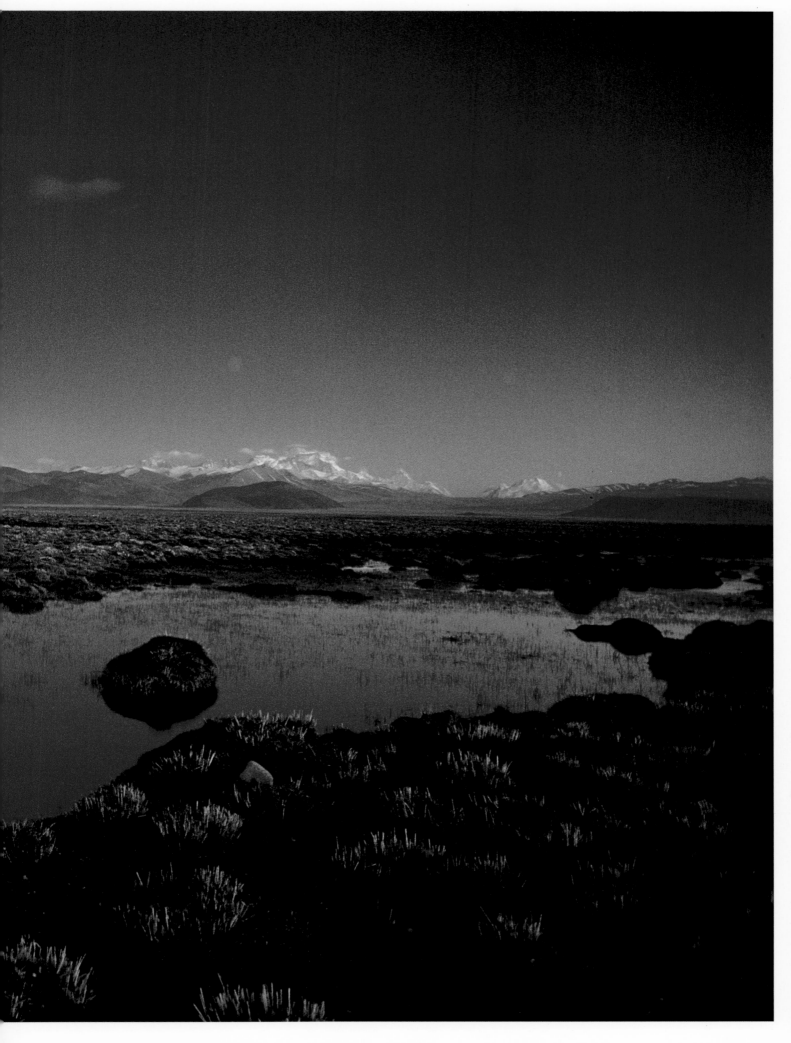

CHRONOLOGY OF THE FOURTEENTH DALAI LAMA

1935 Born on July 6 into a peasant family of Takster, a small village in the Amdo region of northeastern Tibet; named Lhamo Dhondrup.

1936 Three search parties set out from Lhasa to find the fourteenth incarnation of the Dalai Lama.

1937 Discovered by search party. Moslem warlord demands ransom before granting them permission to return to Lhasa with him. Tibetan government pays equivalent of three hundred thousand dollars in silver.

1939 Overland journey to Lhasa from August to October.

1940 Enthroned as Tenzin Gyatso, the Fourteenth Dalai Lama of Tibet, in Lhasa on February 22. Assumes ceremonial duties, with regents controlling political affairs.

1941 Begins intensive religious education.

1943 Britain reaffirms Tibet's autonomous status. Tibet remains neutral throughout World War II.

1950 Invested with absolute spiritual and temporal power over Tibet three years before normal ascension because of invasion by Chinese army. Appeal to United Nations on October 27 is declined. Escapes Chinese on December 19, fleeing overland in winter from Lhasa across the Himalaya to a village near the border of India.

1951 Seventeen-Point Agreement drafted by China for "Peaceful Liberation of Tibet" signed under duress by Tibetan officials in his absence. Returns to Lhasa after guarantee of religious and personal freedoms for his people.

1954 Leads Kalachakra teachings in Lhasa. Travels to Beijing; meets Mao Zedong, Zhou Enlai, and Deng Xiaoping, as well as Khrushchev, Bulganin, and Nehru. Publishes *A Meditation on Compassion* in Tibetan in Lhasa.

1955 Rebellion against communist "reforms" begins in Kham and Amdo.

1956 Overland pilgrimage to Sikkim for 2,500th anniversary of Buddha's birth. Meetings with Prime Minister Nehru of India and Premier Zhou Enlai of China. On June 1, as retaliation against guerrilla activity in Kham, Chinese bomb huge monastery of Lithang while it is filled with monks and pilgrims.

1959 Leaves Tibet after the March 10 national uprising against Chinese occupation. Reaches India on April 27. More than eighty thousand Tibetans killed. Tens of thousands of Tibetans follow His Holiness's path across the Himalaya into exile. Passes examinations for Geshe Lharampa degree, highest in Tibetan Buddhist education, after nearly two decades of study of monastic discipline, philosophy, and metaphysics. Receives honorary doctor of philosophy degree from Benares Hindu University and Magsaysay Award for community leadership from the Philippines.

1960 Establishes Tibetan government in exile in Dharamsala, with military protection from India. Begins efforts to preserve Tibetan culture there.

1962 Publishes autobiography, *My Land and My People*, in the United Kingdom.

1963 Drafts new constitution of Tibet, blending Buddhist principles of nonviolence and tolerance, constitutional monarchy, and popular democracy.

1965 Publishes *An Introduction to Buddhism* in Switzerland.

1966 Mao's Cultural Revolution reaches central Tibet, destroying all but nine of more than six thousand remaining monasteries during the ensuing decade. Soldiers ransack the Jokhang, Lhasa's main temple, on August 25.

1967 Visits Japan and Thailand.

1969 Publishes *Happiness, Karma, and Mind* in the United States.

1972 Visits Thailand. Publishes *The Opening of the Wisdom Eye* in the United States. Offers to return to Tibet on condition that Chinese hold plebiscite to determine wishes of his people.

1973 First travels of any Dalai Lama outside Asia. Meets Pope Paul VI at the Vatican. Visits ten other countries: Switzerland, the Netherlands, Belgium, Ireland, Norway, Sweden, Denmark, the United Kingdom, West Germany, and Austria. Receives Palketta Award in Norway.

1974 Visits Switzerland and Tibetan settlements in southern India.

1975 Publishes *The Buddhism of Tibet and the Key to the Middle Way* in the United Kingdom and the United States.

1978 Visits Japan.

1979 Visits Mongolia, USSR, Greece, and Switzerland, and makes first visit to the United States. Awarded honorary doctor of humanities degrees by Seattle University and University of Oriental Studies, Los Angeles. Receives Peace Medal from Asian Buddhist Committee for Peace. Sends first fact-finding delegation into Tibet from Dharamsala after request by Chinese that he return to Tibet. Delegation observes wholesale devastation of culture as well as intense support for the Dalai Lama by the people.

1980 Visits the United States, Canada, Japan, and the Vatican. Meets Pope John Paul II. Second and third fact-finding delegations visit Tibet; the latter, led by his younger sister, Pema Gyalpo, is expelled by Chinese after a great crowd in Lhasa displays faith in the Dalai Lama and lack of support for the Chinese rule.

1981 Visits Nepal, United States, and the United Kingdom, where he meets with the Duke of Westminster. Performs first Kalachakra Initiation in the West in Madison, Wisconsin.

1982 Visits Mongolia, USSR, Malaysia, Singapore, Indonesia, Australia, Hungary, Spain, West Germany, France, Italy, and the Vatican. Fourth fact-finding delegation visits Tibet. Another Tibetan delegation traveling from Dharamsala meets with Chinese intransigence in Beijing.

1983 Visits Switzerland, West Germany, Austria, and Turkey.

1984 Visits Japan, the United Kingdom, West Germany, and the United States. Delegation to Beijing from Dharamsala discusses Chinese overture for his return to Tibet in 1985, but fails to gain any solid concessions. Publishes *Kindness, Clarity, and Insight* in the United States.

1985 Visits Switzerland. Another fact-finding delegation visits Tibet. Publishes *Opening the Eye of Awareness* in the United Kingdom.

1986 Visits West Germany, Austria, the Netherlands, the Vatican, USSR, Italy, and France. Delivers World Environmental Day message on universal responsibility for environmental protection.

1987 Visits Switzerland, West Germany, and the United States. Receives Leopold Lucas Prize in West Germany. Introduces Five-Point Peace Plan for Tibet at Congressional Human Rights Caucus in Washington, D.C., on September 21. One week later Chinese soldiers halt demonstrations for independence in Lhasa by firing directly into the crowd.

1988 Visits Italy, West Germany, Switzerland, the Vatican, Norway, Sweden, Denmark, and France. Proposes specific framework for negotiations between Tibetans-in-exile and Chinese on June 15 to members of the European Parliament at Strasbourg, France. Receives Albert Schweitzer Humanitarian Award.

1989 Visits United States twice, Costa Rica, Mexico, France, West Germany, and Norway. Thirtieth anniversary of Tibetan uprising, on March 10, is marked by demonstrations in Lhasa as well as at Chinese embassies and consulates in major cities of the world. Receives Raul Wallenberg Congressional Human Rights Award in New York. Performs Kalachakra Initiation in Santa Monica, California. Receives Nobel Peace Prize in Oslo on December 10.

1990 Visits Czechoslovakia, Belgium, United States, Italy, Canada, Netherlands, and France. Designates 1991 as International Year of Tibet. Performs Kalachakra Initiation in Sarnarth, India, where China prevents over 10,000 Tibetan pilgrims from attending.

1991 Visits United States, United Kingdom, Ireland, Mongolia, Baltics, Bulgaria, and USSR. Meets President George Bush and Prime Minister John Major. Helps convince the U.S. Congress to declare Tibet an "occupied country." Receives Ambedkar award for humanitarian service.

1992 Visits Hungary, Austria, Russia, Venezuela, Argentina, Brazil, Chile, Australia, and New Zealand. Participates in United Nations Earth Summit conference. Attends Salzburg Festival and addresses Hungarian Parliament. Recognizes eight-year-old Ugyen Thinley as the seventeenth Gyalwa Karmapa.

1993 Visits United States, United Kingdom, France, Germany, Austria, Hungary, Canada, Gabon, and Poland. Meets President Bill Clinton. Visits Austria to attend the United Nations World Human Rights Conference in Vienna, where his participation is blocked by China, causing a large group of Nobel laureates to stage a boycott.

ACKNOWLEDGMENTS

Galen and I are grateful to all who have given time, thought, and support toward the creation of this book. Between 1981 and 1988, before we conceived the idea, most of the photographs that appear here were made on four assignments for the *National Geographic* magazine and book service. Our special thanks to Bill Garrett, Bill Graves, Anne Kobor, Bruce McElfresh, and John Schneeberger. His Holiness the Dalai Lama became involved after Galen's idea passed from Bruce Bunting, vice president of World Wildlife Fund, to Tenzin N. Tethong, director of the International Campaign for Tibet, to his elder brother in Dharamsala, Tenzin Geyche Tethong, Secretary to His Holiness the Dalai Lama. Tenzin Geyche facilitated our audiences and arranged permission for us to reprint writings published by the Information Office of His Holiness the Dalai Lama. Sections of the 1962 autobiography, *My Land and My People*, appear here with minor editing as the essays "Tibet As I Knew It" and "My Life in Lhasa." The essay "Ecology and the Human Heart" has been adapted from a speech given in New Delhi in 1988. The remaining three essays are based on our personal interviews. Many of the quotations that accompany the photographs are direct responses to the images, while others are reprinted from books and speeches.

Snow Lion Press of Ithaca, New York, generously gave us permission to use the illustrations of the eight auspicious signs of Buddhism that appear in the frontmatter and at the beginning of each essay. Snow Lion Press also granted us permission to use words by the Dalai Lama from the many works of his they have published. We acknowledge quotes from *The Buddhism of Tibet* and *Kindness, Clarity, and Insight*. Nancy Nash, of the Buddhist Perception of Nature in Hong Kong, provided Galen with a wealth of environmental information on Tibet as well as permission to use parts of the Dalai Lama's 1986 World Environment Day statement that appeared in her book, *Tree of Life*.

Tseten Samdup, press officer for the Information Office, spent most of two weeks helping us in Dharamsala. Suzie Eastman, a close friend who encouraged us from the beginning and volunteered her help from running errands to reading manuscript, joined in on our first Dharamsala audience with her good friend Rex Fuqua, who helped fund the project through the Realan Foundation.

When we mentioned our idea to David Cohen, then president of Collins Publishers, USA, he suggested that we might be ready to produce our own books. I had doubts until I had a long, encouraging conversation with Bob Madden, the editor in charge of layout for *National Geographic*, who had worked on our articles for the magazine. Bob had also designed several books for photographers on state-of-the-art desktop-publishing equipment that closely matched what Collins was using. With his shopping list in hand, Galen and I formed Mountain Light Press.

Collins generously allowed Jennifer Barry, who created the award-winning design of Galen's 1989 book, *The Art of Adventure*, to work for us on a free-lance basis from concept to final product. Jenny and I fine-tuned the design together as I entered the data into the computer. The text was transcribed by Terri Brown and initially edited by Galen before it received a final copyedit from Barbara Youngblood. Bruce Borowsky, John Decker, Guy Riessen, David Sumner and Jim Thornburg worked with the photographs. Repro Images of Vienna, Virginia, made high quality enlarged duplicate transparencies to be used for reproduction. Sparky Campanella, Raman Shabbas, and Steve Schaffran of Barneyscan, a local company, got us up and running with an amazing desktop scanner to digitize 35mm slides for layout on a computer screen. We commissioned B. B. Thapa of Kathmandu and Bob Tope of Virginia to produce special maps and Barbara Roos to do the index.

John Ackerly, Michelle Bohana, Susan Kolp, and Tenzin N. Tethong provided valuable comments on Galen's introductory texts while Tenzin Geyche Tethong and Lhakdor, the religious assistant and translator of the Office of His Holiness the Dalai Lama, read the quotations and essays for accuracy and continuity. Before the final edit, Tom Cole and Suzie Eastman read the entire text. Many native Tibetan speakers, linguists, and editors offered suggestions on the spelling of Tibetan names. We decided we would rather err toward reader friendliness than try to render precise transliteration of consonants not used in English. Those familiar with Pinyin spellings of Tibetan names will notice that they have not been used here. We believe that the Pinyin system of English transliteration of Chinese characters, urged by the Chinese government, should never be applied to Tibetan words. It makes little sense to us, and even less to Tibetans, to translate Tibetan into Chinese and then into often unrecognizable English using a system that assigns unfamiliar pronunciations to several consonants, such as sh to x, ts to z, and ch to q. Only where certain Pinyin words are in common usage and relate to China (which no one spells Qina), instead of Tibet (which few spell Xizang), have we chosen them: "Beijing" instead of "Peking," or "Deng Xiaoping" instead of "Teng Hsiao-p'ing."

Galen's friend Drummond Rennie, deputy editor, West, of the *Journal of the American Medical Association*, exercised predictably sound editorial judgment by suggesting we contact Elizabeth Knoll, who became the book's sponsoring editor at the University of California Press. James Clark, director of the Press, helped us realize our goal of having a close working relationship with our publisher.

We also wish to thank the many others who aided us in various ways, among them: Dani, Phil and H. Ayers, Howard Barney, Chun-wuei Su Chien, Bob Craig, Tom Eastman, Lucy Garrick, Mary Glaeser, Rodney Jackson, Harold Knutson, Martha and Arthur Luehrmann, Eileen McWilliam, Kevin O'Farrell, Marcia Roberson, George Schaller, Kim Schmitz, Taj Group Hotels, Kesang Tashi, Tibet House, Jere van Dyk, Woodlands Institute, and Ted Worcester.—*Barbara Cushman Rowell*

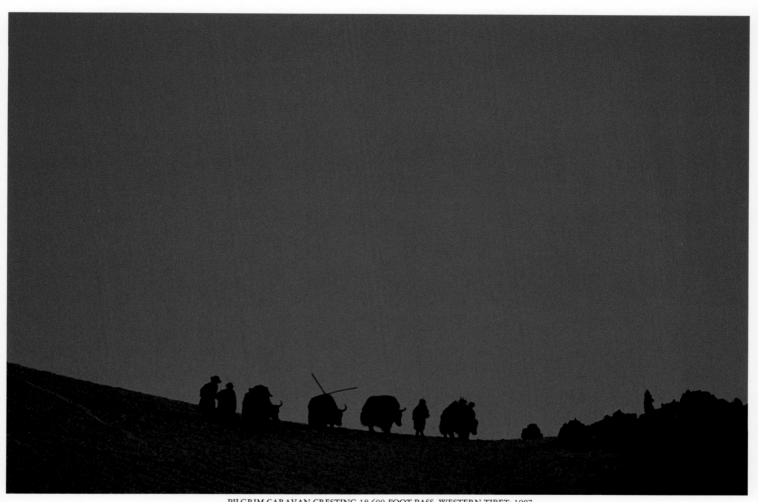

PILGRIM CARAVAN CRESTING 18,600-FOOT PASS, WESTERN TIBET; 1987

*"My country, Tibet, lived in peace
and harmony, our people never having seen a modern army or
police force until the Chinese invasion."*

INDEX

Aarvik, Egil, 18

Amdo, 12-13, 14, 22-39, 116; Anye Machin Range in, 20, 23, 26, 30, 37, 74, 146; Kumbum Monastery in, 12-13, 22, 24, 25, 144; in map, 12; in photographs, 20-37, 74, 146; wildlife in, 60, 69, 74

Animals, 23, 53, 111; Chinese and, 8, 40, 60, 64; in Lhasa, 23, 65, 66, 68, 70, 73, 75, 84, 111, 112-114; of nomads, 40, 42, 45; wild, 8-11, 17, 53, 58-77

Antelope, 58

Anye Machin Range, 20, 23, 26, 30, 37, 74, 146

Asses, Tibetan wild (*kiang*), 8, 61, 62, 63

Automobiles, 14, 114, 115

Barkhor Path, 86, 88

Birds, 68, 70, 71, 73, 75

Britain, 7, 56, 84, 103, 104, 114

Brown, Terri, 18

Buddha, 3, 81, 88, 100, 147; dharma wheel and, 75, 98; and equality of beings, 59; reincarnations of, 11, 152, 154. *See also* Chenrezi

Buddhists/Buddhism, 11-12, 17, 33, 34-36, 48, 108, 147; and compassion, 8, 11-12, 17, 79-80, 94; and culture, 79, 98, 144; dharma and, 98; Gelukpa, 12-13, 22, 118; greetings of, 4; and Kailas, 128; and natural environment/living beings, 53, 59, 60, 75, 79, 80; origins in Tibet, 88, 103, 116, 121; and pilgrimages, 133, 136, 139, 140; and prayer wheels, 94; and science, 17, 36. *See also* Dalai Lama; Monasteries; Temples

Bush, George, 7

Changtang, 60

Chemayungdung Valley, 42, 45, 62

Chenrezi, 8, 11-12, 13, 94, 106. *See also* Dalai Lama

China, 7-8, 11, 14-17, 18, 34, 36, 103, 104; and Amdo, 22; and animals, 8, 40, 60, 64; and nomads, 40; and pilgrimages, 128; Tibet invaded by, 7, 14, 22, 114, 161

Choegyal, Tendzin, 14

Chomolungma (Mount Everest), 2, 15, 67, 82, 83; British and, 56, 114; Rongbuk Monastery beneath, 102, 105

Cho Oyu, ii

Circumambulation, 128, 139-40, 147, 151

Climbing, 56, 114

Communism, 7, 34, 60

Compassion, 17, 33-36, 79-80; Chenrezi as Buddha of, 8, 11-12, 94; and natural environment, 8, 53, 72, 79-80

Congressional Human Rights Caucus, U.S., 14

Crane, 75

Dalai Lama, Fifth, 16, 111

Dalai Lama, Seventh, 112

Dalai Lama, Thirteenth, 12, 13, 104

Dalai Lama, Fourteenth (Tenzin Gyatso), 4-7, 8-13, 18; on Buddhahood, 152, 154; childhood of, 12-14, 22, 24, 65, 111, 112; education of, 14, 106, 111; essays by, 33-36, 53-54, 79-80, 103-6, 111-14, 139-40; family of, 12, 23, 24, 111; in Lhasa, 13, 14, 23, 65-75 passim, 84, 89, 104, 111-15; mechanical abilities of, 13, 14, 112, 114; on mental peace, 33-36, 45, 54, 106, 107, 109, 134, 148, 150; and natural environment/wildlife, 3, 8-11, 18, 21, 53-54, 55, 61-84; Nobel Peace Prize, 1, 18; peace plan of, 14, 18, 21, 80; in photographs, 5, 19; photographs of, 14-17, 52; on pilgrimages, 129-33, 139-41, 143, 147; and politics, 8, 10, 14-17, 18, 27, 33-34, 36; and science, 17, 34, 36, 54, 81, 150

Darchen, 141

Deer, 74, 75

Deities, 11-12, 36, 100, 101

Democracy, 6, 104

Derge, 92

Dharamsala, India, 4-7, 8, 9, 17, 19, 89

Dharma, 98

Dharma wheel, 75, 98

Dhondrup, Lhamo, 12-13. *See also* Dalai Lama, Fourteenth

Dogs, 76

Dolma La, 133

Drepung Monastery, 82, 88, 113

Drokpas, 40. *See also* Nomads

Eastman, Suzie, 4

Education: of Dalai Lama, 14, 106, 111; of nomads, 40

Electricity, 112, 114

Environmental protection, 8, 11, 17, 18, 21, 60; Dalai Lama on, 8, 11, 18, 21, 53-54, 55, 79-80, 83

Equality, of all beings, 59

European Common Market, 33

European Parliament, Strasbourg, 3

Everest. *See* Chomolungma

Family, Dalai Lama's, 12, 23, 24, 111

Five Point Peace Plan, 14, 18, 80

Flowers, 2, 3, 82-85

Freedom, 8-11, 33, 61

Fuqua, Rex, 4

Gampo, Songtsen, 88

Ganden Monastery, 88, 109, 117-19

Ganden Tipa, 118

Ganges River, 128

Gazelles, 65

Gelukpa sect, 12-13, 22, 118

Geneva Report of the International Commission of Jurists, 7

Goats, 42, 45

Golok people, 22, 23, 26, 28, 30, 31

Government: Tibetan, 7, 103-4, 106. *See also* Politics

Gulls, 71, 70

Guring La, 27

Gurla Mandhata, 141

Gyalpo, Pema, 8

Gyantse, 144, 145

Gyatso, Desi Sangye, 16

Gyatso, Tenzin. *See* Dalai Lama, Fourteenth

Happiness, 33-36, 106, 107, 134, 148

Harrer, Heinrich, 14

Himalaya, 60, 103. *See also* Chomolungma (Mount Everest)

Hindus, 128

Hitler, Adolf, 18

Horses, 23, 111

Human rights violations, Chinese, 7

Immortality, 11, 17

Impermanence, 11

Incarvillea, 84, 85

India, 4, 7, 14, 103, 116; Dharamsala, 4-7, 8, 9, 17, 19, 89

Indus River, 128

Japan, 79, 104

Jesus Christ, 147

John Muir Trail, 17

Jokhang (Tsuglakhang) Temple, 7-8, 88; in photographs, 86, 91, 99, 100, 101, 110; pilgrims and, 88, 93, 139

Kailas, Mount, 73, 126-42; pilgrimages to, 14-17, 126, 128, 129-34

Kama Valley, 2, 82, 83

Kangbochen, vi, 56

Kangrinpoche. *See* Kailas, Mount

Kangyur, 113

Karma, 106, 127

Karnali River, 128

Kata, 4

Kham, 14, 50, 60, 92; on map, 12

Khampas, 22, 50, 92, 106, 132

Kharta Plains, 85

Khasa, 81

Khashag (Cabinet), 104

Kissinger, Henry, 7

MY TIBET

*was created and produced at Mountain Light Press
in Albany, California, in association with the
University of California Press.*

*Designed by Jennifer Barry
Edited by Galen Rowell and Barbara Youngblood
Computer-generated layout by Barbara Cushman Rowell
Transcription by Terri Brown*

*Layout and composition executed on an
Apple MacIntosh IIx using Aldus PageMaker software,
Adobe Garamond 3 type fonts, and images
digitized on a Barneyscan. Output to Linotronic 300
by Hunza Graphics of Berkeley. Transparencies
by Repro Images of Vienna, Virginia*

*Color separations by Dai Nippon Printing Company, Tokyo
Printed and bound by Dai Nippon Printing Company, Hong Kong*